RETRO LONDON

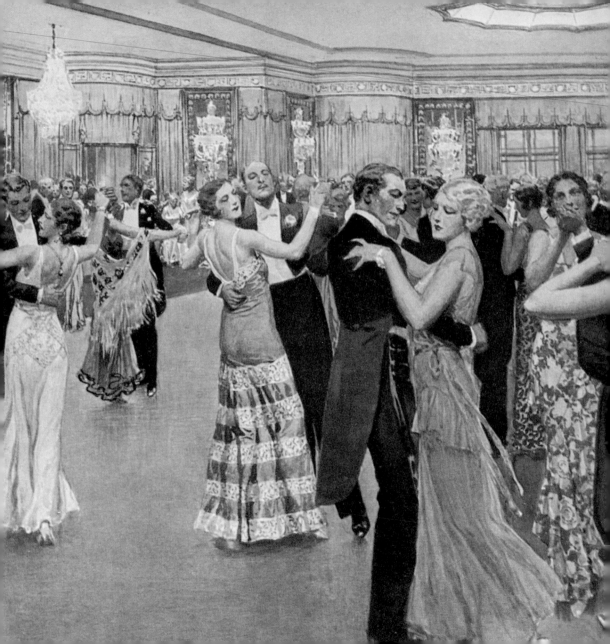

RETRO LONDON

LUCINDA GOSLING

In Association with the Mary Evans Picture Library, London

NH
NEW HOLLAND

First published in 2015 by New Holland Publishers Pty Ltd
London • Sydney • Auckland

The Chandlery Unit 009 50 Westminster Bridge Road London SE1 7QY United Kingdom
1/66 Gibbes Street Chatswood NSW 2067 Australia
5/39 Woodside Ave Northcote Auckland 0627 New Zealand

www.newhollandpublishers.com

A record of this book is held at the British Library and the National Library of Australia.

ISBN 9781742577128

Managing Director: Fiona Schultz
Publisher: Alan Whiticker
Project Editor: Simona Hill
Designer: Peter Guo
Production Director: Olga Dementiev
Printer: Toppan Leefung Printing Ltd

10 9 8 7 6 5 4 3 2 1

Keep up with New Holland Publishers on Facebook
www.facebook.com/NewHollandPublishers

CONTENTS

INTRODUCTION

FIRST-TIME VISITORS to London venturing out on an exploration of the capital could do worse than board the No. 11 bus at Liverpool Street Station. For a fraction of the cost of a sightseeing tour, the No. 11 creeps from the City in the East to Fulham in the West, carrying passengers past some of the most pre-eminent London landmarks. First, it makes its way through the famous streets of finance, where grand neo-Classical and Palladian structures built with the profits of Empire now compete for space with sheer-sided skyscrapers and futuristic glass office buildings. The mean, narrow roads along which many of these stately buildings squeeze—Cornhill, Poultry, Cheapside—are Roman in origin, for this is the ancient and original heart of London, which was a seething hive of industry and activity at a time when the likes of Islington or Kensington were quiet, rural outposts. At Mansion House, the official residence of the Lord Mayor, there is some sense of the patrician space one might expect in a place of such prosperity, but the relentless grind of Londoners on the move leaves the magnificent portico of the Royal Exchange and the old Bank of England (not to mention the Duke of Wellington, captured for eternity in bronze) facing each other across a perpetually gridlocked network of traffic lights. Hundreds of commuters and City workers, too impatient to wait for the lights to change, skip and dodge traffic. Time travel back 50 or 100 years to this same junction and the same congestion caused the hansom cab and omnibus drivers of the last century just as many headaches.

A few minutes on, and the bus passes by the massive, commanding structure of St Paul's Cathedral. Despite the towering, gleaming structures sprouting up rapidly within a mile or two of Sir Christopher Wren's masterpiece, St. Paul's dome remains the most iconic and recognisable centrepiece in London's ever-changing skyline. Down Ludgate Hill, small streets and alleys channel off to the left and lead wanderers down to the Thames passing hidden pubs and a Wren church that glories in the name of St. Andrew by the Wardrobe. Further on is Ludgate Circus and the wedding cake spire of the church appropriately named St Bride's emerges above the rooftops. Travelling along Fleet Street, you can still spot buildings that hint at this street's former role as home to the country's press. One building, no. 186, still bears the signs of the long since obsolete *Dundee Courier* and the monochrome *Express* building stands as a reminder of more purposeful times. Alight here and you could slip through a doorway to visit Temple, the capital's legal district, and its famous 12th-century church of the Knights Templar, or sip a pint in Ye Olde Cheshire Cheese, once the local of essayist Dr Johnson. Onwards down the Strand—with its Edwardian theatres and the glamorous Savoy Hotel before emerging onto Trafalgar Square where tourists flock to pose by Landseer's stately lions, gaze up at Nelson's Column or mill around in the National Gallery. Next onto Whitehall, past Downing Street, Horse Guards Parade and the Cenotaph before the glorious Gothic complex of the Houses of Parliament and Westminster Abbey appear. Moving on past Victoria Station, the final stretch of the journey runs the length of the King's Road, once full of cool boutiques and cooler shoppers in the swinging sixties, now lined with upmarket chain stores for wealthy West Londoners.

This perfect, if by no means exhaustive, potted tour of London is made all the more satisfying when passengers learn this is a route that has been in operation since 1906. Londoners and tourists alike who climbed aboard the No. 11 a century ago would have passed many of the same sites, and wondered at the blend of old and new which is a fundamental characteristic of the city. If there is one thing London does well, it is reinvention. It is a city constantly evolving, sometimes by choice, sometimes through necessity—such as in the aftermath of the Second World War. But it does so with a deep-rooted confidence in its own traditions and venerable history. Many beautiful London buildings have been lost to London over the years, either through fire, war or short-sighted town-planning decisions. But plenty remain, from the ancient fortress of the Tower of London to the early 19th century streets known to Charles Dickens. While the cranes and building sites in constant attendance are testament to

London's continuing vitality and modernising zeal, it is London's history that draws between 4.7 and 4.9 million visitors to the capital every summer.

Despite its packed programme of sights, the 11 bus route covers only a fraction of London which, as the decades pass, has continued to stretch, swell and push its boundaries. Like tree rings, the suburbs of London have multiplied and reproduced; prosperous Edwardian housing following on from Victorian terraces; 1930s suburbia eventually encroached by post-war high-rises and vast housing estates. But none of this has a uniform pattern. London is often referred to as a vast patchwork of what estate agents like to call 'villages'. Indeed, many of them often were once villages, offering a rural idyll outside of the smoke and stench of the city, but were eventually swallowed up and woven into the urban fabric of London during its rapid and relentless 19th century expansion.

And so London, for those who live and work there, exists in two parts. There is London, the vast metropolis to which everyone belongs, and then there is the local part of London to which the individual belongs. Localism allows London-dwellers to identify themselves amid the homogenous anonymity of living in a large conurbation. In pubs, at work or at parties, people who meet others who come from the same area of London feel an inexplicable affinity with each other. In London, more than anywhere, the synchronicity of finding someone who also lives in Wood Green, Catford, Crystal Palace, Leytonstone or Hanwell seems a miraculous coincidence and triggers hours of conversation about local streets and commuter routes.

Inevitably, this tribal inclination leads to a friendly rivalry between different London areas, particularly North and South London, efficiently demarcated by the snaking River Thames. Londoners can be fiercely loyal to their chosen side, though in truth, there is little to set one above the other except that North London has more tubes and it's a standing joke that taxi drivers (many of whom favour East London as their home) won't go south of the river late at night. There is a rivalry too now between East and West. Much of West London is affluent and smart, as evidenced by eye-watering property prices, but the past two decades has seen a vibrant transformation across East London. Hoxton, Old Street and Shoreditch, to the north of Liverpool Street, for many decades scruffy, rundown and populated mainly by small factories and sweatshops, is now home to creative and digital media companies, hip bars and restaurants and equally fashionable residents. Further out, Stratford underwent massive regeneration for the 2012 Olympic Games and the Queen Elizabeth Olympic Park, stadium, pool and

velodrome remain as a lasting legacy of a summer when every Londoner was proud to live in the city. West Londoners sometimes declare that, 'West is Best'. East Londoners can just smile in the knowledge that they now have plenty of aces to play.

These shifting tides of change; this seesaw of fortunes, is an ever-present phenomenon throughout London's history. Brick Lane, now part of the East London renaissance has gone through many changes, welcoming waves of French Huguenot, Irish, Jewish and, in the 1960s and '70s, the Bangladeshi immigrant communities to the area. Today, clubs, bars and vintage boutiques make Brick Lane a weekend destination for hipsters. Notting Hill's gentrification in the late 20th century is all the more spectacular for being once labelled by Charles Booth, founder of the Salvation Army as the 'worst area in London'. The deprivation and slums of nearby North Kensington, documented in the 1950s photographs of Roger Mayne, some of which feature in this book, are an indication of just how far removed the district has become today from its past. Likewise the Jewish and Bangladeshi communities making homes and a living in Brick Lane back in the 1970s, are captured by Paul Trevor and provide a surprising contrast with Brick Lane's current edgy sophistication.

Changes to the urban landscape have been matched by changes to London's tastes in entertainment, developments in its public transport and its job market. The capital is home to national sporting venues from Wembley Stadium north west of the city to the world famous Wimbledon All-England Lawn Tennis Club in the south west. Lord's Cricket ground, the Oval and now the Olympic stadium have all witnessed legendary sporting moments over the years. London (at last count) can boast six teams in the Premier League. And yet in the 1920s and 1930s, football rated as London's third most popular spectator sport, eclipsed by dirt track racing and greyhound racing.

Now just two greyhound stadiums remain in London and then in the far reaches of Wimbledon and Romford. Some of the other extinct or near-extinct phenomena associated with London include shoe blacks, chimney sweeps, lamplighters, bus conductors, coalmen, police call boxes, uniformed nannies and messenger or telegram boys. Many have vanished in their original recognisable guise, for better or worse, from London's streets. Horse-drawn drays (wagons) have also disappeared, as have the breweries from whence they came. London's docks once teamed with workers loading and unloading cargo into the area's warehouses; now they are redeveloped into an extension of the City—a business utopia dreamed up in the 1980s, traversed by the driver-less Docklands Light Railway. Harrods,

Selfridges, Liberty and John Lewis, London's famed department stores, were once joined by many more temples to the cult of shopping. London is as interested in retail therapy as ever and can rival any city around the world in that respect, but the names of Debenham and Freebody, Gamages of Holborn, Bourne and Hollingsworth, Swan & Edgar, even the more recently closed Barker's of Kensington (now an American whole food store) conjure up an age of old-fashioned values and personal service; a slower, more proper way of doing things. Back in the 1960s, Carnaby Street's groovy vintage boutiques and the Biba store in Kensington not only helped London swing to a fashion beat, but made those older institutions look staid and outdated, until they too became the victims of the life cycle of changing taste.

The iconic cherry red telephone box designed by Sir Giles Gilbert Scott was phased out after the privatisation of British Telecom in 1981—now a period piece they are more likely to be seen in miniature form sold in tourist shops in Oxford Street and Covent Garden. The demolition of the Victorian Doric arch at Euston Station is widely considered one of the great crimes of 1960s town planning and lobbying continues today to restore this piece of London's past to its rightful place. Soho's Italian-run cafes with their retro formica interiors and noisy coffee machines have all but vanished, replaced by multi-national coffee chain shops, while pubs, still considered a bastion of traditional London life, are closing at a rate of around 100 every six months in London and the south east. Less tangibly, many comment wistfully on the dwindling sight of children playing out on the streets; a trend attributed to increased traffic on the roads and the sedentary attractions of computers and games consoles indoors.

Many of us, whether old enough to remember or not, yearn for these lost pieces in the jigsaw of London's past. We may get a fleeting sense of them on our journeys around the 21st century city, but pictures that document this past, and show London how it once was, go further toward satisfying our unquenchable thirst for nostalgia.

Mary Evans Picture Library has made a business out of preserving our past in the form of pictures since 1964. When the library started back then, it wanted to visually record not just the familiar school textbook history, but also the minutiae of everyday life; what people wore, what they ate, what amused them and what shocked them, through photographs, but also through illustrations, magazine covers, scraps, cigarette cards, advertisements, theatre programmes, music sheets, tickets, documents and cartoons. Founded and based ever since in Blackheath in south east London, documenting London life has been at the heart of the library's remit for the past 50 years.

Drawing on this vast archive, *Retro London* seeks to bring together a collection of photographs and other images documenting the world of 20th-century London, from the early Edwardian era through two World Wars, a new Elizabethan age and the swinging sixties to the dawn of Thatcherism in the late 1970s. London lovers will see much they can identify within this book, from the mundane frustrations of public transport to the thrill of a night, 'up West'. It shows London at its best—and at its lowest ebb; at its grittiest and at its most glamorous. Packed with more sights and history than even the No. 11 bus route, *Retro London* is a fascinating and surprising tour through the last century as experienced by one of the world's most fascinating and surprising cities. Sit back and enjoy the ride.

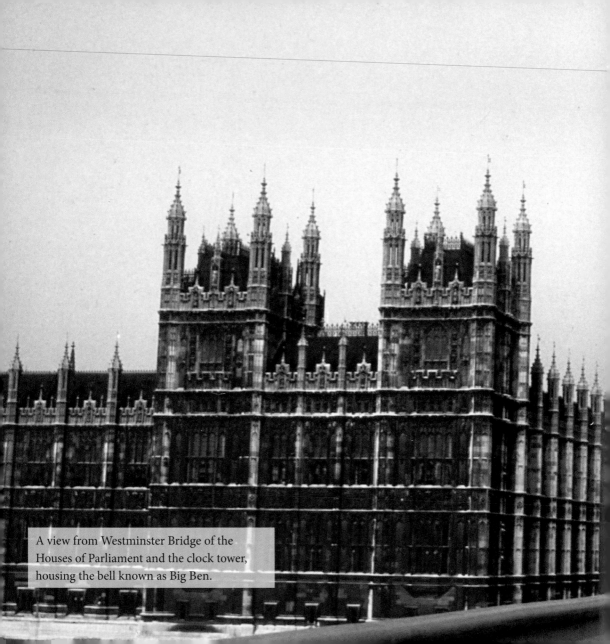

A view from Westminster Bridge of the Houses of Parliament and the clock tower, housing the bell known as Big Ben.

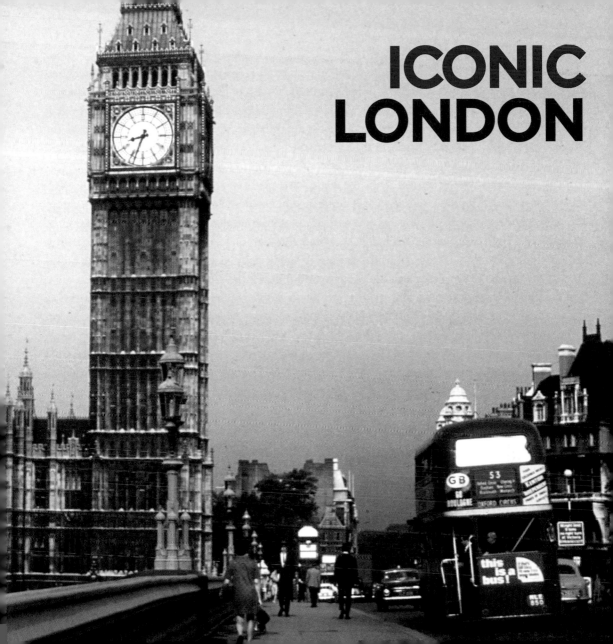

ICONIC
LONDON

including Michael Faraday, George Eliot and Karl Marx. More recently, Malcolm McLaren, founder of the punk group the Sex Pistols, was buried here.

It's true that those who have lived in London for decades will admit there is always more to discover and Dr Johnson's oft-used declaration that one who is tired of London is tired of life still holds true. Anyone seeking that single, elusive symbol of London should simply stop looking. London's unique selling point is its diversity and infinite variety and has been so for centuries.

RIGHT: People crossing London Bridge with Tower Bridge in the background in the 1950s.

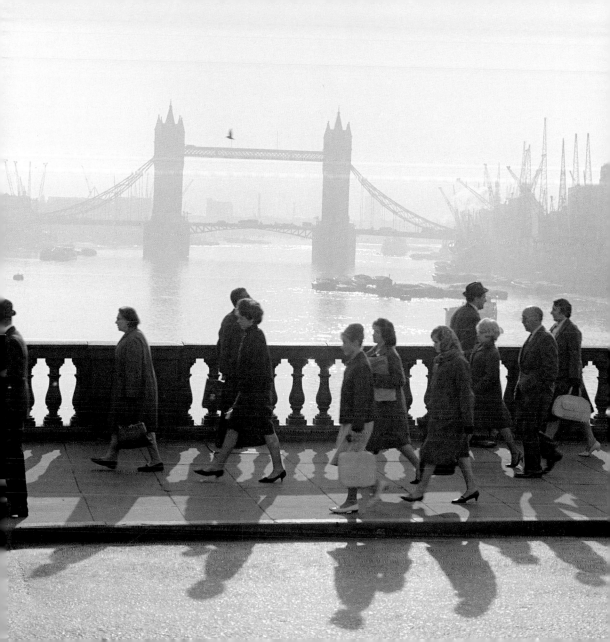

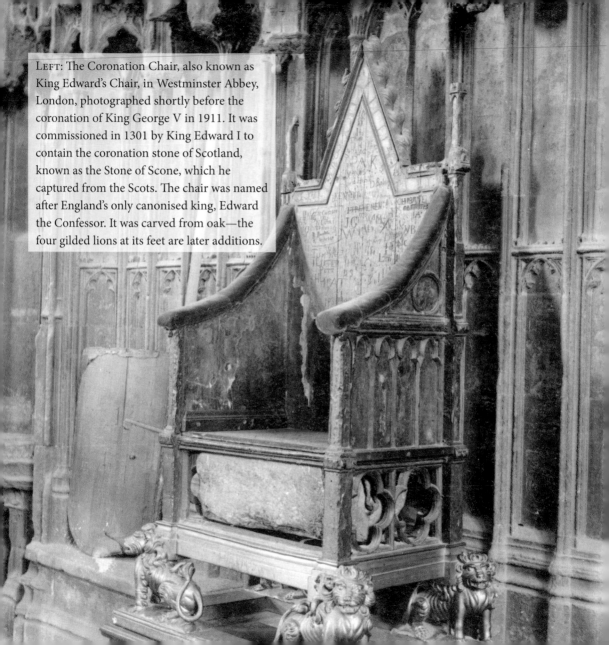

LEFT: The Coronation Chair, also known as King Edward's Chair, in Westminster Abbey, London, photographed shortly before the coronation of King George V in 1911. It was commissioned in 1301 by King Edward I to contain the coronation stone of Scotland, known as the Stone of Scone, which he captured from the Scots. The chair was named after England's only canonised king, Edward the Confessor. It was carved from oak—the four gilded lions at its feet are later additions.

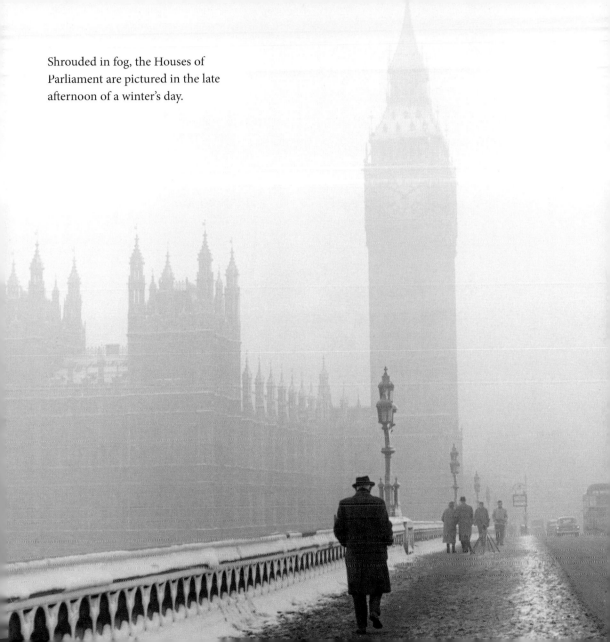

Shrouded in fog, the Houses of
Parliament are pictured in the late
afternoon of a winter's day.

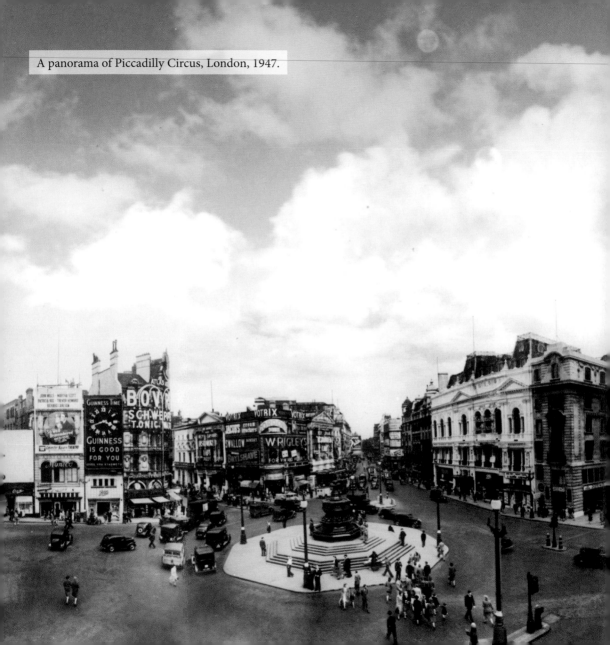

A panorama of Piccadilly Circus, London, 1947.

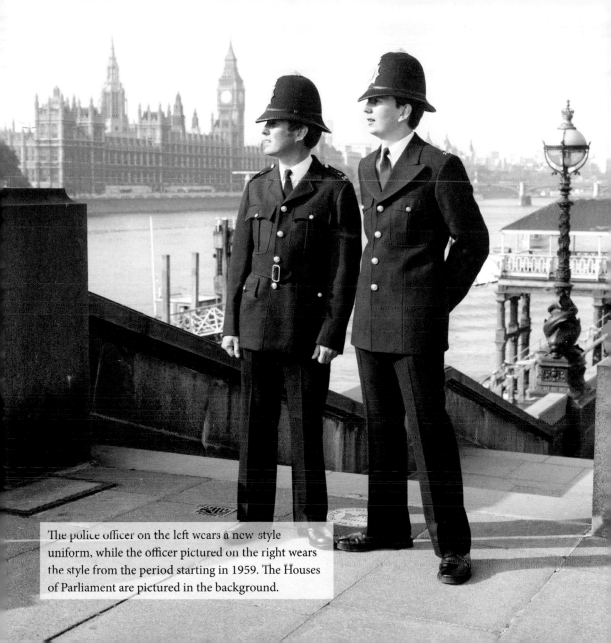

The police officer on the left wears a new style uniform, while the officer pictured on the right wears the style from the period starting in 1959. The Houses of Parliament are pictured in the background.

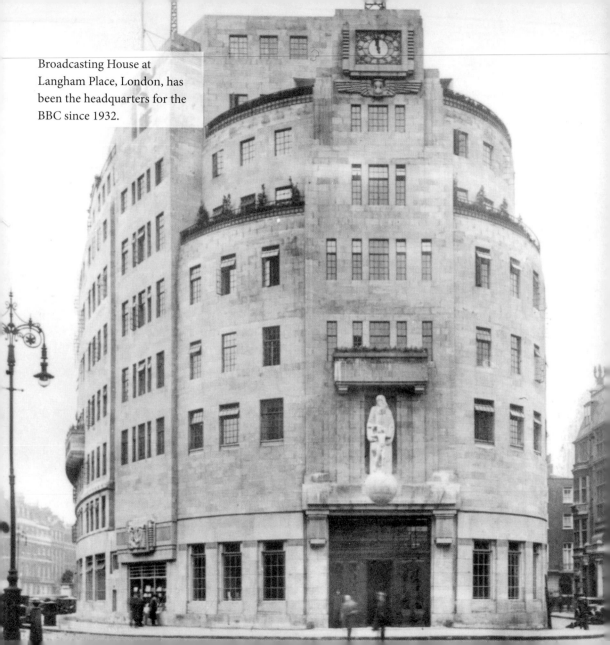

Broadcasting House at Langham Place, London, has been the headquarters for the BBC since 1932.

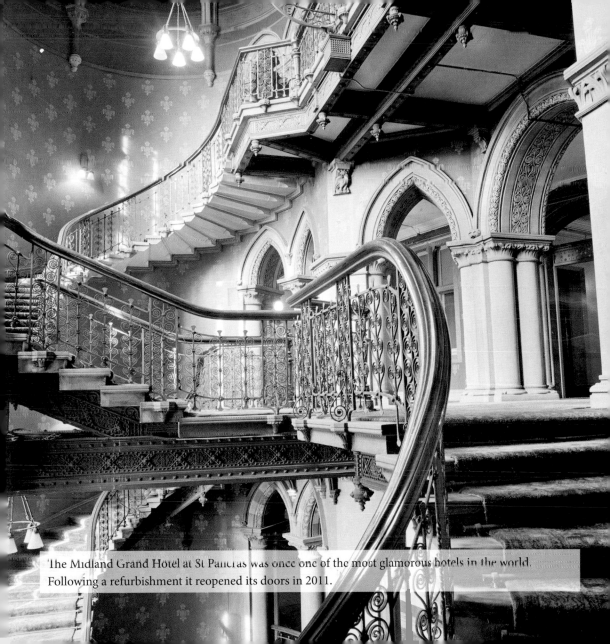

The Midland Grand Hotel at St Pancras was once one of the most glamorous hotels in the world. Following a refurbishment it reopened its doors in 2011.

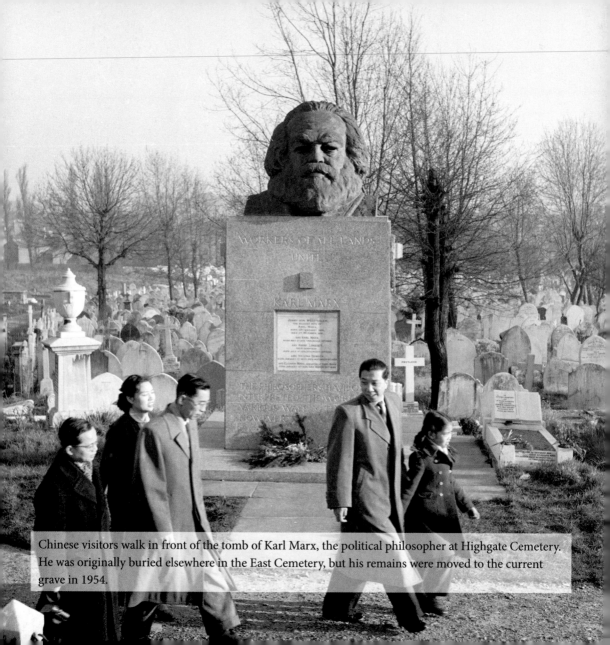

Chinese visitors walk in front of the tomb of Karl Marx, the political philosopher at Highgate Cemetery. He was originally buried elsewhere in the East Cemetery, but his remains were moved to the current grave in 1954.

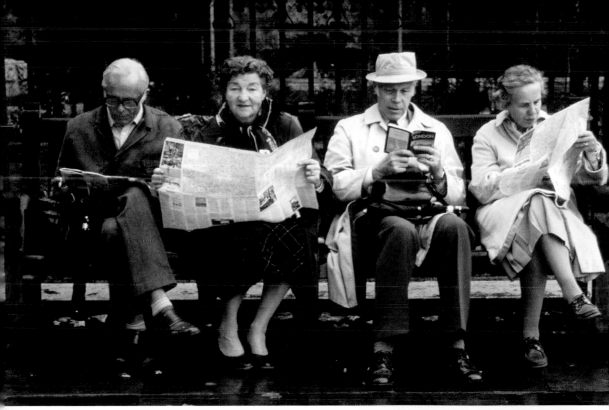

ABOVE: Tourists are an integral part of London's make-up. Here, four visitors, equipped with maps and guidebooks, sit on a bench and plan the day's adventures.

RIGHT: The book cover of *Adventures in London* by James Douglas, showing a silhouette of the London skyline.

FAR RIGHT: British icons on sale at a London market stall in the 1960s. Lord Kitchener signs, and dolls dressed in the uniform of the Coldstream Guards.

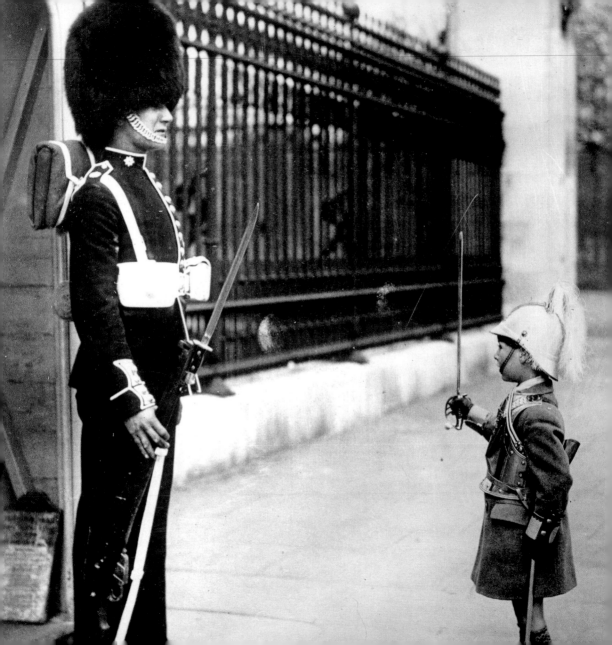

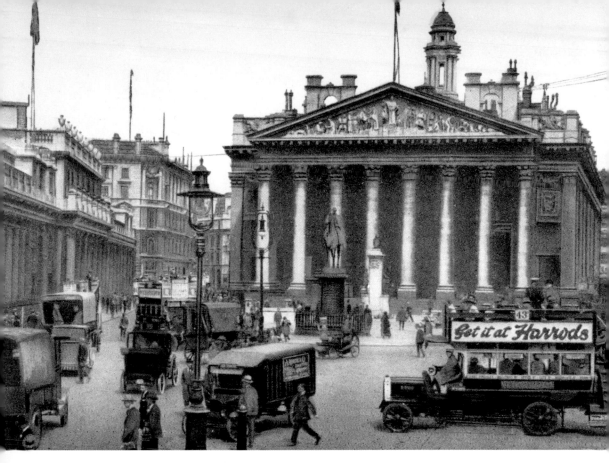

LEFT: A small boy in uniform raises his toy sword in salute to a Coldstream Guard on sentry duty in Whitehall, 1935.

ABOVE: The Royal Exchange with its ornate pediment and Greek columns dominate this picture. Built as a centre of commerce, it has twice burnt down and been rebuilt. The Bank of England is pictured on the left of the image. Note the omnibus advertising the famous department store, Harrods, *c.* 1912.

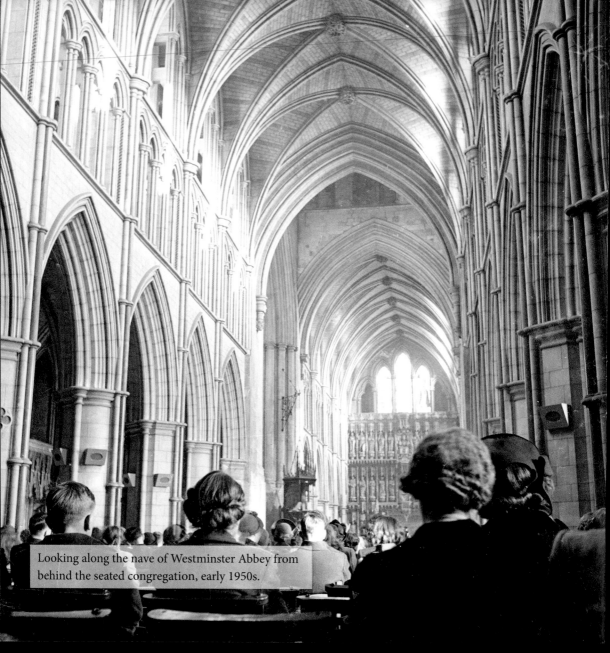

Looking along the nave of Westminster Abbey from behind the seated congregation, early 1950s.

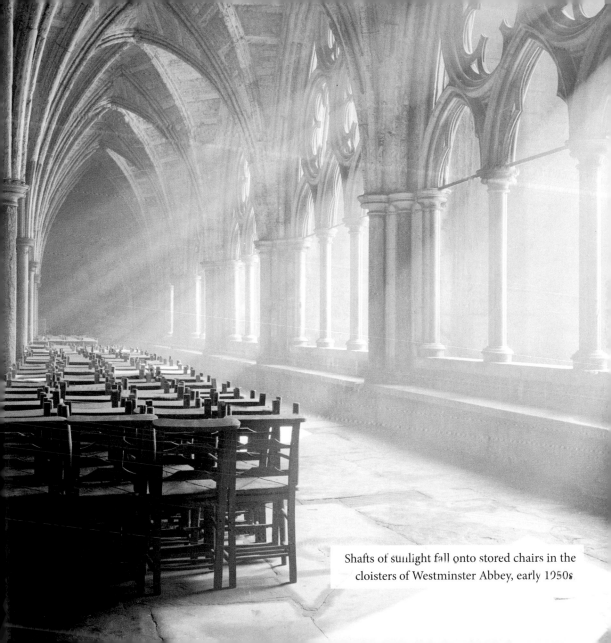

Shafts of sunlight fall onto stored chairs in the
cloisters of Westminster Abbey, early 1950s

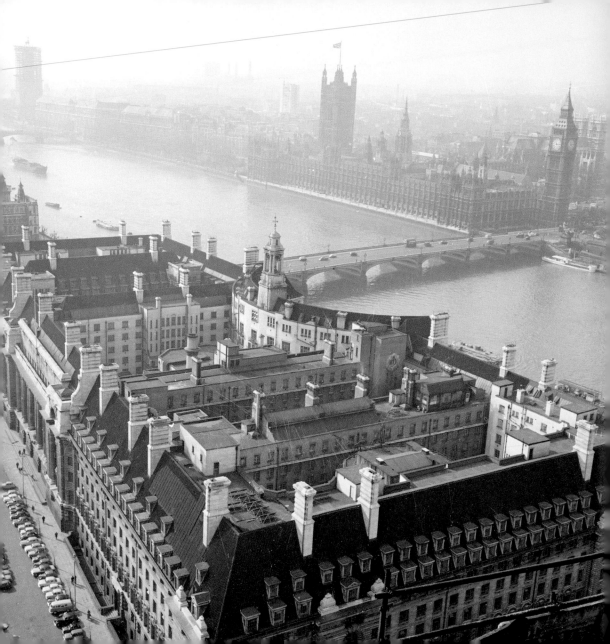

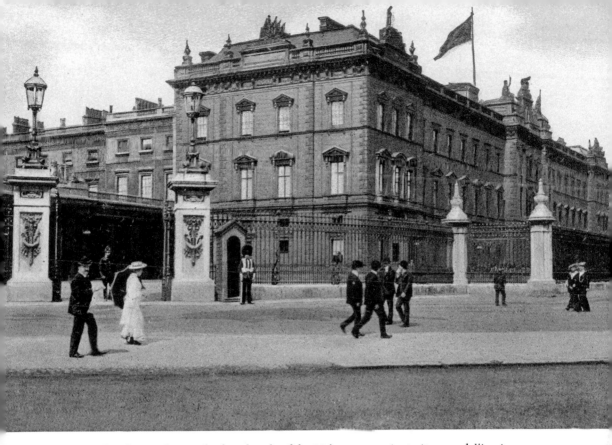

ABOVE: Buckingham Palace in the first decade of the 20th century prior to its remodelling in 1913 when the familiar façade of white stone was added.

LEFT: A view from Lambeth looking south over County Hall and the River Thames toward Westminster Bridge and the Houses of Parliament.

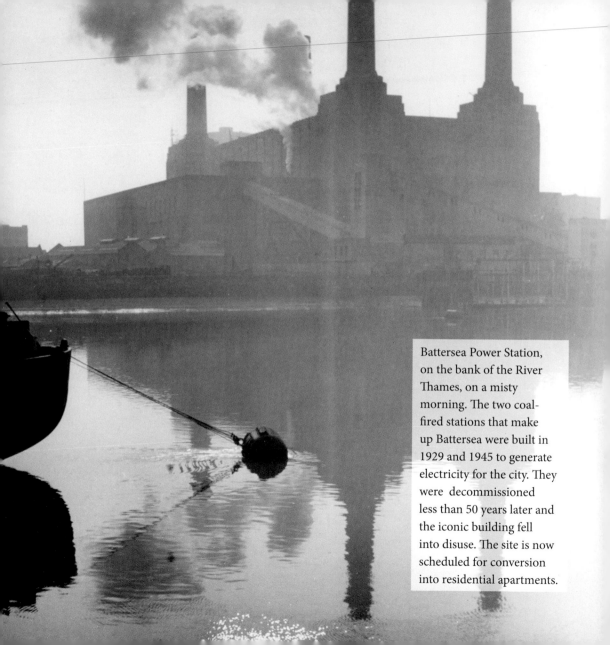

Battersea Power Station, on the bank of the River Thames, on a misty morning. The two coal-fired stations that make up Battersea were built in 1929 and 1945 to generate electricity for the city. They were decommissioned less than 50 years later and the iconic building fell into disuse. The site is now scheduled for conversion into residential apartments.

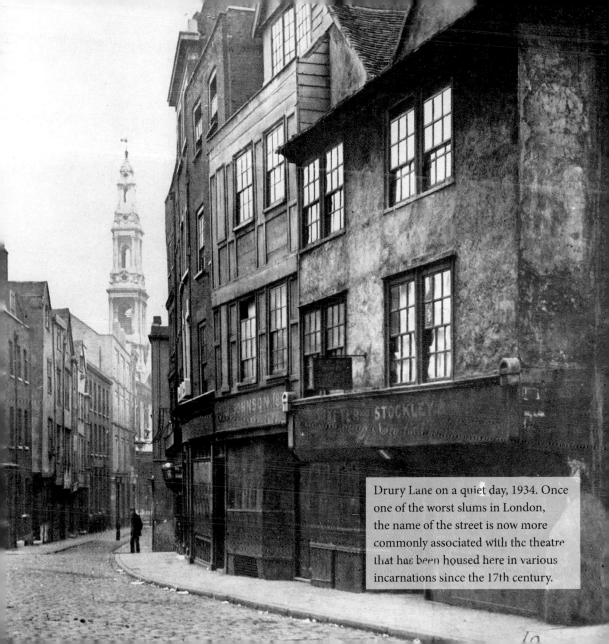

Drury Lane on a quiet day, 1934. Once one of the worst slums in London, the name of the street is now more commonly associated with the theatre that has been housed here in various incarnations since the 17th century.

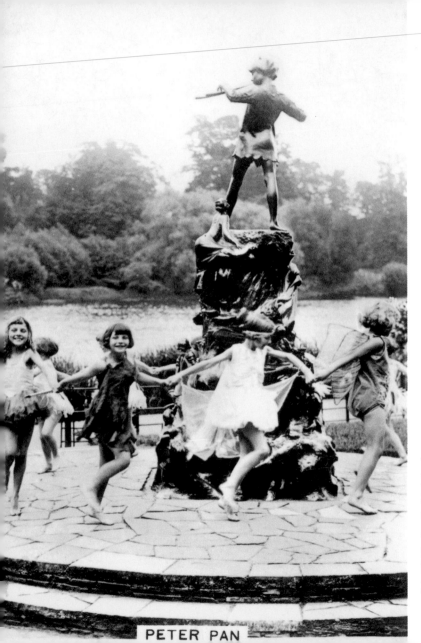

PETER PAN

The magical statue of
Peter Pan by George
Frampton in Kensington
Gardens was installed
overnight on 1 May 1912,
paid for and arranged
by Peter Pan's creator,
J M Barrie.

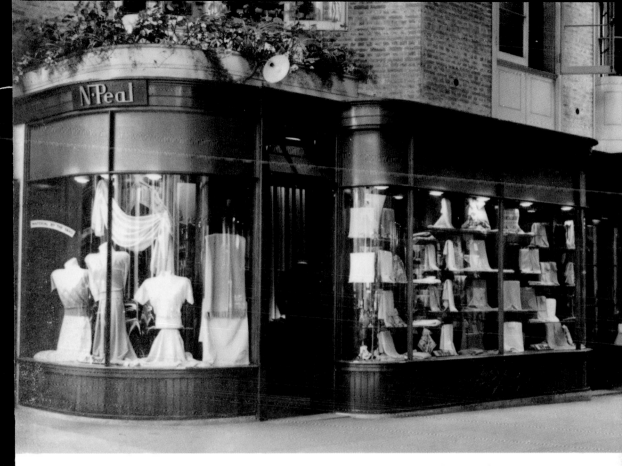

Burlington Arcade in London was a precursor of European shopping malls. This covered walkway between Piccadilly and the rear of Bond Street once housed more than 70 shops. N. Peal is still in the same location today.

ABOVE: A rehearsal for the Trooping the Colour at Horse Guards Parade is in full flow.

RIGHT: Royal horse guards ride under an archway at Whitehall, London, possibly arriving to take part in the Trooping the Colour, an annual parade of pomp and pageantry to celebrate the monarch's birthday.

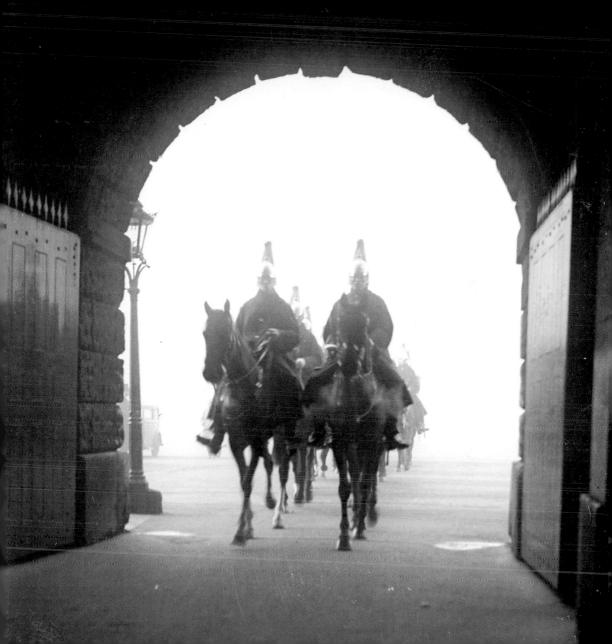

One of the British constitution's great traditions, the State Opening of Parliament takes place each year on the first day of a new Parliamentary session. The Queen's Speech sets out the agenda for the forthcoming session.

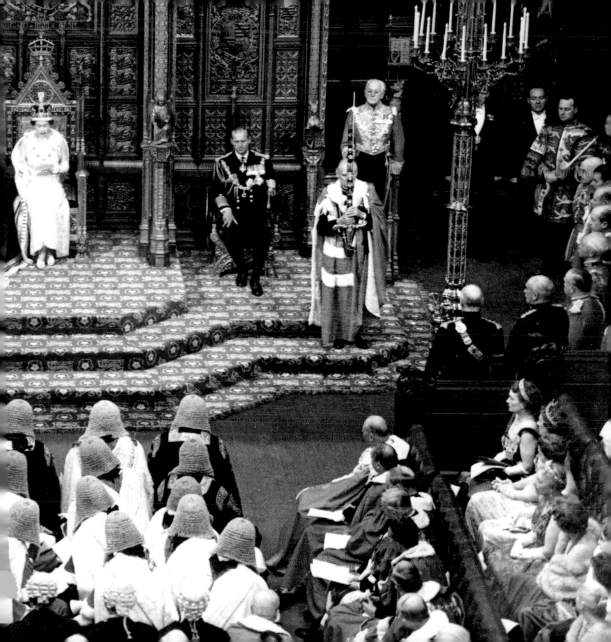

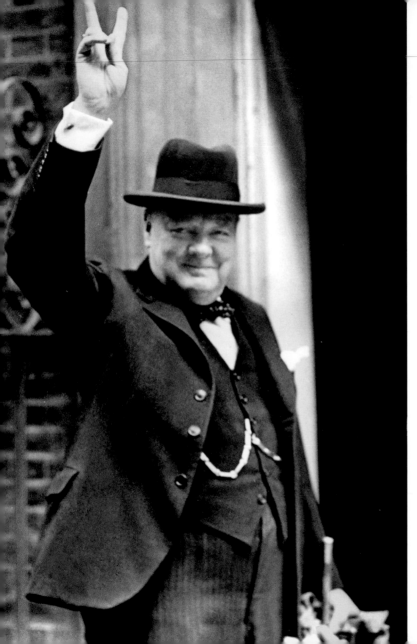

British Prime Minister
Winston Churchill
(1874–1965) makes the
victory gesture in front of
10 Downing Street.

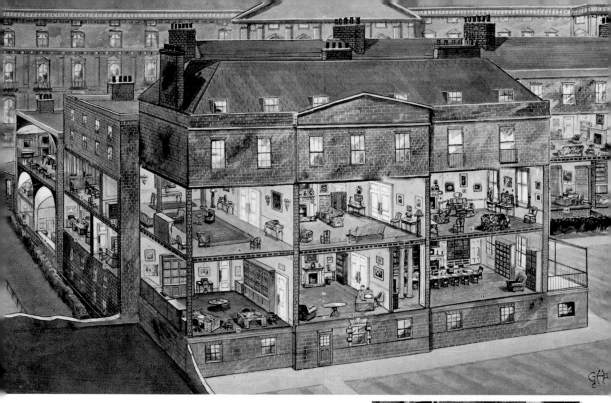

ABOVE: Cut-away illustration of the interior of 10 Downing Street, official residence of the British Prime Minister, by G. H. Davis in *The Illustrated London News*, 1949.

RIGHT: Journalists and photographers await the British Prime Minister outside 10 Downing Street.

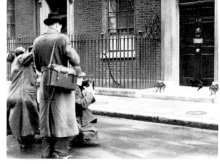

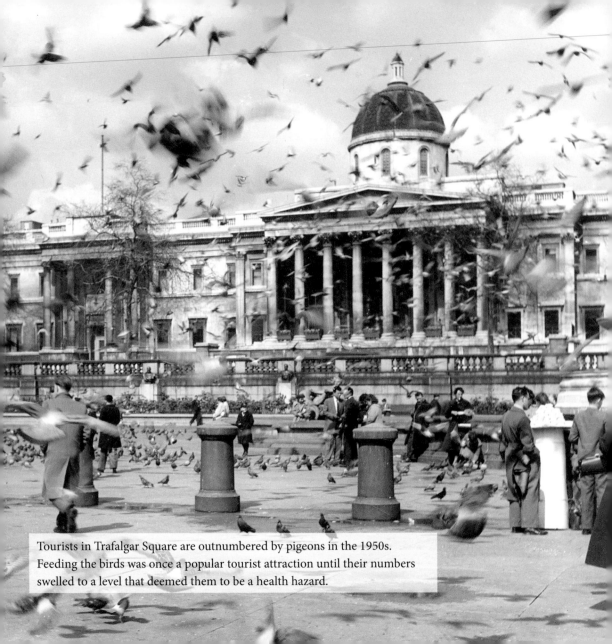

Tourists in Trafalgar Square are outnumbered by pigeons in the 1950s. Feeding the birds was once a popular tourist attraction until their numbers swelled to a level that deemed them to be a health hazard.

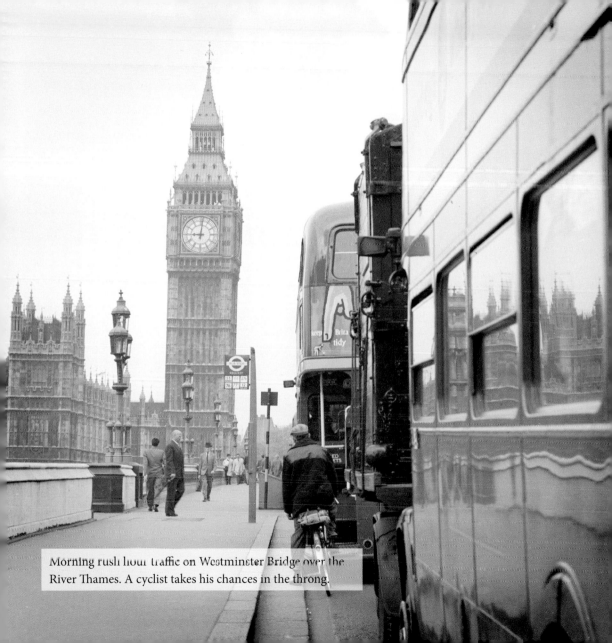

Morning rush hour traffic on Westminster Bridge over the River Thames. A cyclist takes his chances in the throng.

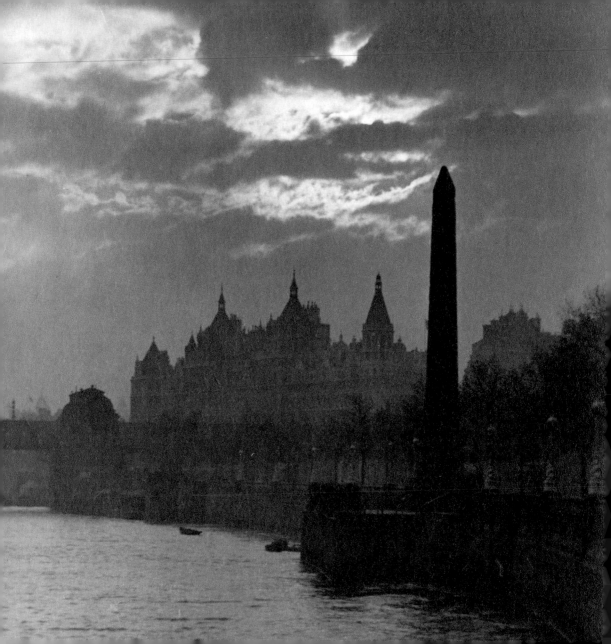

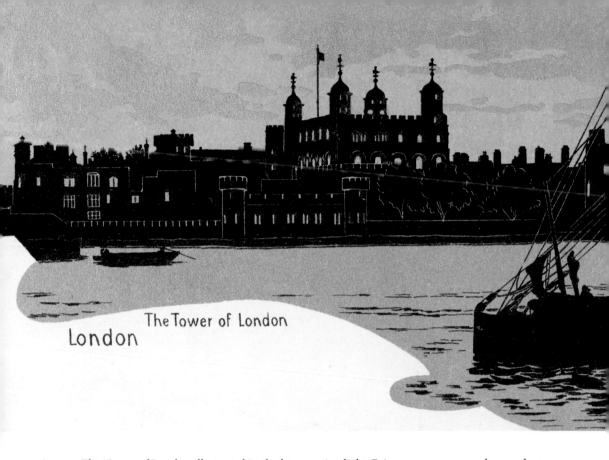

The Tower of London

London

ABOVE: The Tower of London illustrated in the late evening light. Prisoners were once taken to the tower by boat.

LEFT: Cleopatra's Needle, an ancient Egyptian obelisk on the Victoria Embankment of the River Thames.

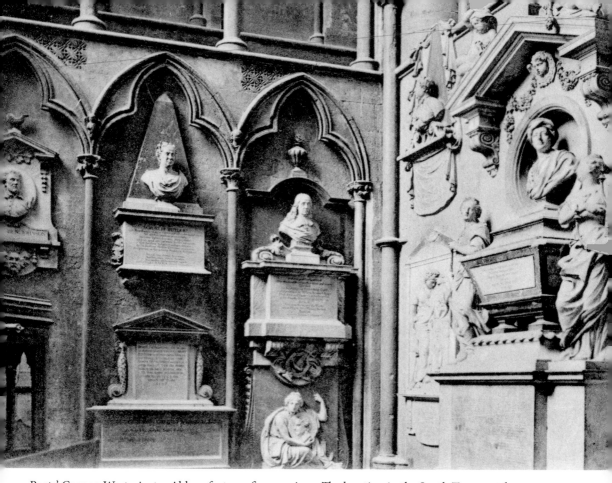

Poets' Corner, Westminster Abbey, features fine carvings. The location in the South Transept has become the final resting place for poets, playwrights and authors of renown.

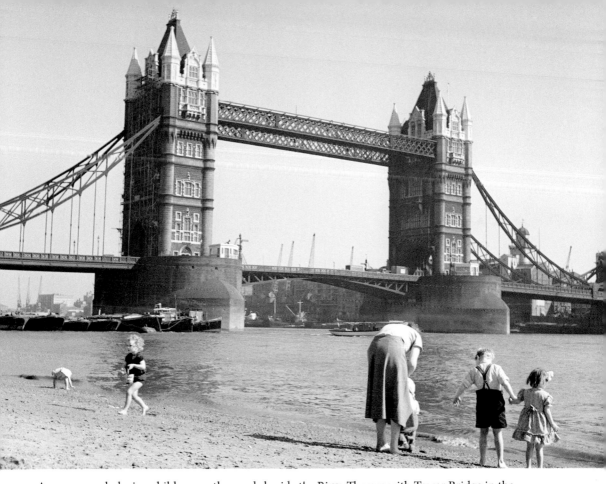

A woman and playing children on the sands beside the River Thames with Tower Bridge in the background.

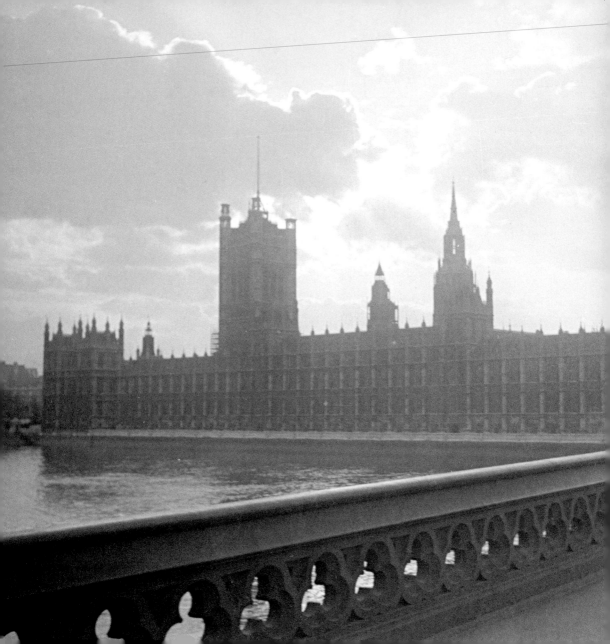

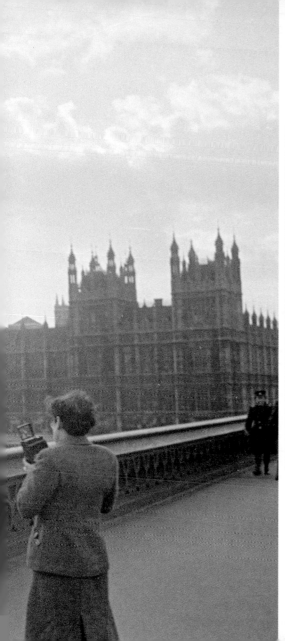

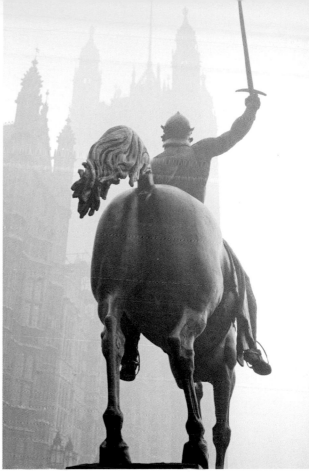

ABOVE: A close-up view of the rear of the equestrian statue of King Richard I with the side elevation and Victoria Tower of the Palace of Westminster in the mist behind.

LEFT: A woman takes a photograph of the Houses of Parliament from Westminster Bridge.

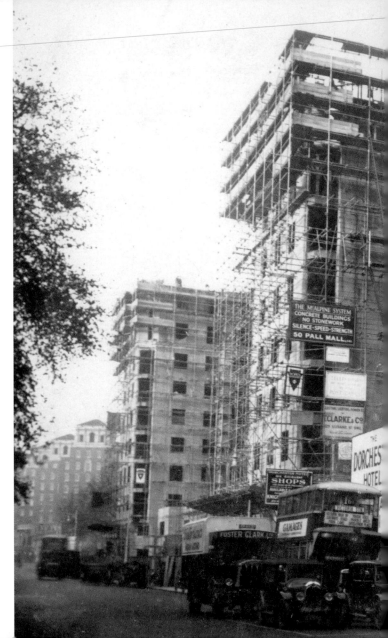

The Dorchester Hotel, Park Lane, London W1, at the east end of Hyde Park, with scaffolding all around it. A policeman directs the traffic below. This prestigious hotel opened its doors in 1931.

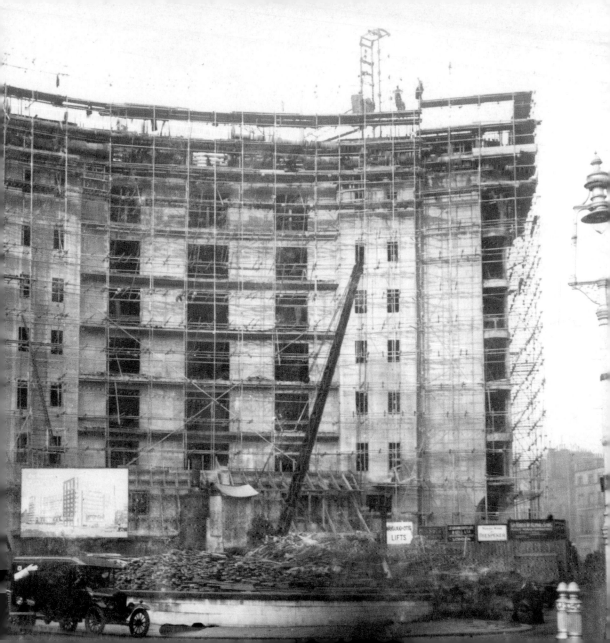

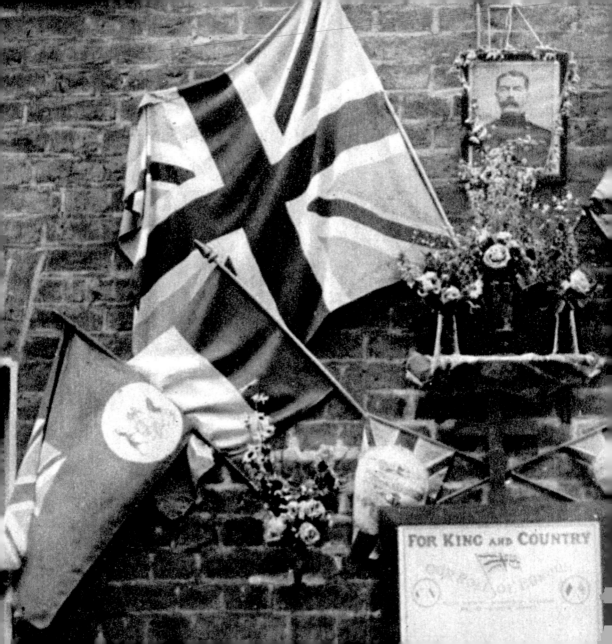

FOR KING AND COUNTRY

A shrine around a roll of honour attached to the wall of a house in Palace Road, Hackney, and adorned with flags, flowers and a portrait of the recently deceased Lord Kitchener. More than 100 men had enlisted from Palace Road and the framed Roll of Honour and its decorations were a tribute to their remembrance by local people. There were similar rolls of honour in Balcorne Street, Havelock Road, Frampton Park Road and Eaton Place. This system of recording local patriotism was instigated by the Reverend B. S. Batty, Rector of St John of Jerusalem, South Hackney.

LONDON AT WAR

four more Zeppelin raids that year of increasing severity and by 1917 Germany had abandoned night-time Zeppelins air raids in favour of Gotha bombers which would prove more deadly and accurate. During one raid on 13 June 1917, a primary school in Poplar was hit, killing 18 children and injuring 37.

In total, 668 would lose their lives in air raids on London between May 1915 and May 1918. A further 1,938 people would be injured. These figures are significant, but far worse was to come in the Second World War. Having learnt valuable lessons two decades earlier, the news of war was greeted with anxiety and foreboding by Britons in 1939 and the first month saw a mass evacuation of 660,000 women and children from London. Another 140,000 left during the Blitz and when the city came under attack from V1 rockets in 1944, another 308,000 left for the countryside. Official figures record 29,890 Londoners were killed and 50,507 seriously injured due to enemy bombing. The Blitz, which Britain would endure for eight long months, was launched with startling ferocity in September 1940, and had a simple aim; to crush the British people psychologically as well as physically, allowing Hitler's Operation Sea Lion (the invasion of Britain) to be realised swiftly and effectively when the population was at its weakest point and lowest morale.

Instead, it ignited the famous Blitz spirit and became an iconic emblem of Britain's stoic pluck and determination in the face of adversity. London was by no means the only area in Britain to suffer, but its location and status saw it experience the worst of the bombing—more than half of the war's casualties were in London, with the East End, especially West Ham and Stepney, suffering particularly heavily. Yet the city adapted remarkably well to the challenges of war. Slogans such as, 'London can take it' or 'London will stand fast', came to recast the Londoner as a figure of national heroism. 'You might as well try to shake the nerve of a mountain as of this population', wrote Mr E. C. Bentley in *The Illustrated London News* in August 1940. Londoners went everywhere equipped with gas masks and observed blackouts assiduously; suburban gardens were given over to vegetable growing and women, once again, stepped into the breach filling a wide range of civilian and military roles. Many of them joined the ARP (Air Raid Patrol) or AFS (Auxiliary Fire Service, later the NFS, National Fire Service), both part of the civilian defence service that worked tirelessly around the clock to extinguish the thousands of fires and rescue civilians from the rubble of buildings.

Central London certainly did not escape the attentions of the Luftwaffe. Westminster Abbey suffered bomb damage, though thankfully it was limited. St Paul's had been ringed by an inferno on

29 December 1940 that was to lay waste to an area stretching from Cheapside to Cannon Street, and yet miraculously it survived almost intact, largely due to the heroic efforts of fire-fighters—a stately symbol of London's defiance amid the fire and smoke. Hundreds of other much-loved and ancient buildings did not fare so well. Queen's Hall in Langham Place was destroyed, as were several Wren churches and the old Dutch Church in Austin Friars, built in 1250 and a survivor of the Great Fire of London. John Lewis's department store on Oxford Street, together with its contents, was burnt in its entirety to the ground.

In October 1940, London's tube stations were put into use as shelters during air raids for between 100,000 and 140,000 individuals every night. West End theatres published programmes listing the nearest shelters should the wail of sirens interrupt a show. The famous Windmill Theatre at Piccadilly Circus embodied the city's irrepressible courage and resilience, boasting at the end of the war, 'we never closed'. More genteel amusements were available at the National Gallery. Cleared of its priceless artworks, it reopened to give daytime concerts organised by pianist Dame Myra Hess.

On 13 September 1940, Buckingham Palace was bombed, with King George VI and Queen Elizabeth narrowly escaping injury. Later that day, they carried on their duties, driving into the East End to inspect the damage wrought by the latest raid. At last able to empathise as well as sympathise, the Queen famously commented of her near brush with death that at last she, 'could look the East End in the face'.

In a radio broadcast from the Palace on 23 September that year, the King spoke to the nation and summed up London's unwavering wartime resolve, by ending his broadcast, 'The walls of London may be battered, but the spirit of the Londoner stands resolute and undismayed'.

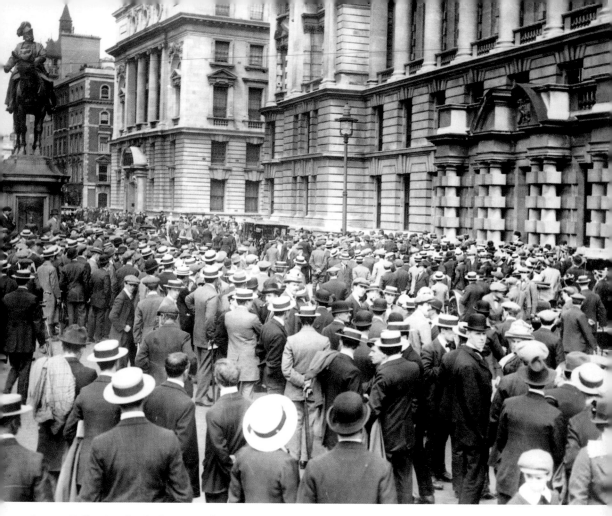

ABOVE: Following the declaration of war in August 1914 men converged on the War Office in Whitehall, London.

RIGHT: Curious bystanders witness the symbolic removal of the brass plate at the German Embassy in London, following the departure of the Ambassador, Prince Lichnowsky on 6 August 1914.

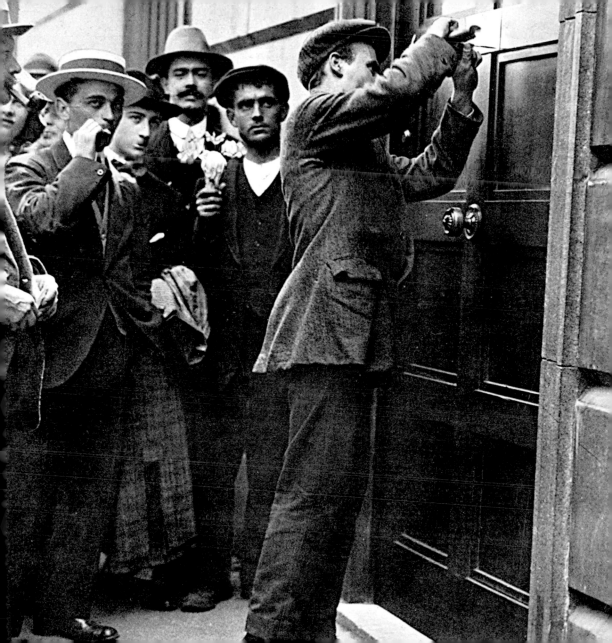

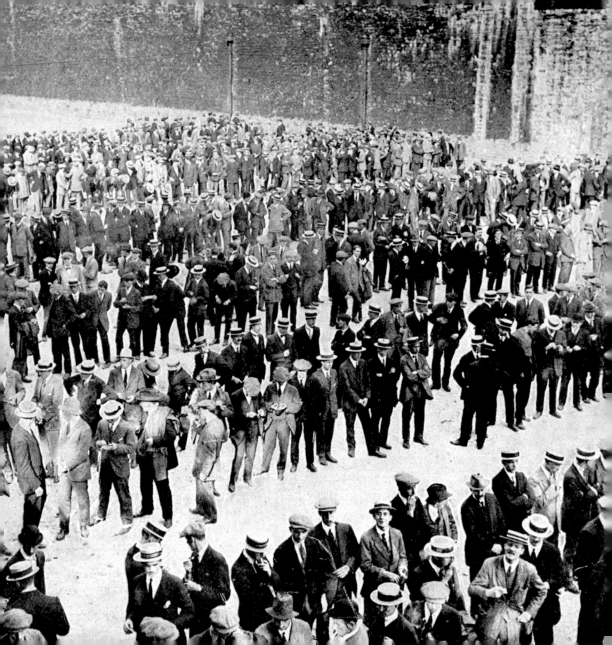

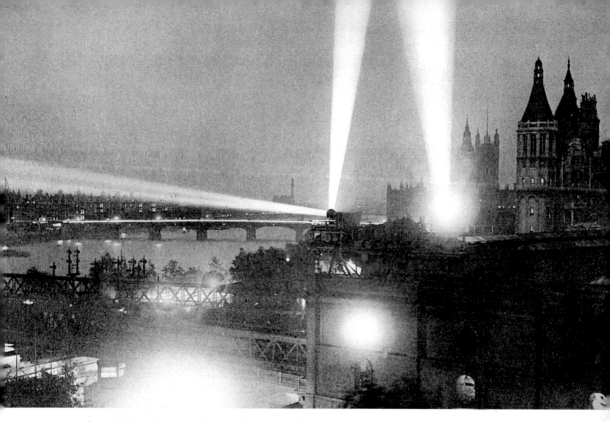

ABOVE: Searchlights throw up shafts of light over the London skyline in September 1914, on the look out for German Zeppelin aircraft. *The Tatler* magazine published this photograph with the comment, 'What with darkened streets, public-houses closed at eleven o'clock, soldiers everywhere, and searchlights flashing in all directions, London presents at the moment an aspect which is enough to startle the oldest inhabitant and to bring before us in some small measure the reality of war.'

LEFT: Young men in civilian clothes answer the call to enlist at the start of the First World War. All of these men are employees of City firms, and are joining the City of London Battalion, consisting of 1,300 men. At the Tower of London, they wait to swear the oath of allegiance.

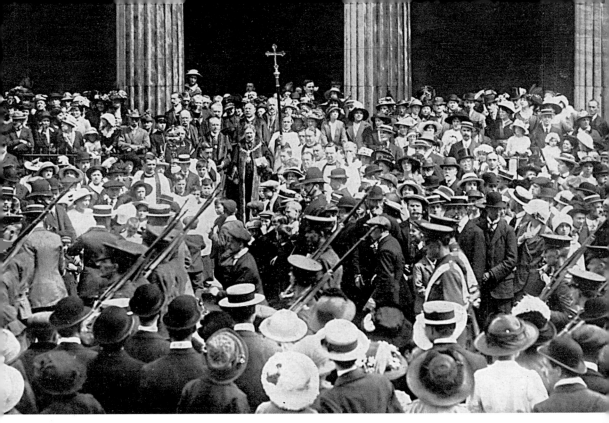

ABOVE: London servicemen are blessed as they pass St. Pancras Church, London.

RIGHT: Soldiers load motor buses with ammunition from the Powder Magazine in Hyde Park, 12 August 1914.

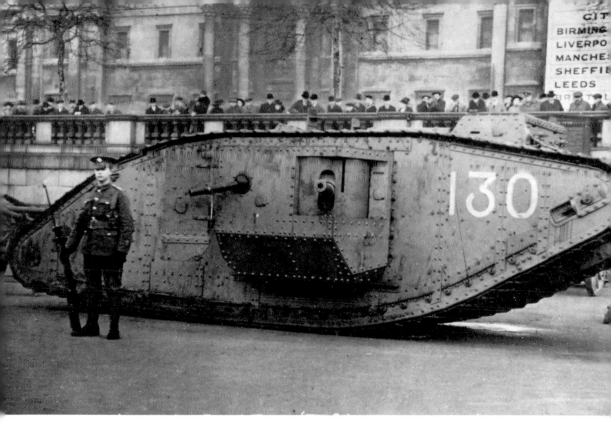

A Mark.1 Tank used in Trafalgar Square to sell National War Bonds. The sign visible at the rear details which British city had sold the most war bonds.

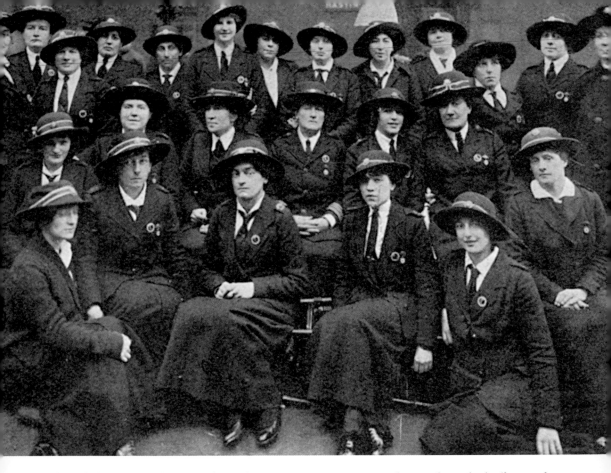

Female staff of the Soldiers' Free Buffet at Charing Cross Station, set up, along with similar buffets at other London terminus, to provide food and refreshments to soldiers passing through the station, either coming home on leave or returning to the front. The buffets were free, staffed entirely by volunteers and catered for thousands of soldiers each week.

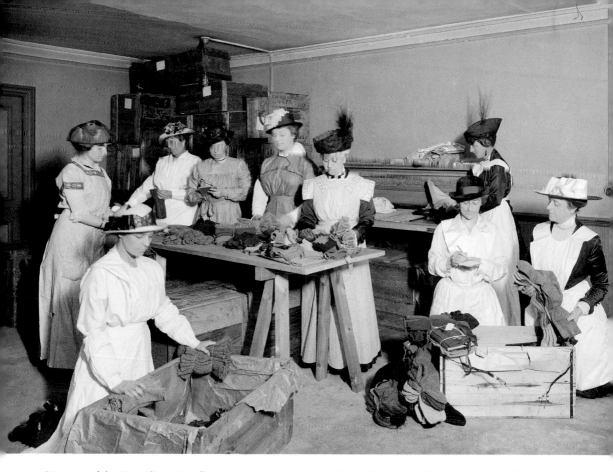

Women of the Canadian War Contingent Association pack 'comforts' including much needed socks, at the Westminster Palace Hotel in Victoria in 1915. The Association was formed by Canadians in Britain in 1914 for the benefit of the Canadian contingents fighting in the First World War.

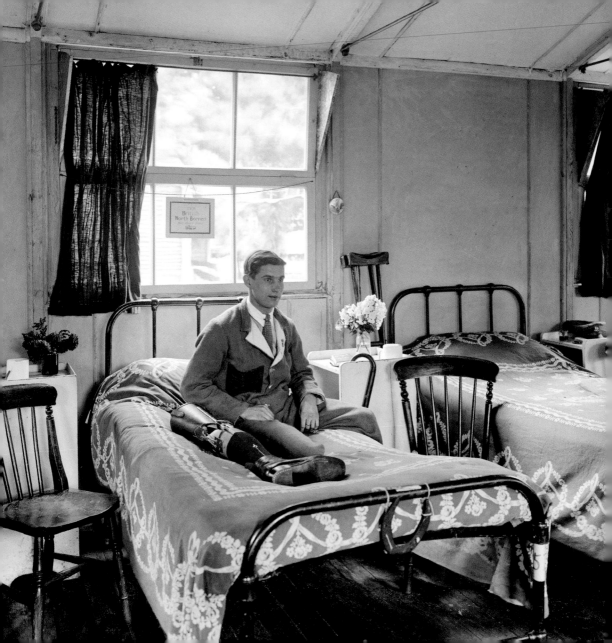

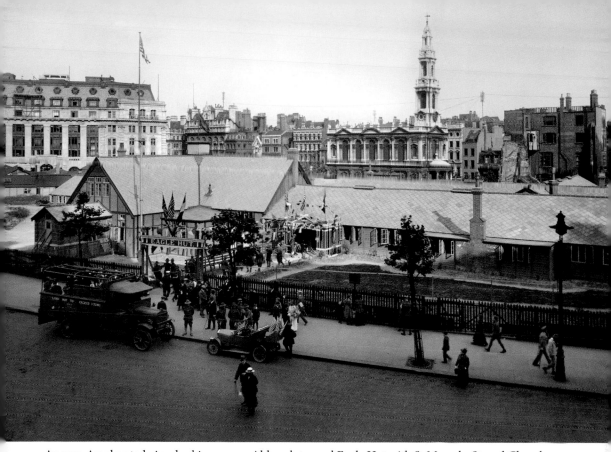

ABOVE: An elevated view looking across Aldwych toward Eagle Hut with St Mary-le-Strand Church and Australia House in the background. Eagle Hut was a serviceman's centre, run by the YMCA, offering meals and overnight accommodation to American servicemen while in London. It opened on the 3 September 1917.

LEFT: At Queen Mary's Hospital, Roehampton, a wounded serviceman, missing part of a leg, is seated next to a prosthetic leg. Queen Mary's Hospital was established in 1915 for servicemen who had lost limbs during action in the First World War. Several thousand amputees were rehabilitated at the hospital with many of the patients receiving prosthetic limbs.

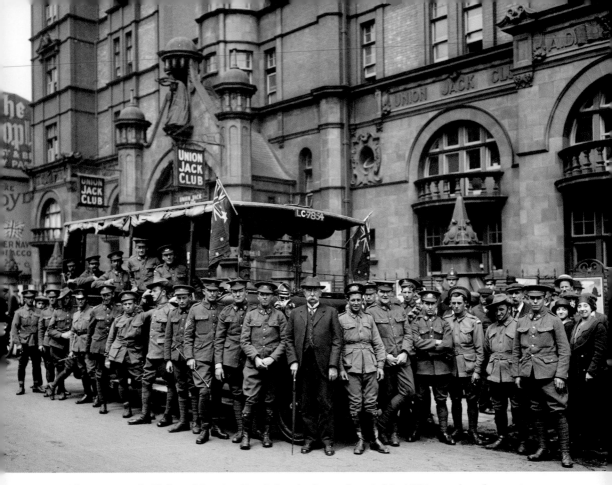

ABOVE: The Union Jack Club, in Waterloo Road, Lambeth was founded in 1907 as a place for servicemen to stay while in London. It was heavily used during both world wars. The photograph, showing Australian soldiers, was taken for the Orient Steam Navigation Company. This original building was later demolished and replaced.

RIGHT: A procession organised by the National Union of Railwaymen who marched to Hyde Park in order to demonstrate against rising food prices during the First World War.

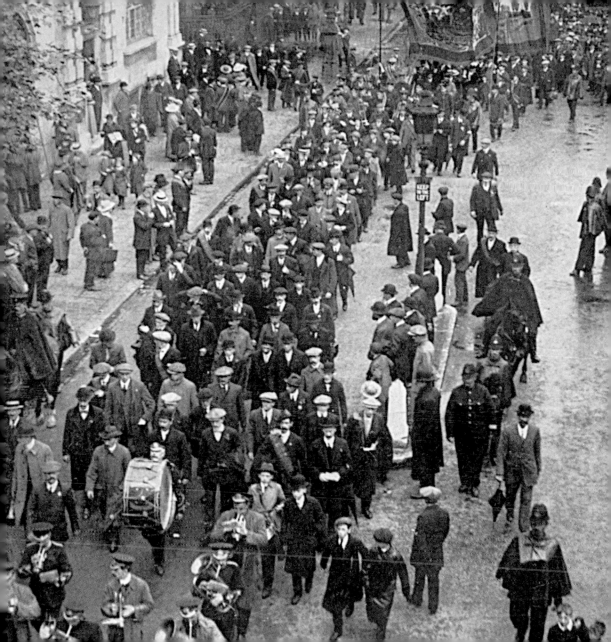

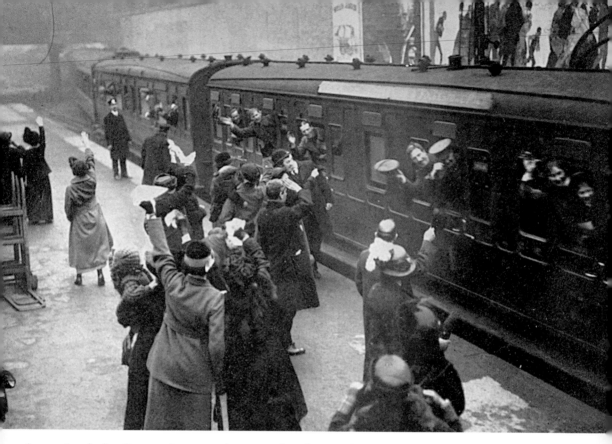

ABOVE: London's railway stations were the scene of much joy and emotion during the Great War as troops arrived home on leave, or departed from the Front, bidding farewell to loved ones, uncertain whether they would ever meet again.

RIGHT: Belgian nurse Marie Somers known as the Angel of Antwerp, addresses a recruiting rally in Trafalgar Square, London, around 1915. Somers assisted the escape of four wounded British soldiers in Antwerp but was captured by the invading German forces and tortured before escaping.

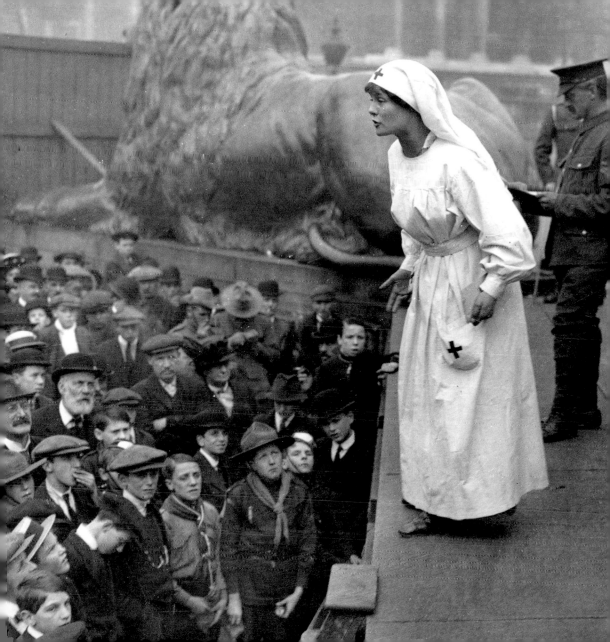

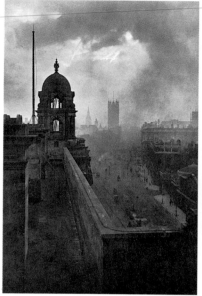

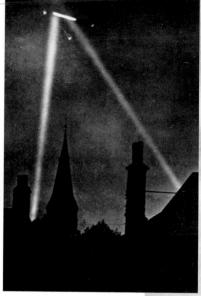

ABOVE: A view from the top of the War Office, down Whitehall toward Westminster, looking suitably ominous in September 1914 with the Great War underway. From here, the latest news from the Front as well as the casualty lists, were conveyed.

ABOVE RIGHT: The first Zeppelin air raid on London.

RIGHT: Searchlights on Old Lambeth Bridge, London.

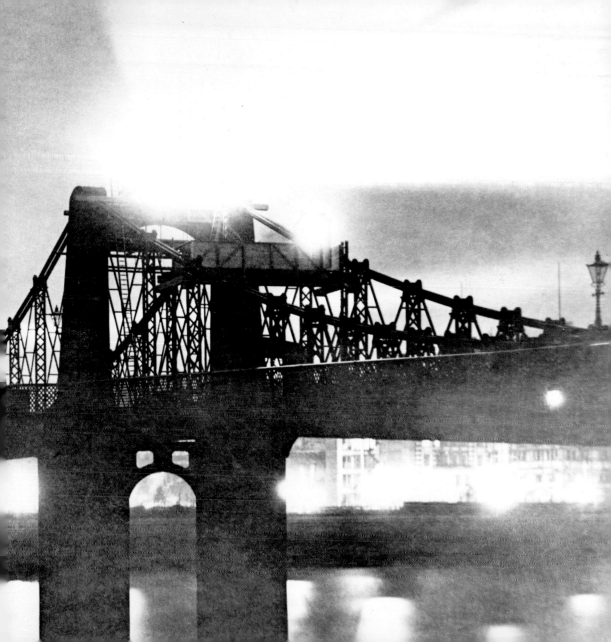

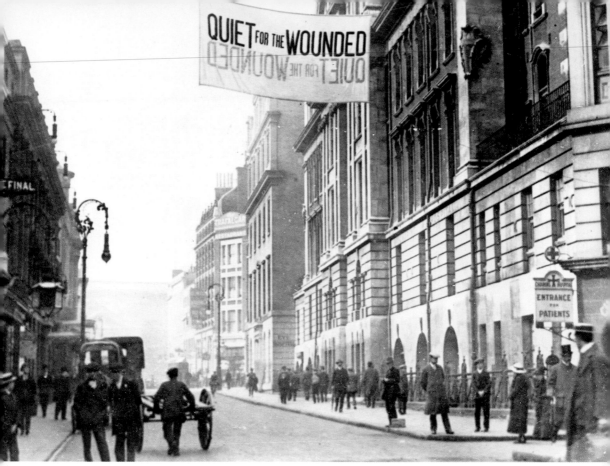

ABOVE: A 'quiet for the wounded' sign hangs outside Charing Cross Hospital in London during the First World War.

RIGHT: Many buildings and spaces in London were requisitioned for war purposes. Here, St. James's Square between Piccadilly and Pall Mall plays host to the Washington Inn YMCA hut for American officers.

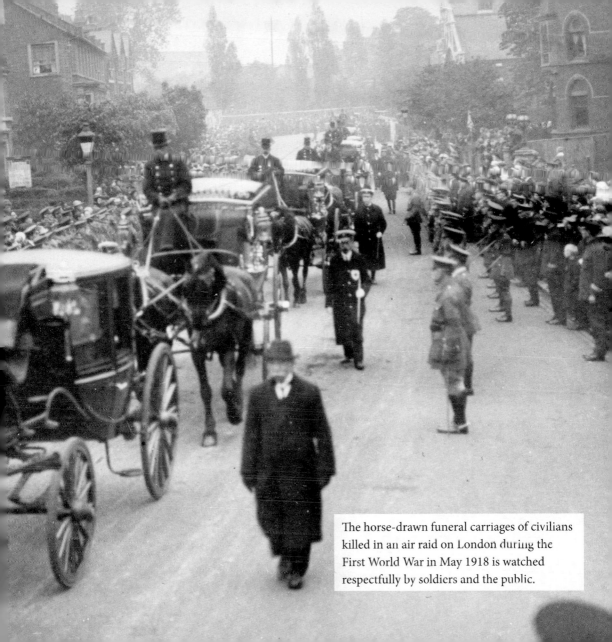

The horse-drawn funeral carriages of civilians killed in an air raid on London during the First World War in May 1918 is watched respectfully by soldiers and the public.

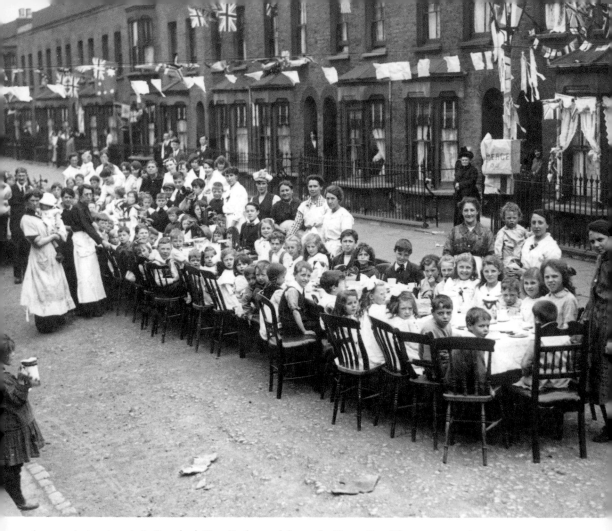

ABOVE: A street party in London's East End, to celebrate the Peace Day Victory procession.

RIGHT: A lorry filled with men celebrating Armistice Day on 11 November 1918. Some wear military uniform, others civilian clothes.

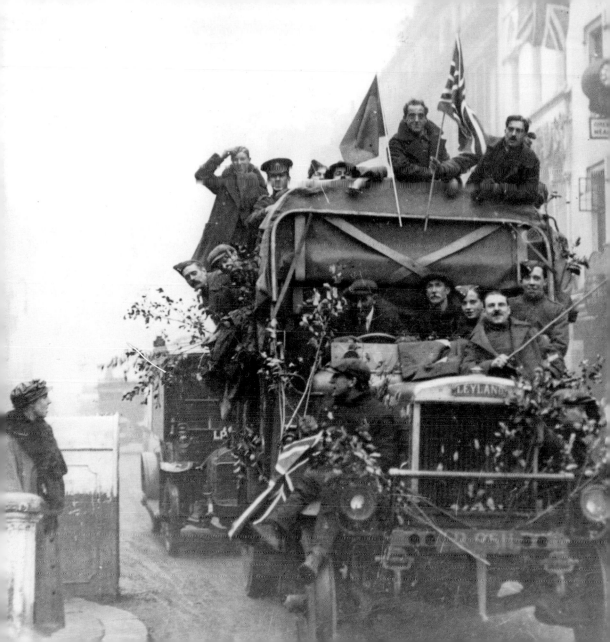

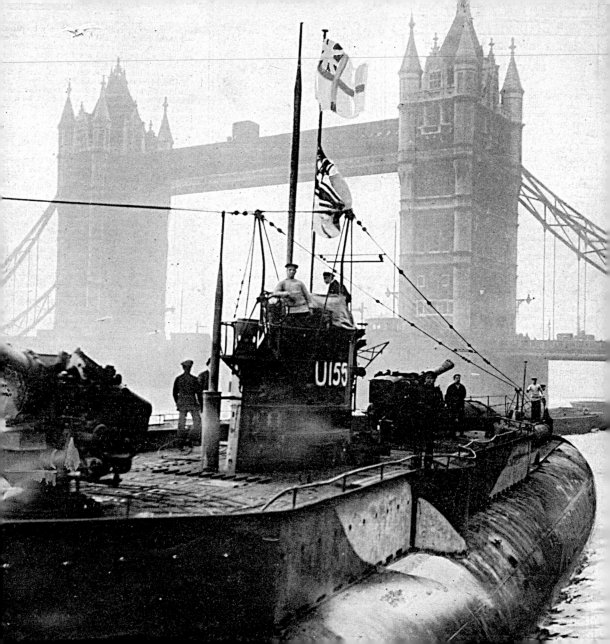

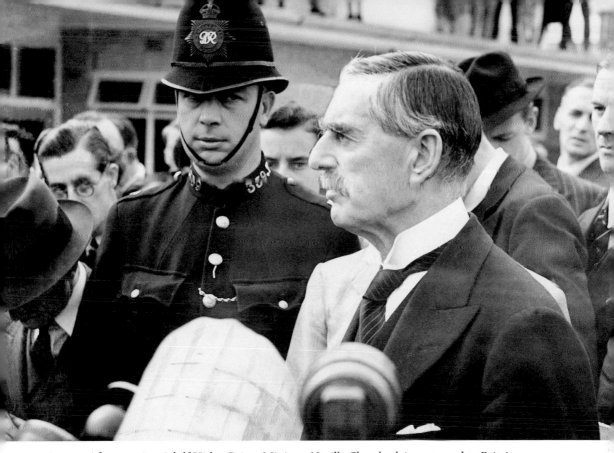

ABOVE: After meeting Adolf Hitler, Prime Minister, Neville Chamberlain, returned to Britain on 30 September 1938. He famously spoke to the crowd at Heston Airport near London and said, 'We regard the agreement signed last night and the Anglo-German Agreement as symbolic of the desire of our two peoples never to go to war with one another again.' He later assured Britons that they would enjoy 'peace for our time'. Less than a year later, Britain and Germany were at war.

LEFT: The German submarine U-155 (Deutschland) in the River Thames flying the White Ensign at the end of the First World War. It was surrendered as part of the Armistice terms, exhibited in London and around the country and finally sold for scrap in 1921.

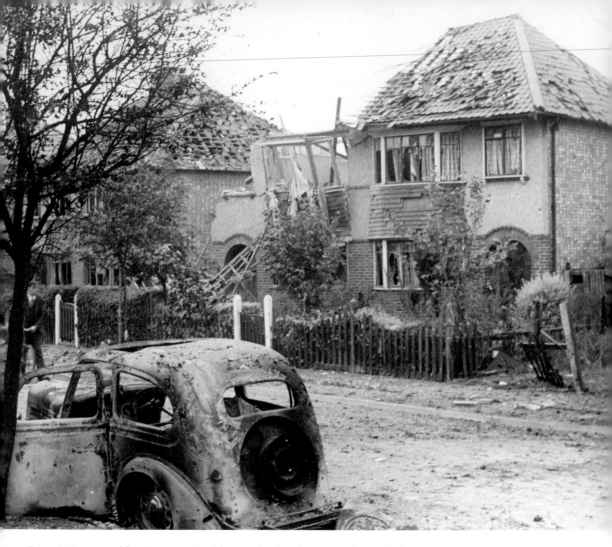

Devastation caused by German air raids on suburban houses and a car in Surrey.

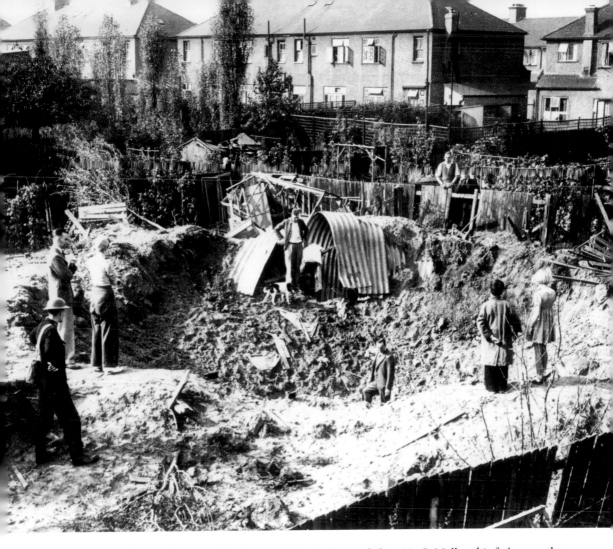

A lucky escape. Despite having to be dug out of the Anderson shelter, Mr G. Mollett, his father, mother, sister and dog survived when a German bomb exploded next to their shelter in London.

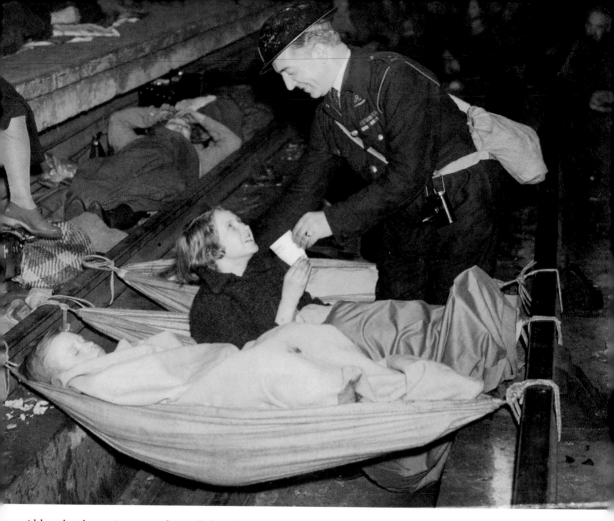

Aldwych tube station is used as a shelter during the London Blitz

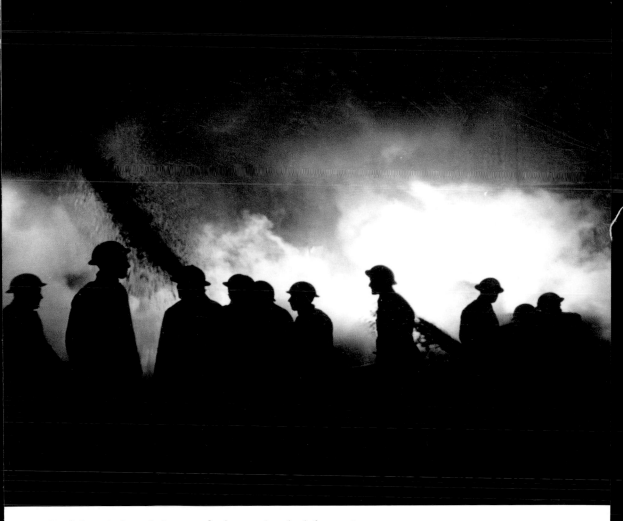

Firefighters in brass helmets and other workers look for survivors.

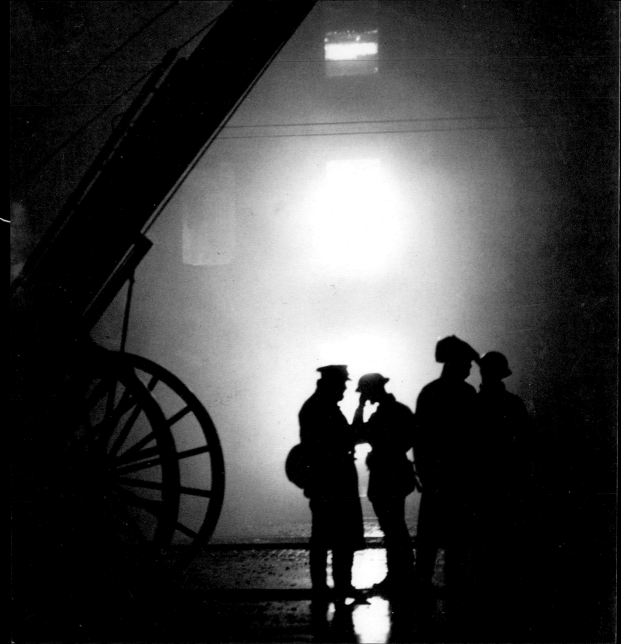

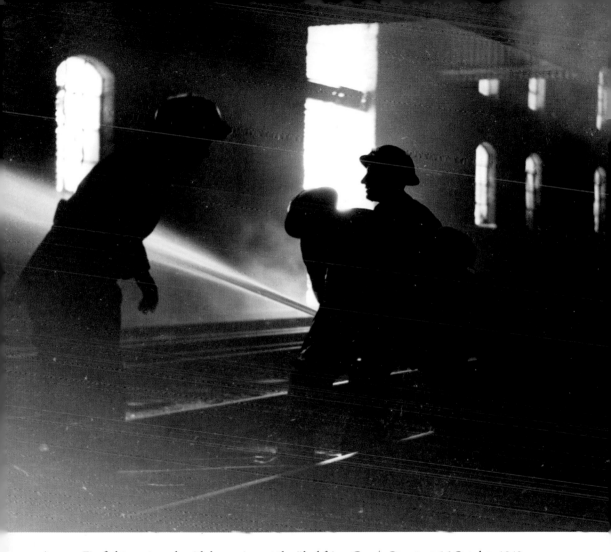

ABOVE: Firefighters at work with hose pipes at the Blackfriars Goods Depot on 16 October 1940.

LEFT: Firefighters stand by in the early hours of the morning, after a night of bombing during the Blitz.

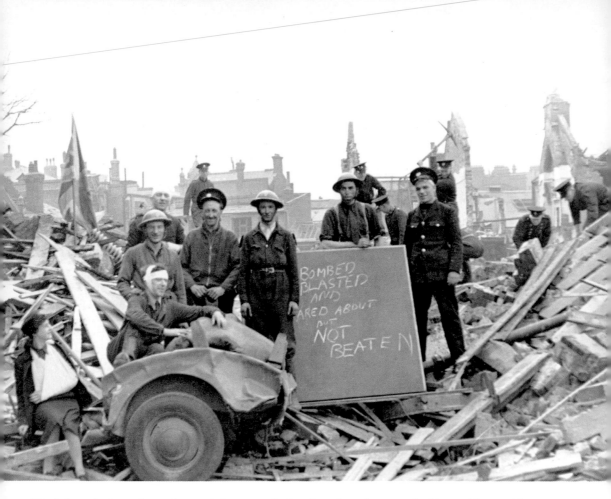

Firefighters from south London in defiant mood, after their fire sub-station had been obliterated by enemy bombing. Colleagues search through the debris for anything salvageable.

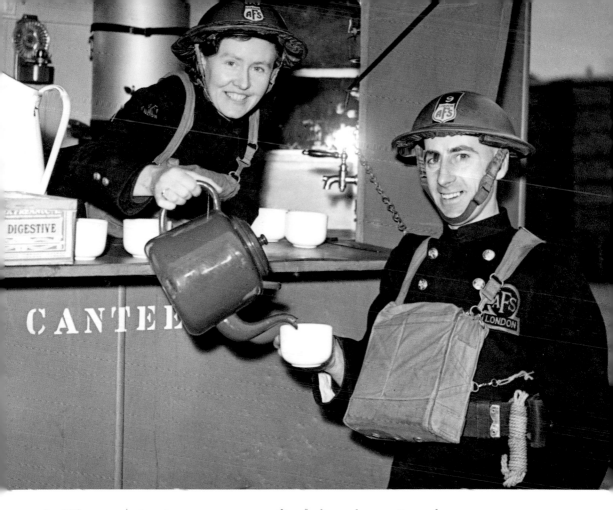

An AFS woman in a canteen van pours a cup of tea for her male opposite number.

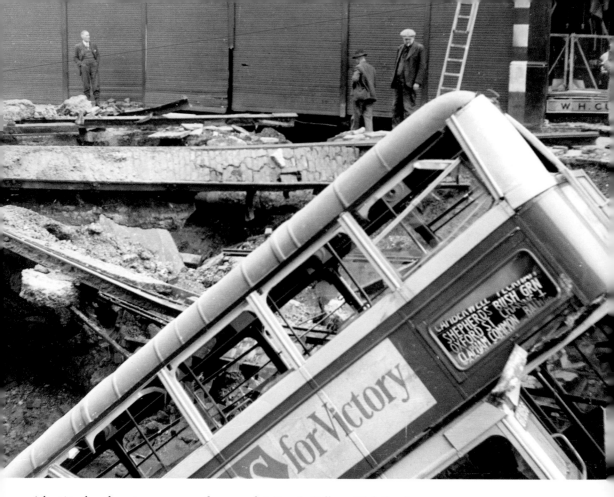

A bus in a bomb crater over an underground station in Balham High Road, 14 October 1940.

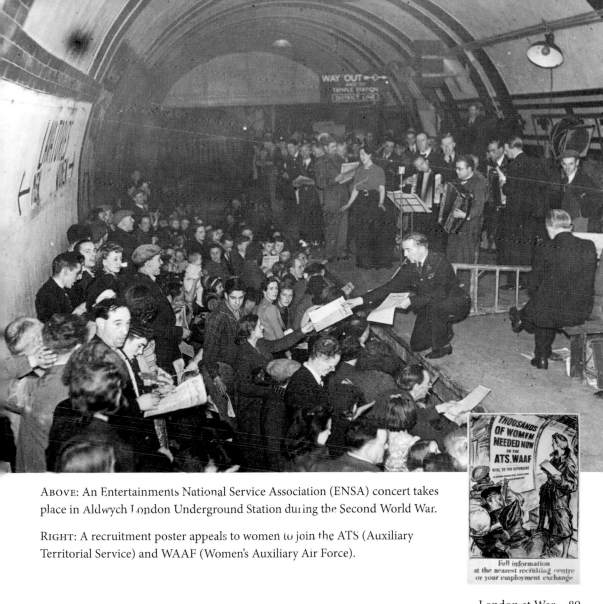

ABOVE: An Entertainments National Service Association (ENSA) concert takes place in Aldwych London Underground Station during the Second World War.

RIGHT: A recruitment poster appeals to women to join the ATS (Auxiliary Territorial Service) and WAAF (Women's Auxiliary Air Force).

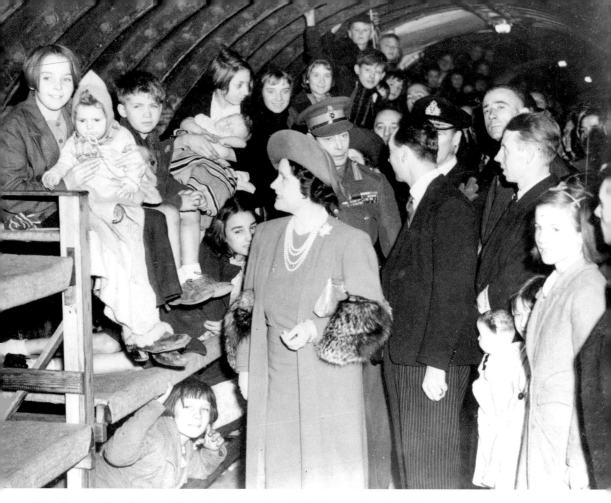

King George VI and Queen Elizabeth visit an air raid shelter in a London Underground station and chat to groups of children clustered on bunk beds.

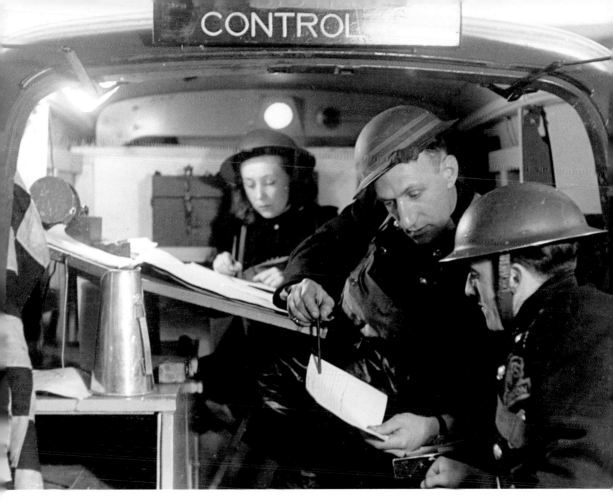

Two men and a woman work side by side in an London Fire Brigade Southern Division control unit during the Second World War. From 7 September 1940 the full weight of the attack on the capital was felt. Extensive fires were started all over London and control vehicles such as this one were sent to the scene of a large fire to report back and request reinforcements as required.

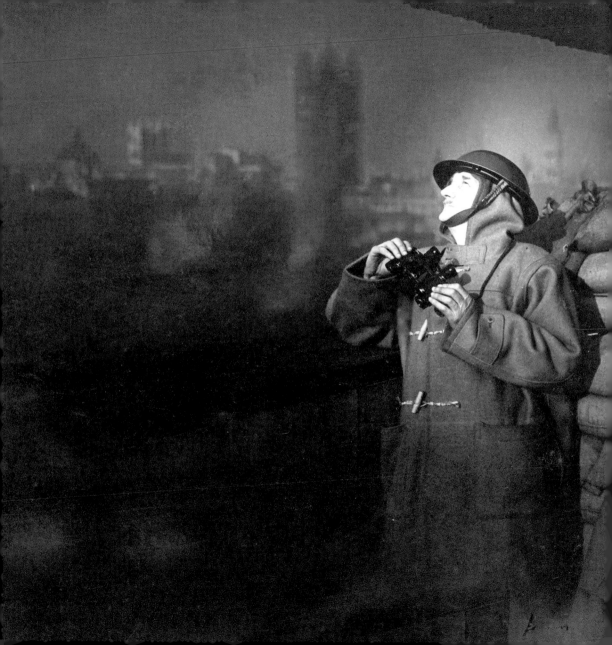

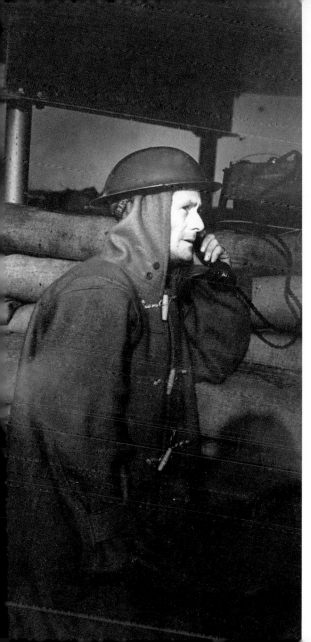

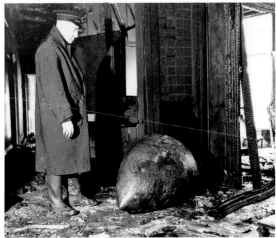

ABOVE: A senior fire officer inspects the nose of a bomb in the Royal Empire Society (now the Royal Commonwealth Society) building in Northumberland Avenue, Central London, following a devastating air raid on 16 April 1941.

LEFT: Firewatchers on duty on the clock tower of the Smith Building, Albert Embankment, next to London Fire Brigade headquarters.

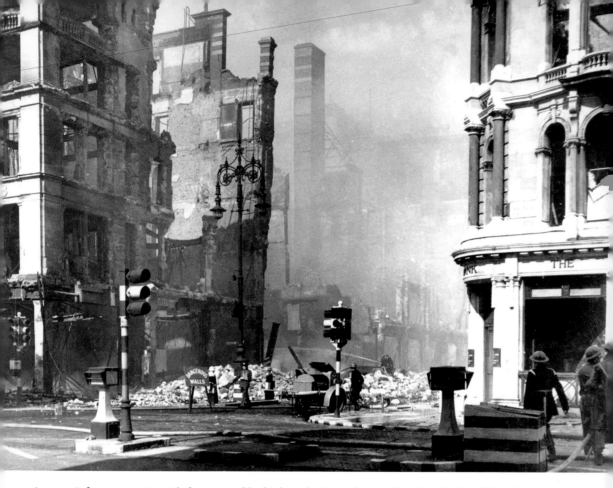

ABOVE: A fire crew extinguish fires caused by high explosive and incendiary bombs that fell in the West End area of Oxford Street and Regent Street on 18 September 1940. The burnt-out shell of a building on the left is the John Lewis department store.

RIGHT: After devastating fires resulting from heavy bombing raids, fire crews are in action with five jets and a turntable ladder, and continue to damp down No.6 Warehouse, Surrey Commercial Docks, Rotherhithe, 7 September 1940.

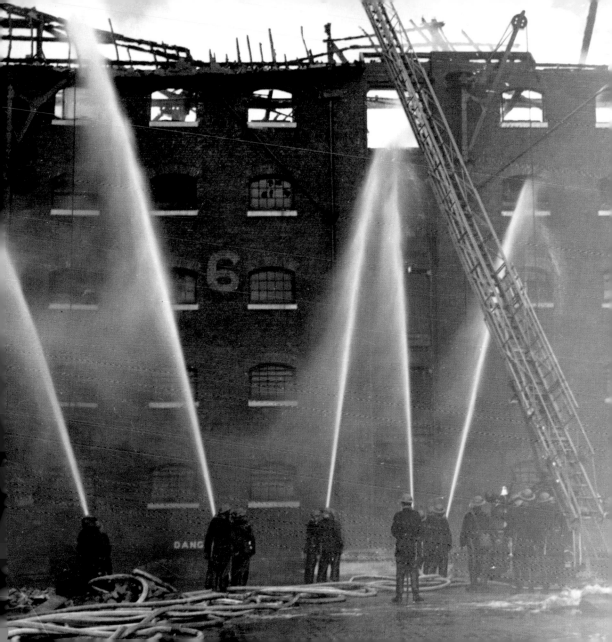

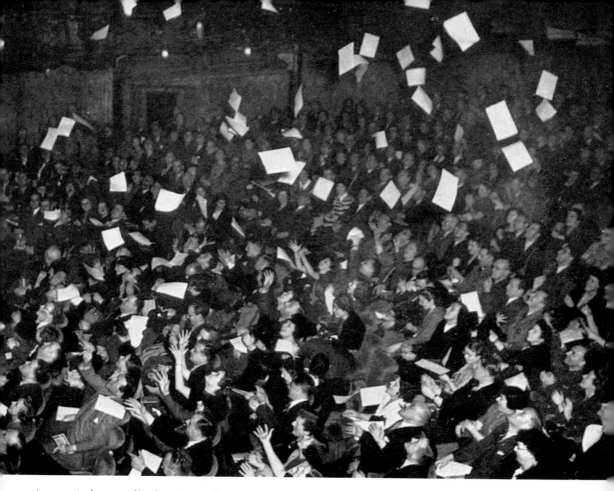

ABOVE: A shower of leaflets descend upon the audience at the London Palladium, which was staging its first war-time revue, *The Little Dog Laughed*. The leaflet raid was preceded by the sound of aeroplane engines through the auditorium.

RIGHT: Keep calm and carry on. Two workmen continue with their 'private' luncheon, although the sirens have sounded another 'alert', October 1940.

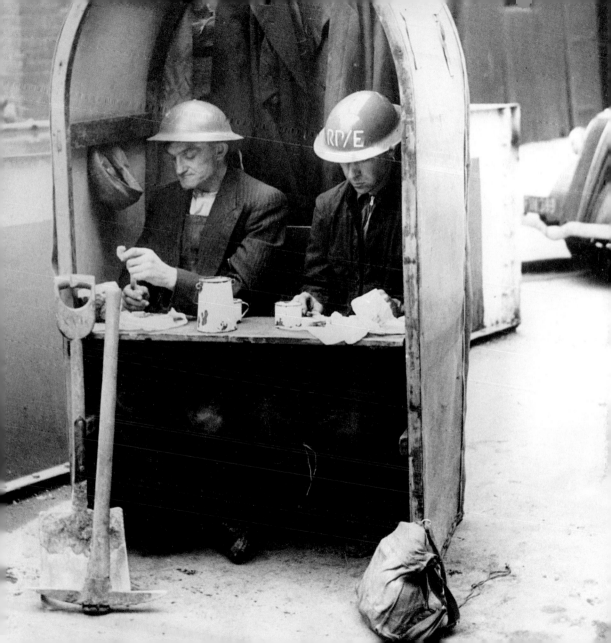

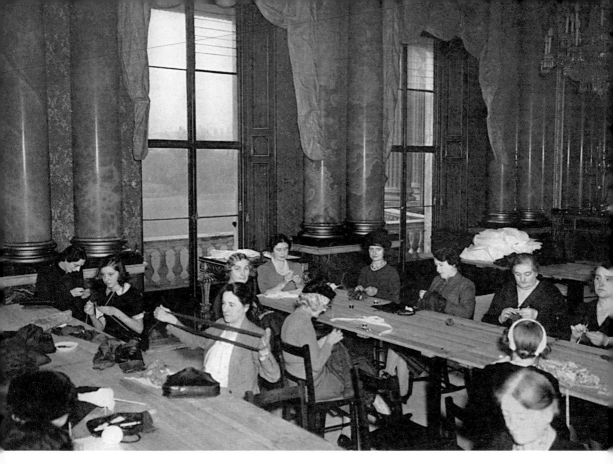

Members of the household and wives of employees of the Royal Mews assemble in the Blue Drawing Room at Buckingham Palace for Queen Elizabeth's Sewing Bee, held twice a week during the Second World War to produce garments and surgical dressings for the Red Cross. The women are sat at trestle tables in one of the most beautiful State apartments, which was originally Queen Victoria's ballroom.

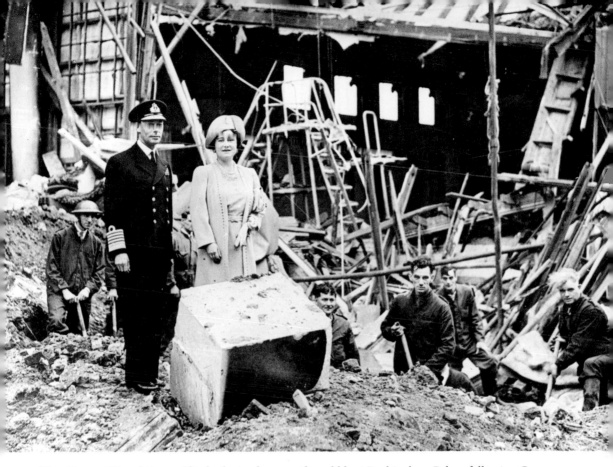

King George VI and Queen Elizabeth stand among the rubble at Buckingham Palace following German air raids during the Blitz, September 1940. The Palace suffered bomb damage on 8 September and on the morning of the 13th, the King and Queen were in residence when a bomb was dropped into the Quadrangle. They escaped unhurt but one workman was killed.

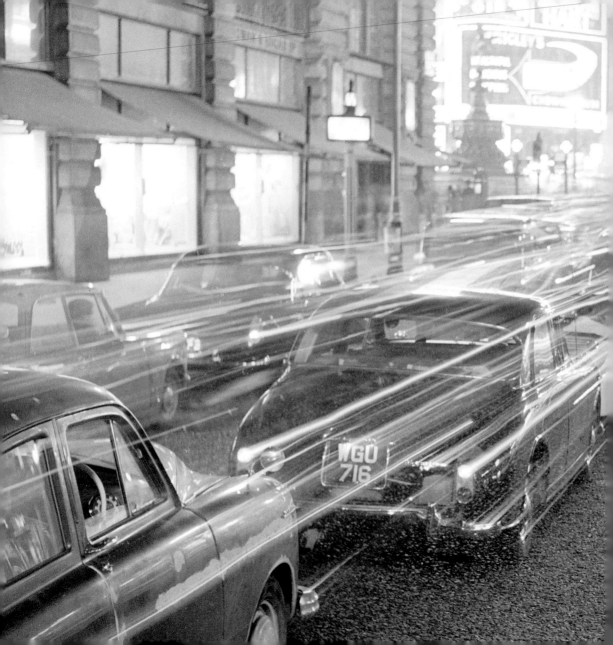

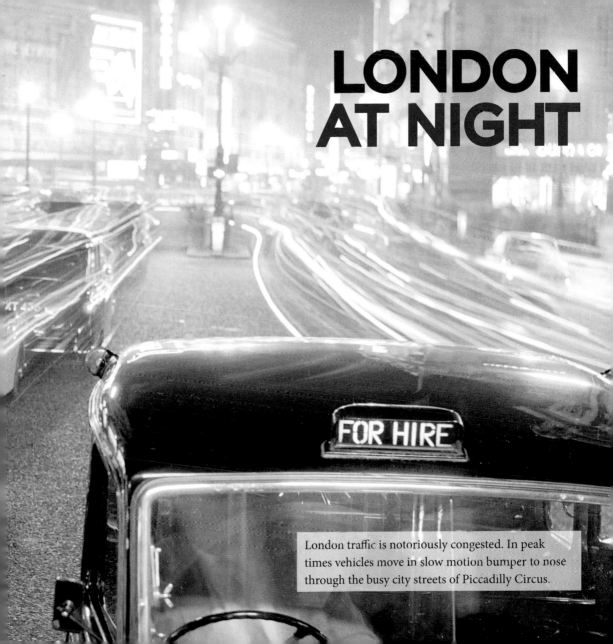

LONDON AT NIGHT

London traffic is notoriously congested. In peak times vehicles move in slow motion bumper to nose through the busy city streets of Piccadilly Circus.

in 1933, and the sight of rough sleepers in London has never truly gone away. The Embankment area and its gardens were famous as a dormitory at night during the 20th century. Tragically, more than a hundred years later, homeless people still claim doorways and sheltered places here and in other areas around London. It may seem a problem that can never be completely solved but there have been many philanthropic initiatives over the years to alleviate the discomfort and loneliness of sleeping rough. The Salvation Army opened up night hostels to provide a roof over the heads of the homeless and sent members out into the night to find rough sleepers to let them know where they could find shelter. At the London County Council Night Office near Charing Cross, queues of 'casuals'—people of no fixed address, perhaps having come to London to seek employment—were assessed and given a ticket to one or other of the voluntary organisations offering shelter. Other homeless people might find accommodation in the hundreds of lodging houses—or 'doss houses'—available in the capital for as little as 4d (4 pence) a night, though arrangements were rudimentary. Some lodging houses worked on a bed rota where men were allocated a bed for eight or twelve hours, but for the remainder of the 24 hours, another occupant would take over.

For London's homeless, the night-time hours have been when their desperate situation becomes all the more accentuated. And yet, London at night has always possessed a magical quality. When the dark descends at 4 pm in midwinter, Christmas shoppers are coaxed out of any seasonal blues by the shop windows and twinkling lights. The streets of Soho are considerably less sleazy than they were in the 1950s and '60s, but the area retains a louche personality, and a few neon signs still wink with cheeky promise while the glitter and glamour of West End nightclubs and cocktail bars continue to draw pleasure seekers to the city's heart, much as they did a century ago.

RIGHT: Hidden beauty is revealed in this fine floodlit photograph of the dome of St Paul's Cathedral, London.

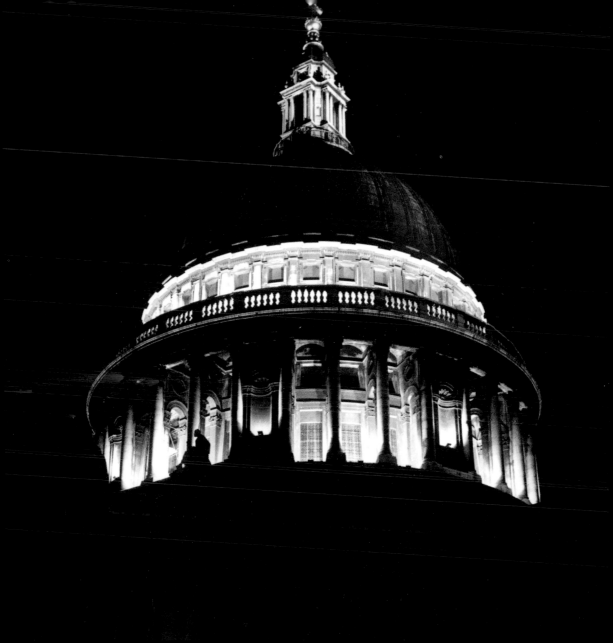

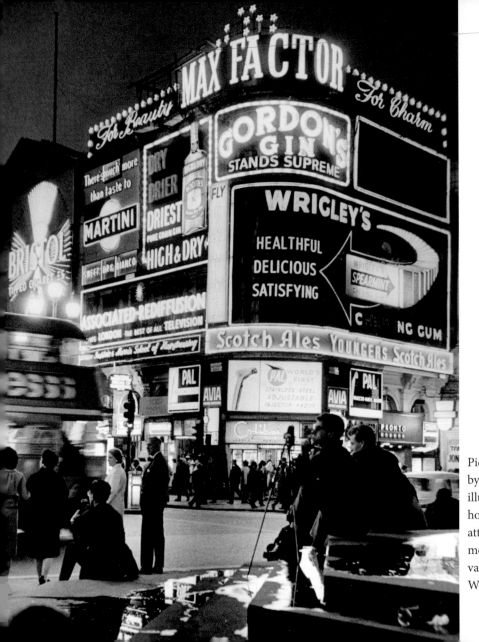

Piccadilly Circus by night. The huge illuminated advertising hoardings seemingly attract people like moths toward the varied delights of the West End.

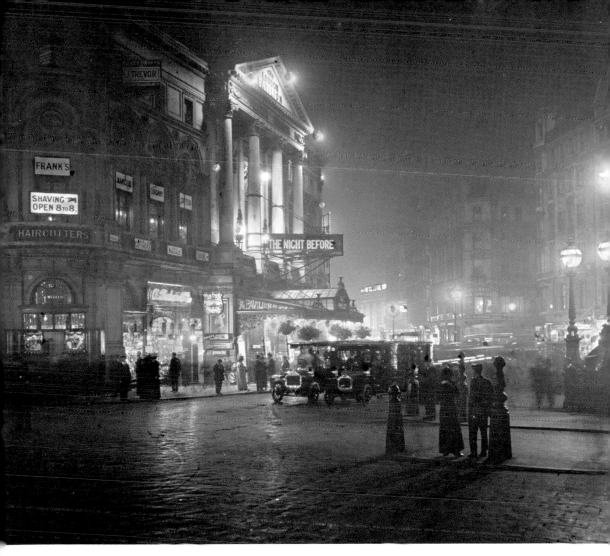

The exterior facade of the Trocadero on Piccadilly Circus.

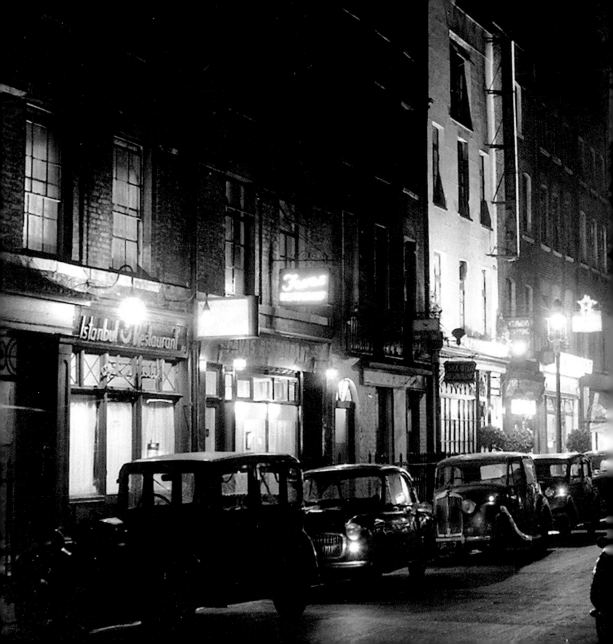

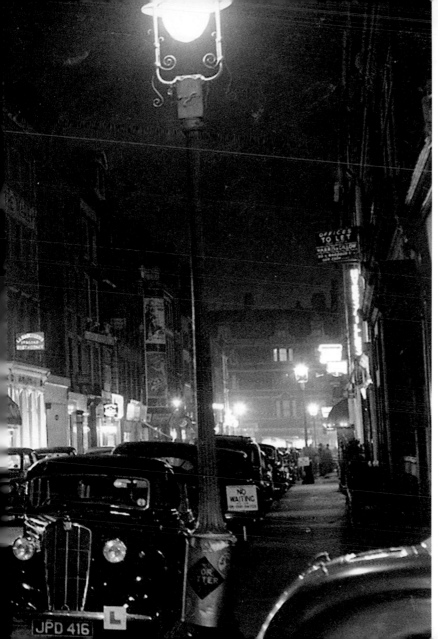

Frith Street in Soho at night
*c.*1955.

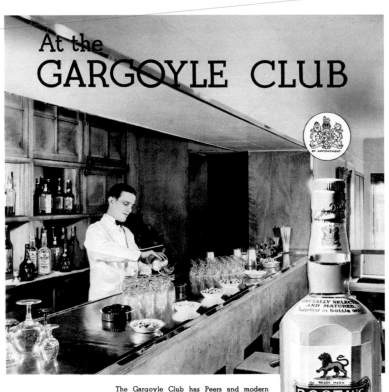

At the GARGOYLE CLUB

The Gargoyle Club has Peers and modern Painters on its distinguished List of Members. From roof garden to ground floor of the club there is colour and design to please conservative and advanced taste—including pictures by Henri-Matisse. There is an old English dining-room, a variety of delicious meals from luncheon to supper, a mirrored ball-room—and a lounge where George at the Bar knows how to make cocktails to please all tastes. He uses Booth's, the only matured Dry Gin.

Real Cocktails begin with

BOOTH'S
The Only Matured DRY GIN

This advertisement for Booth's dry gin shows George, the barman, mixing cocktails. The Gargoyle Club on Meard's Street was a regular haunt for many artists. Founded in 1925, it had been the epitome of decadent glamour, but by the 1950s had become a seedy drinking den. Francis Bacon and Lucian Freud were regulars in its heyday.

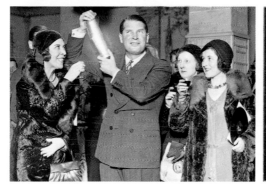

PLAYTIME AT THE PICCADILLY

PICCADILLY HOTEL

LONDON. W.I.
PHONE. REG. 8000.

ABOVE RIGHT: A programme cover for *Playtime at the Piccadilly* cabaret show at the Piccadilly Hotel, London.

RIGHT: The French actor and singer Maurice Chevalier shakes a 'Maurice Chevalier-cocktail' in his hotel during a visit to London in the 1930s.

FAR RIGHT. A programme cover for *New Princes Frivolities* at the New Princes Restaurant, London (artwork by Gordon Conway).

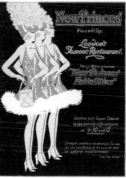

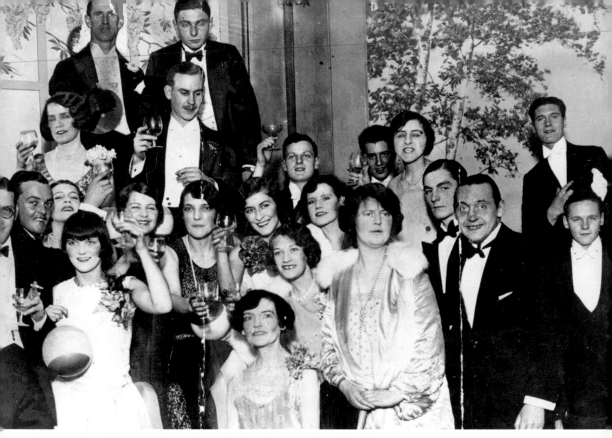

A group of revellers raise their glasses for the photographer at The Silver Slipper nightclub. At the bottom centre is Kate Meyrick (1875–1933), an Irish businesswoman and 'queen' of the London nightclub scene. She ran '43', a late-night jazz club at 43 Gerrard Street in Soho, was prosecuted several times for breaching licensing laws and went to prison for bribing policemen to ignore these breaches. Her book *Secrets of the 43* was banned on its publication in 1933.

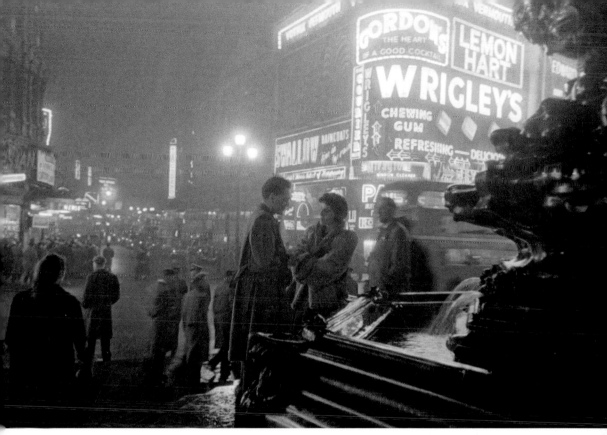

This atmospheric scene shows people gathered in Piccadilly Circus on a dark, wet night in London, *c.*1950. The famous hoardings shine brightly in the background.

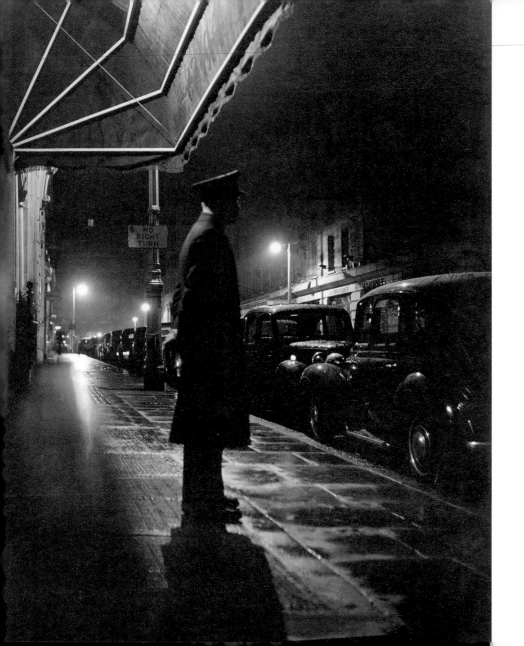

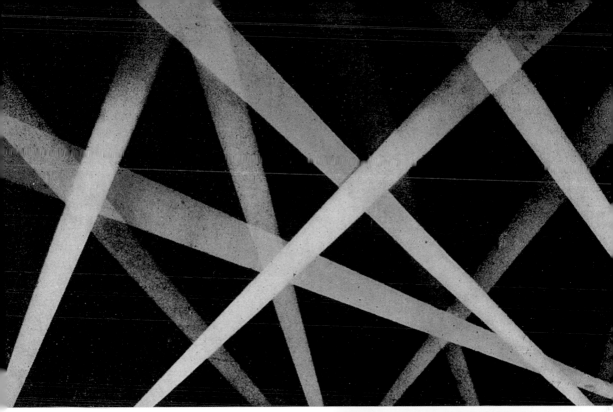

ABOVE: Searchlights cross the night sky over the capital searching for German bombers, early 1940s.

RIGHT: At the electricity sub station in Camden, workers man the station around the clock, providing power to the city.

LEFT: A doorman waits outside the fashionable Embassy Club in London's Mayfair on a dark, drizzly night.

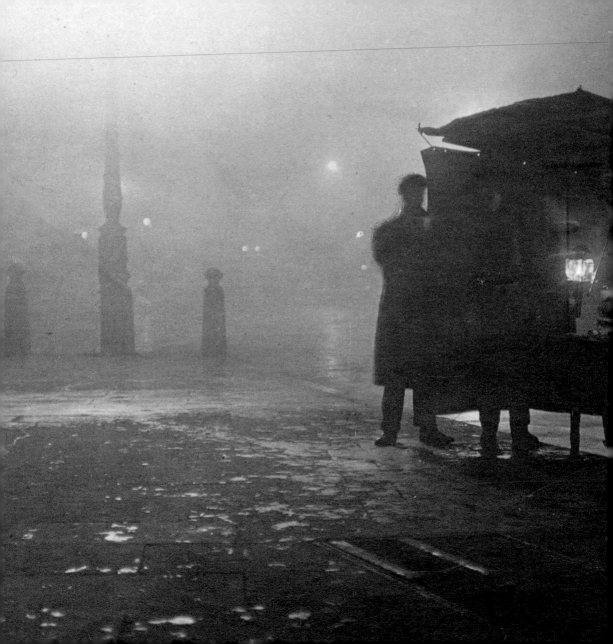

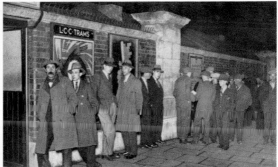

TOP: The homeless form a queue outside the London County Council's Night Office at Charing Cross Bridge. The office had telephone links to the city's casual wards, as well as to the Salvation Army, Church Army and other voluntary organisations, helping those in need find a bed for the night.

ABOVE: The front cover of *The Bystander* magazine shows an evening scene with smart couples in evening dress out on the town.

LEFT: This atmospheric scene depicts a London coffee stall at 2 am. Similar scenes play out today.

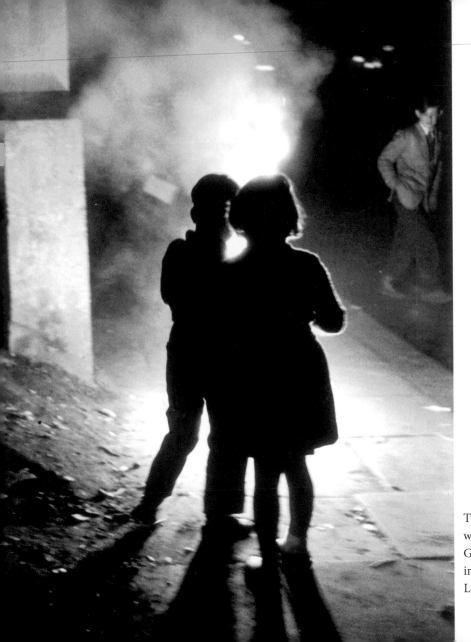

Two young children
watch a bonfire lit on
Guy Fawkes' night,
in North Kensington,
London.

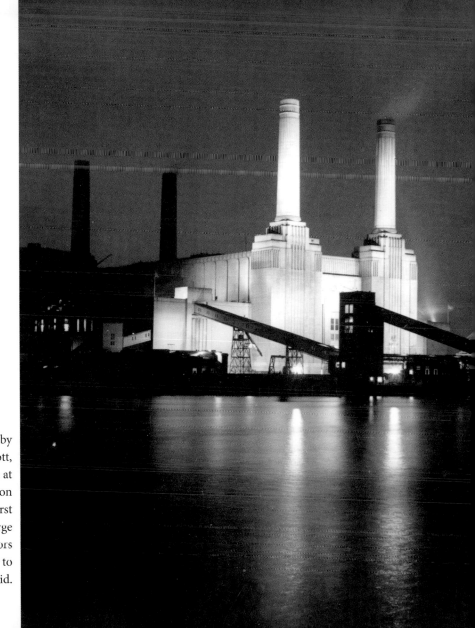

Designed by
Giles Gilbert Scott,
building began at
Battersea Power Station
in 1933. It was the first
of a series of very large
electric generators
set up in order to
nationalise the grid.

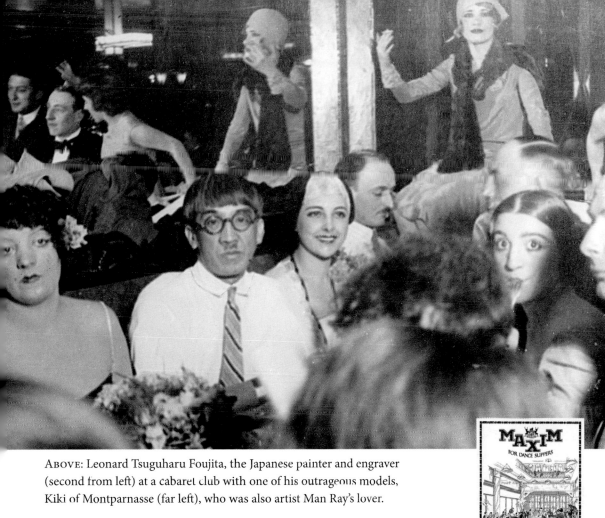

ABOVE: Leonard Tsuguharu Foujita, the Japanese painter and engraver (second from left) at a cabaret club with one of his outrageous models, Kiki of Montparnasse (far left), who was also artist Man Ray's lover.

RIGHT: An advertisement for Maxim's dance and Supper Club, London, 1922.

LEFT: Neon advertisements reflect in the water of the famous fountains in Trafalgar Square, London.

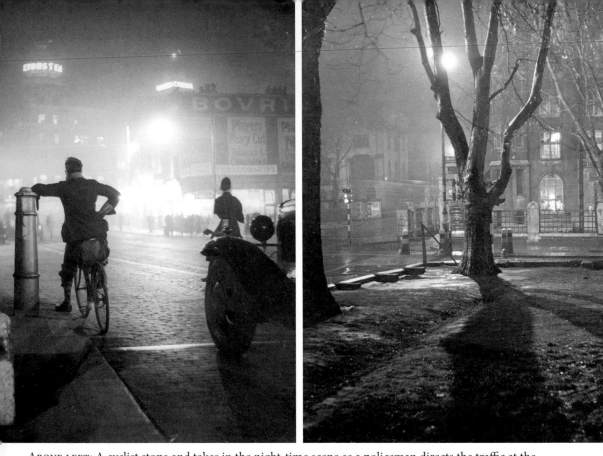

ABOVE LEFT: A cyclist stops and takes in the night-time scene as a policeman directs the traffic at the crossroads on Upper Street, Islington, London.

ABOVE RIGHT: An eerie 'London by night' study, seen from the porch of St Pancras Parish Church.

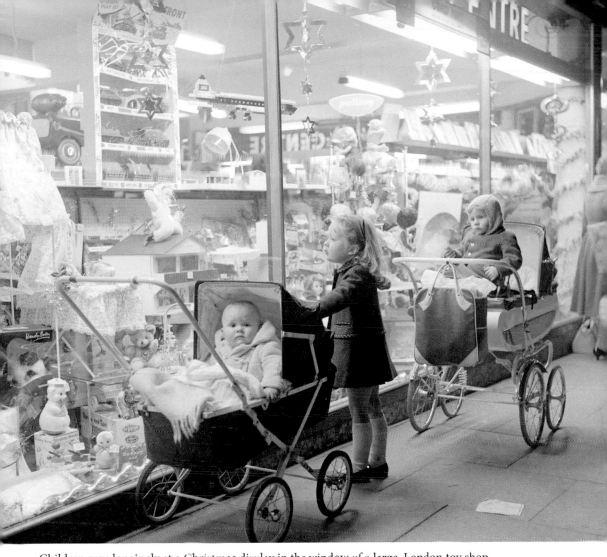

Children gaze longingly at a Christmas display in the window of a large, London toy shop.

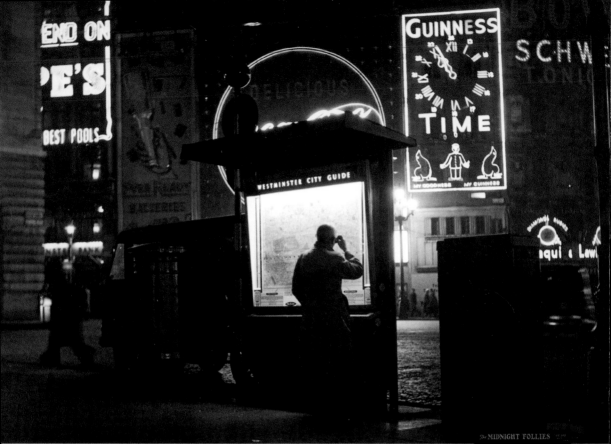

ABOVE: A man in a raincoat studies the Westminster City Guide map at night in Piccadilly Circus.

RIGHT: A programme cover for The Midnight Follies at the Hotel Metropole, London, 1927.

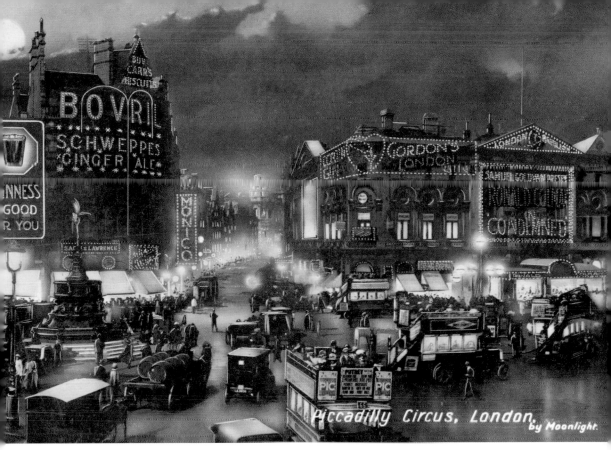

ABOVE: A romanticised view of the bright lights of Piccadilly Circus.

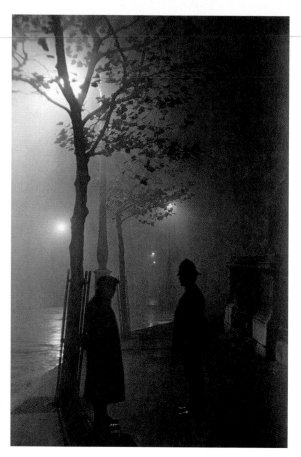

ABOVE: The silhouette of a policeman standing patiently
on the pavement at Trafalgar Square, London, at 2 am.

RIGHT: Fog at Piccadilly Circus in London,
9 January 1935.

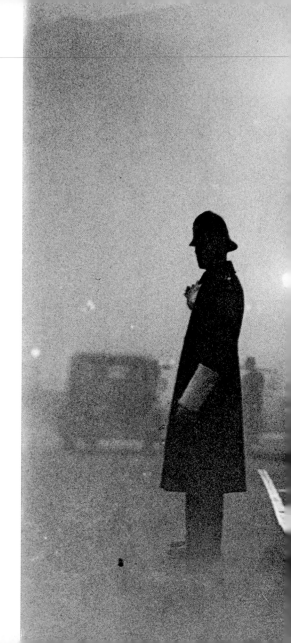

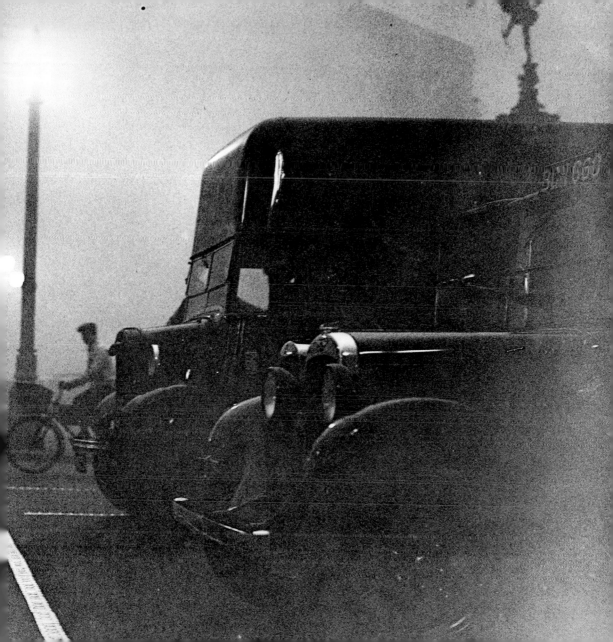

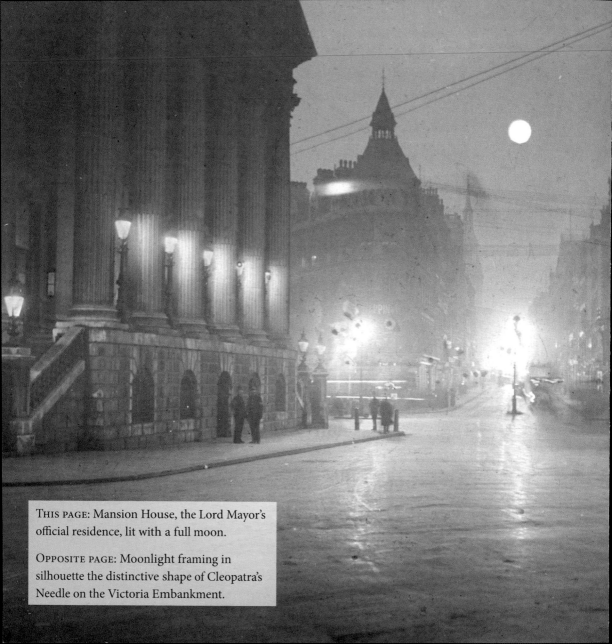

THIS PAGE: Mansion House, the Lord Mayor's official residence, lit with a full moon.

OPPOSITE PAGE: Moonlight framing in silhouette the distinctive shape of Cleopatra's Needle on the Victoria Embankment.

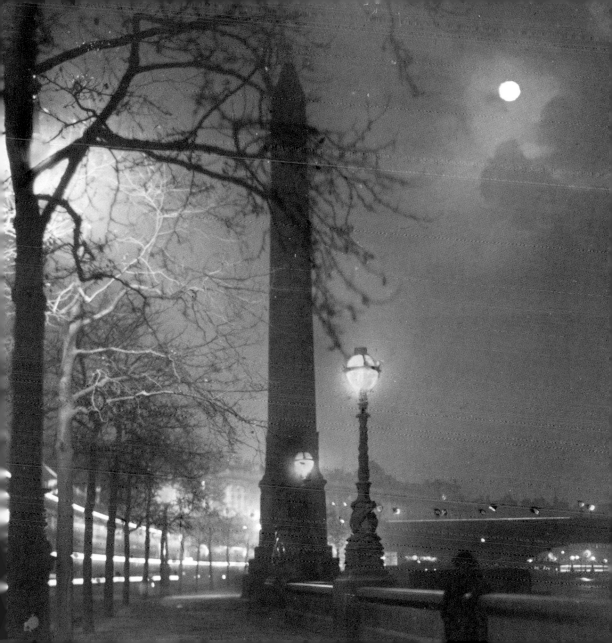

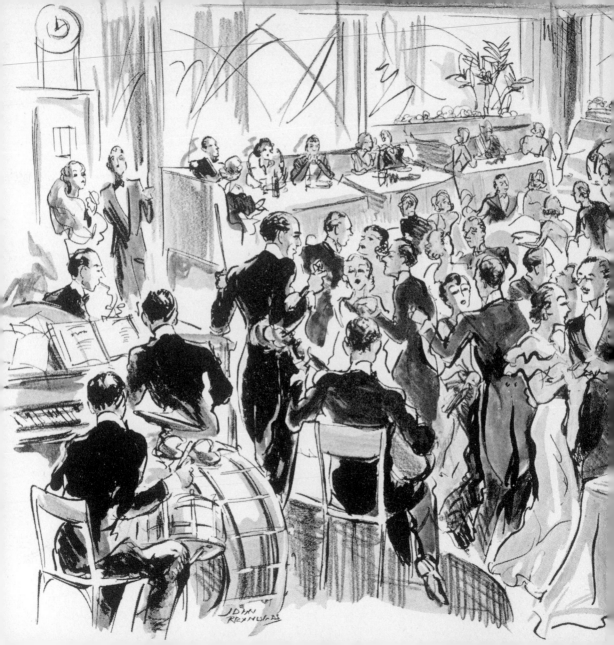

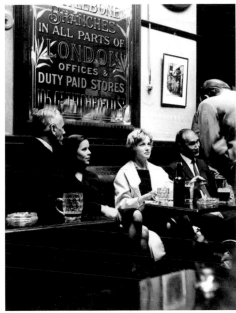

Above: Chelsea Pub scene 1959

Left: View of the Embassy Club in London in 1934, one of the most exclusive supper clubs of the period, frequented by high society, royalty and film stars. The dancefloor is full of couples in evening dress while other sit at tables. Illustration by John Reynolds in *The Bystander*, 1934

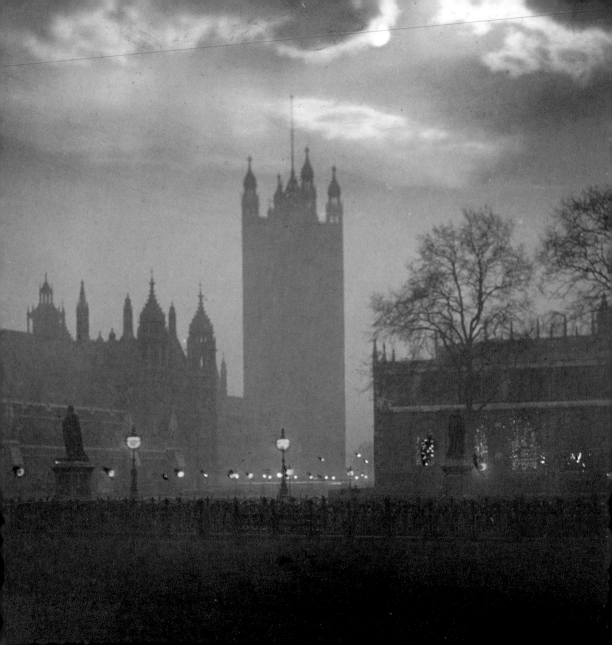

ABOVE: At the Edmundo Ros' Club at 177 Regent Street couples sit, people dance, the band plays and the singer croons. Patrons could enjoy cocktails, dinner and dancing from 8.30 pm every evening to music supplied by Arnold Bailey and his band, and the Latin American Orchestra of Edmundo Ros. Cabaret attractions performed twice nightly.

RIGHT: At the other end of the social scale, men who have not been able to get into a night shelter are sleeping rough on a bench on the embankment in London. A flashlight reveals their sleeping forms bent at awkward angles in an effort to find rest.

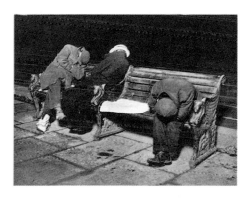

LEFT: The silhouette of the Parliament buildings at Westminster, lit by the yellow glow of street lights.

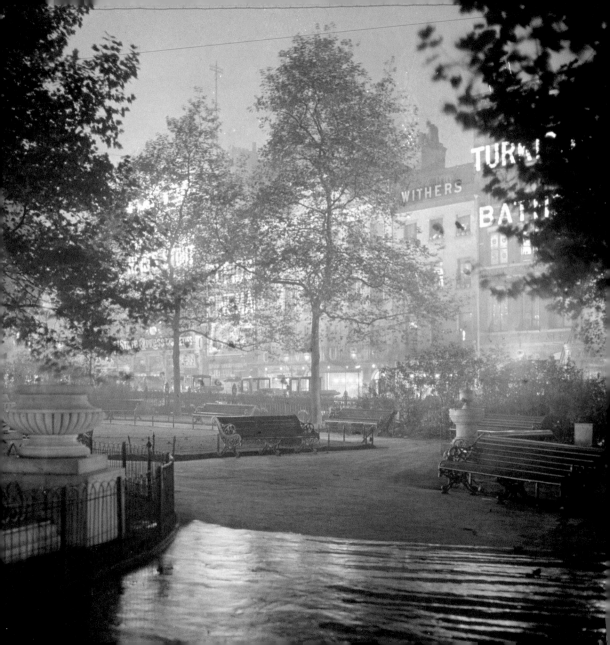

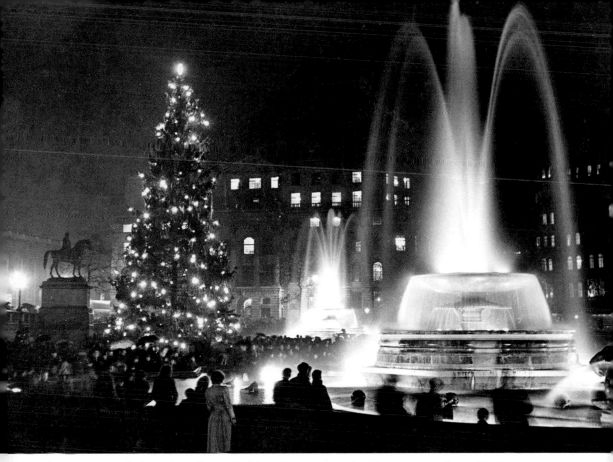

ABOVE: A crowd of people gather in Trafalgar Square to see the Christmas tree dressed in its finery, a present each year from Norway. The fountains, which are also lit, look magnificent.

LEFT: Leicester Square by night.

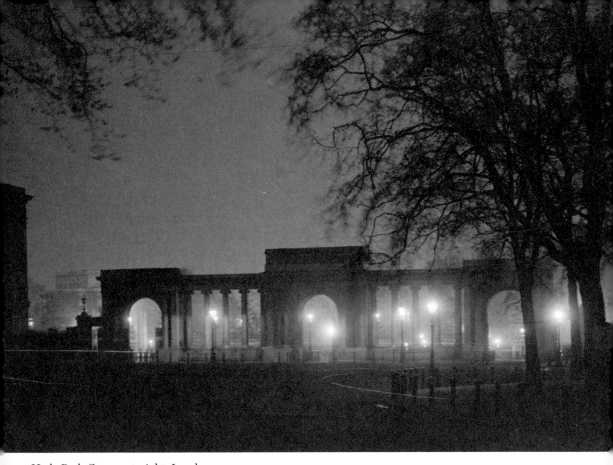

Hyde Park Corner at night, London

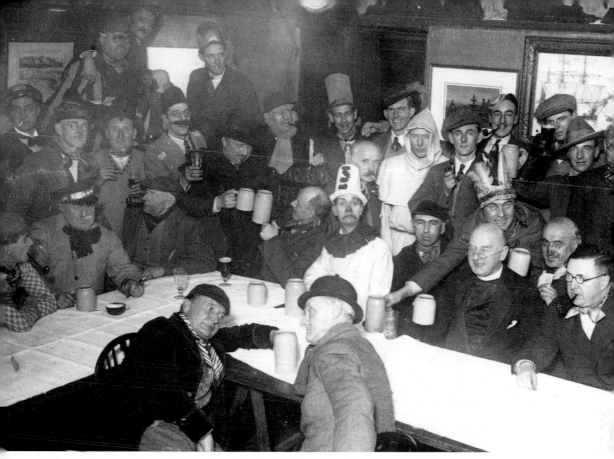

A fancy dress evening at the London Sketch Club, frequented by artists and illustrators, with members in various costumes and acting up for the camera. The silhouette artist, H. L. Oakley, is sat on the right-hand side near the front, dressed as a vicar.

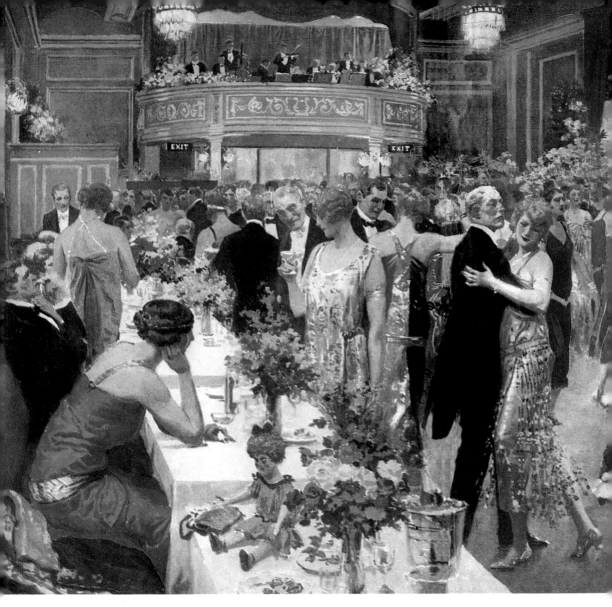

138 London at Night

ABOVE: A huge house on Carlton House Terrace, ablaze with lights during the London season, a short period in the year when members of the upper classes were resident in their London homes. Elegant guests at a ball or party can be seen arriving by car, while up on the verandah or portico a number can be seen enjoying the night air away from the heat and perfume of the dance floor.

LEFT: The Embassy Club in London in 1924, owned by restaurateur Luigi with entertainment supplied by (Bert) Ambrose and the Embassy Club band. According to *The Tatler*, the Embassy, 'has for many years been the gayest and brightest centre in London. It is crowded nightly by notables in the social, sporting and dramatic worlds, who come to sample the wonderful cuisine and dance to Ambrose's famous band.'

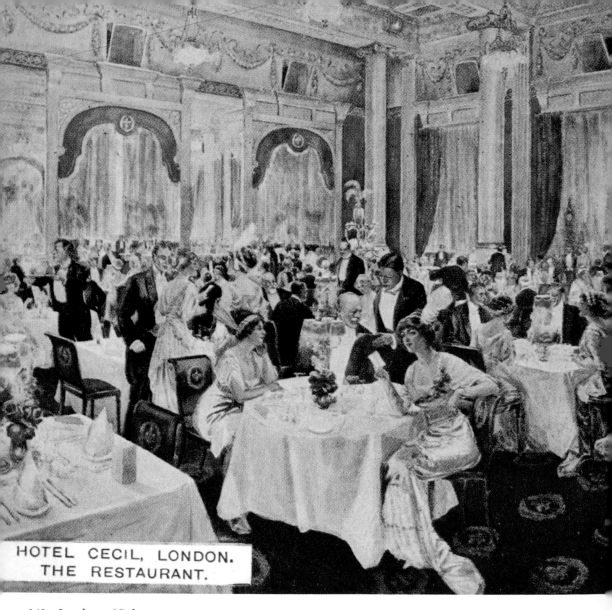

HOTEL CECIL, LONDON.
THE RESTAURANT.

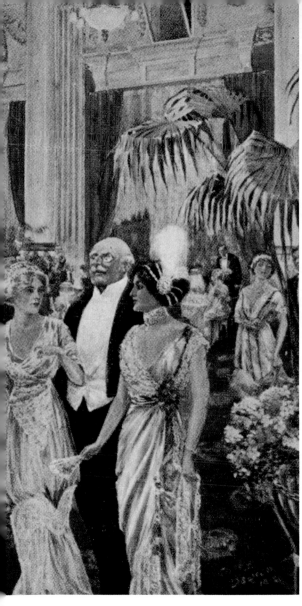

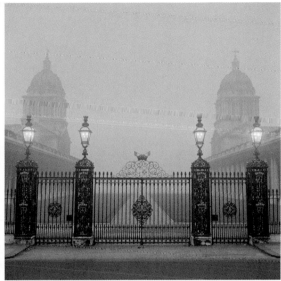

Above: A night-time view of the wrought iron gates and gate piers to the Royal Naval College, Greenwich, from Romsey Road, showing the college in the mist beyond.

Left: An interior view of the opulent Cecil Hotel restaurant in London, showing guests dressed in their finest.

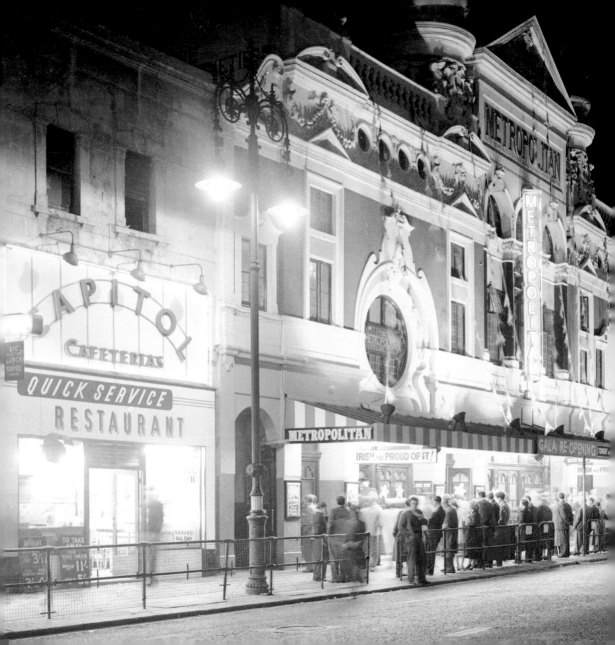

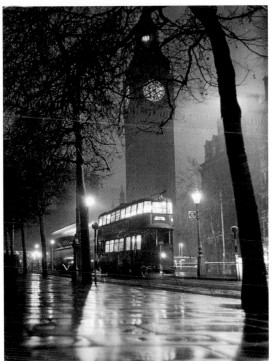

ABOVE: A wet evening at the Westminster Bridge end of the Victoria Embankment, with Big Ben showing the light, which indicates that Parliament is sitting. Note also the tram.

LEFT: The Metropolitan Music Hall at 207 Edgware Road, London. Formerly, the White Lion public house was located here. The theatre was built in 1862 and opened under the new name of the Metropolitan Music Hall two years later. It was re-built again in 1897 by Frank Matcham. It was demolished in 1963 to allow the building of a flyover for the A40.

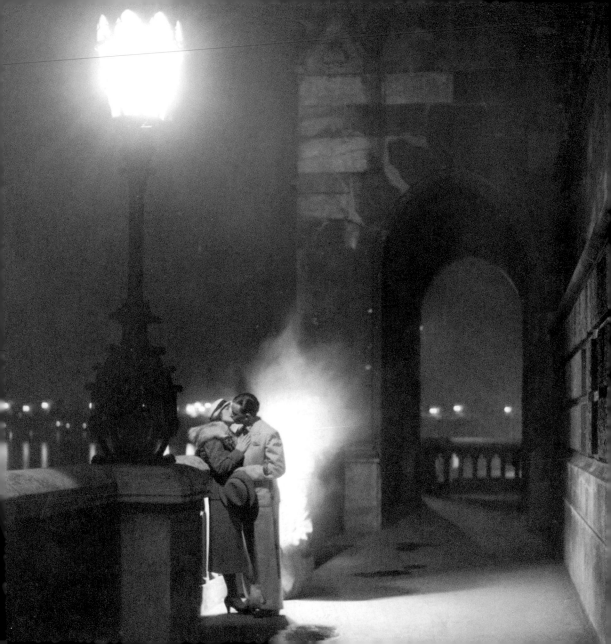

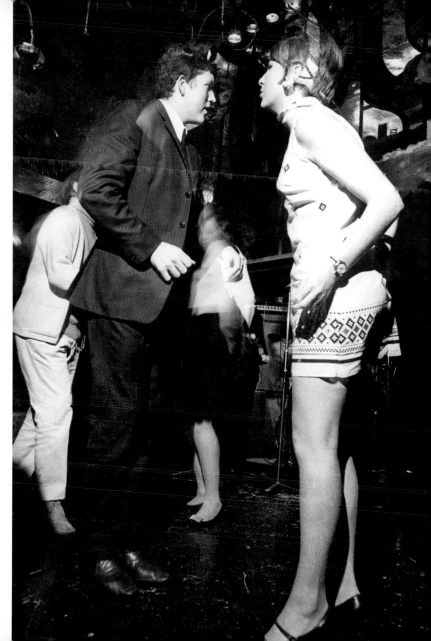

LEFT: A couple stop to kiss by a lamp-post during a romantic evening stroll along the Embankment.

RIGHT: A young couple dance together in a London nightclub, 1960s.

ABOVE: A female DJ plays records in a London nightclub.

RIGHT: Bunny girls operate gaming tables at the Playboy Club in London, which opened in 1966.

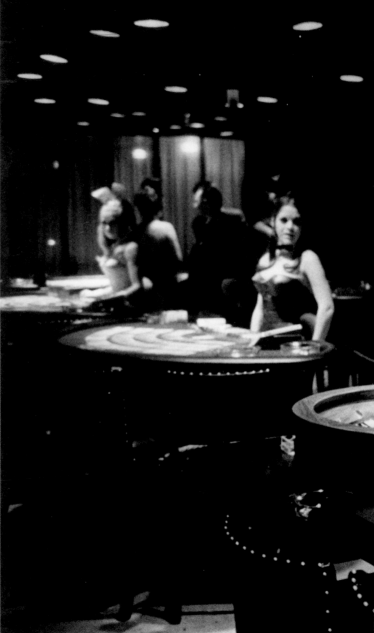

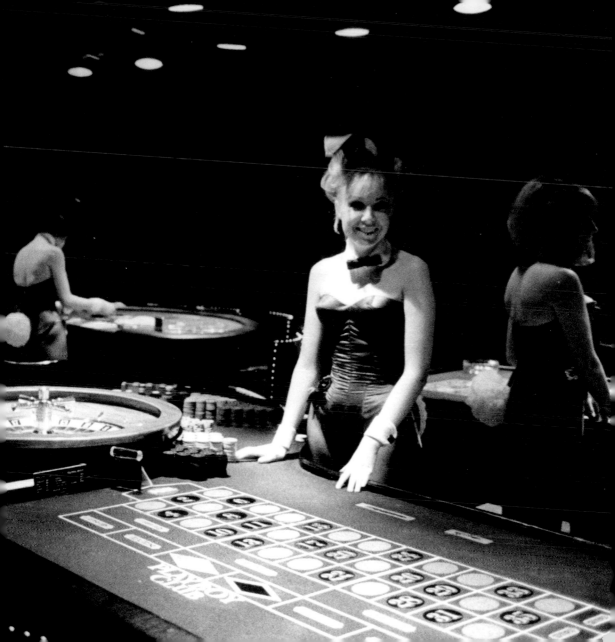

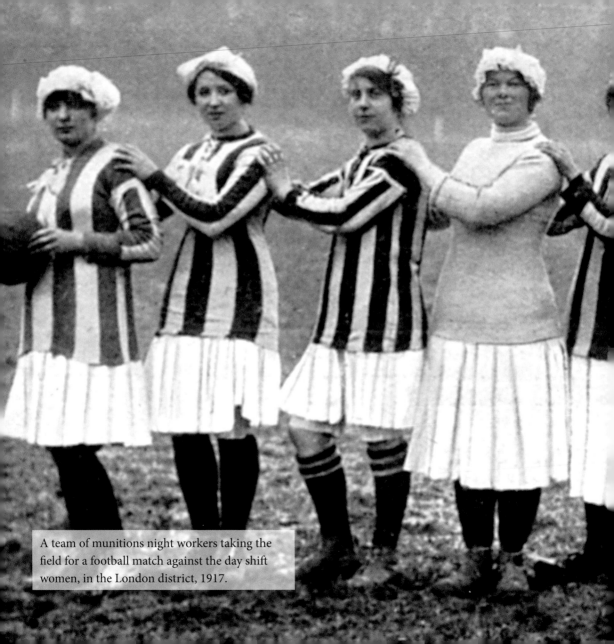

A team of munitions night workers taking the field for a football match against the day shift women, in the London district, 1917.

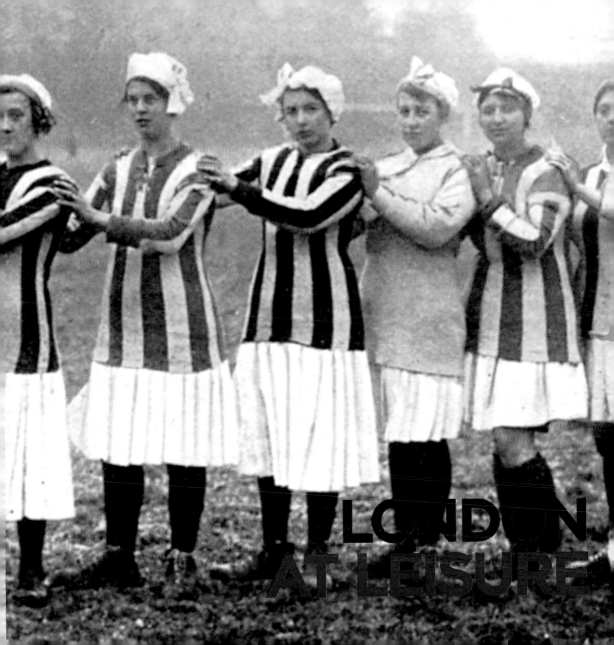

Final match, between Bolton and West Ham (Bolton would win 2-0), 300,000 were admitted through the gates, forcing crowds to spill onto the pitch prior to kick-off. Police were brought in to clear the pitch and restore order, among them an officer on a white horse, so distinctive among the darkened mass that the match was dubbed the 'White Horse Final'. The growth of sport in the capital saw the big London clubs build their own high capacity stadiums; Highbury, the home of Arsenal football club, was built in 1913 and significantly expanded in the 1930s to accommodate 90,000 spectators. Chelsea's ground at Stamford Bridge also once hosted international athletic meetings.

Attendance figures for football was impressive during the 20th century but it was eclipsed by a sport that enjoyed even greater popularity. Introduced to Britain in 1926, and with the first track opening in London in 1927, greyhound racing regularly attained crowds of 100,000 through the turnstiles on race nights. It was a phenomenon that appealed to all classes, finding favour with animal and sport-loving society women as much as the working classes; with many stadiums, including those at Wembley and White City, not only offering seats, but operating as full-scale entertainment complexes with silver service restaurants, huge dance floors and bar lounges.

A tour of London's historic sporting venues would not be complete without a trip to leafy southwest London, and to the Wimbledon All-England Lawn Tennis and Croquet Club, which holds the world's oldest and most prestigious tennis tournament every June and has done since 1877. Nothing seems more British than a day at Wimbledon with its strawberries and cream, glasses of Pimms and the fluctuating fortunes of each match relayed by the musical groans and cheers of the crowd watching the action on court. Those lucky enough to have tickets can walk straight in and take their seats while successive generations of committed fans have gamely queued in the hope of gaining entry. It's all part of the experience.

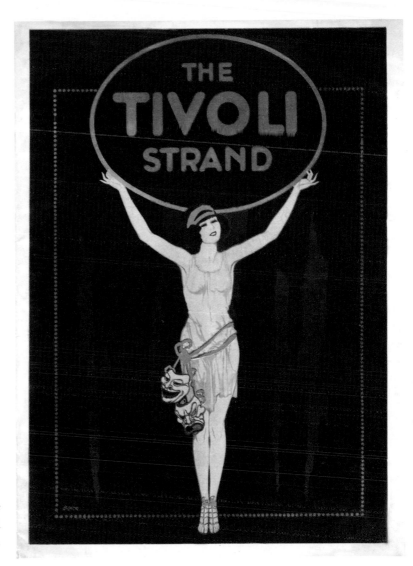

A cinema programme
cover for the Tivoli
Cinema, The Strand, 1923.

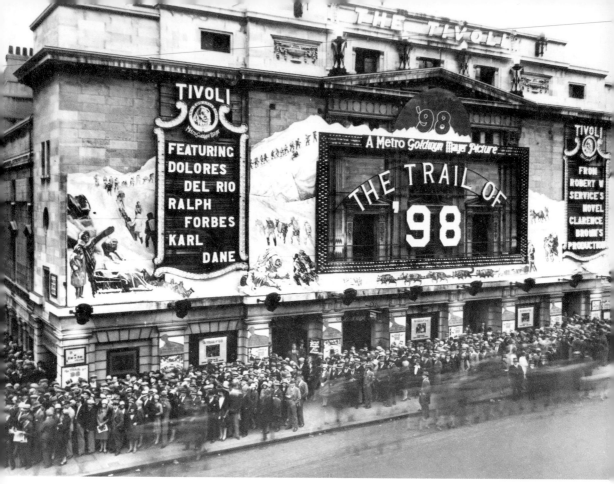

ABOVE: Crowds gather outside the Tivoli cinema in The Strand on Tuesday, 4 September 1928. The cinema represented a chance to be entertained, to be sociable and to escape into a world of fantasy.

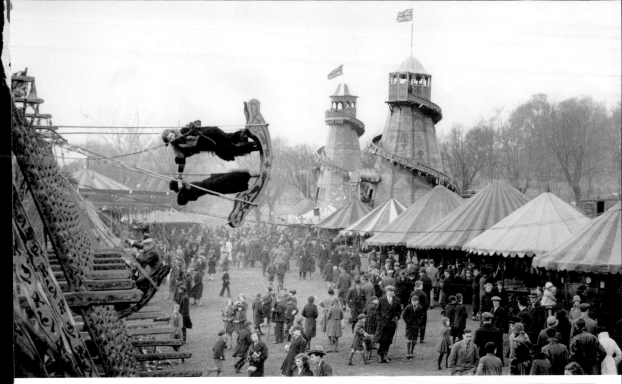

ABOVE: A busy scene at the fair on Hampstead Heath, around 1930, which drew large crowds and provided an afternoon or evening of entertainment at little cost. A large site for a fair on the Heath was assigned in 1865, and the passing of the Bank Holidays Act in 1871 helped to increase its popularity even further.

RIGHT: The barrel organ, a device that played music on the turn of a handle, draws in a crowd in Putney, south west London in 1900.

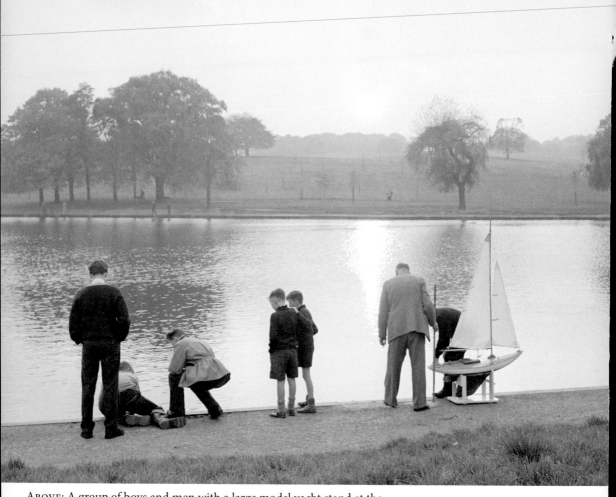

Above: A group of boys and men with a large model yacht stand at the edge of one of the Highgate Ponds on Hampstead Heath, London.

Right: A man starts the motor of a model boat while boys watch on, at the edge of this Highgate Pond on Hampstead Heath.

156 London at Leisure

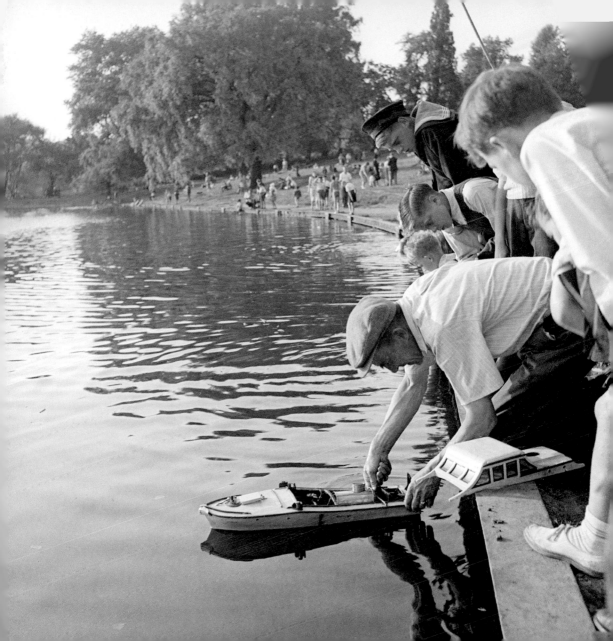

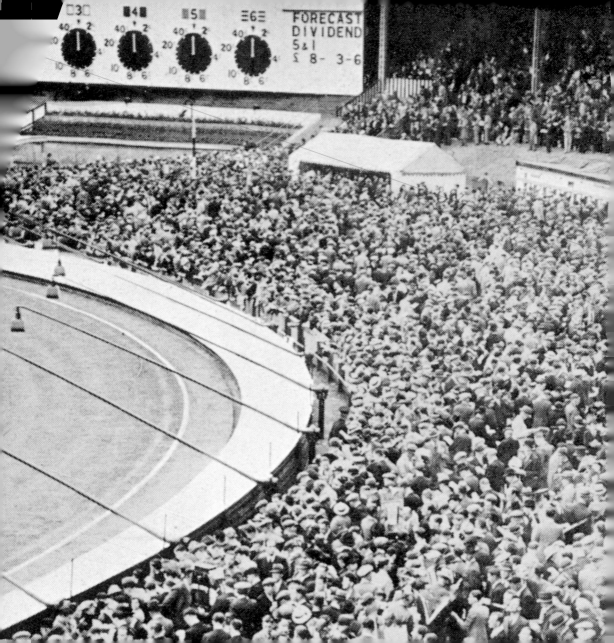

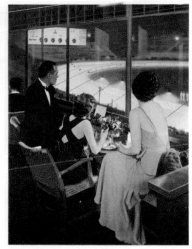

DINNER AT WHITE CITY.

London's most unusual and entertaining evening—dinner at White City. Good food and service, an excellent cellar—and greyhound racing watched from the great glass-enclosed restaurant which overlooks the floodlit track? A new and exciting fashion in London's evening entertainment.

ABOVE: Glamorous diners in evening attire watch greyhound racing at White City from the comfort of their table in the dining room's viewing gallery, 1937.

LEFT: In 1937, a record crowd of 83,000 went to the White City to see Wattle Bark win in the record time of 29.26 seconds. The number of spectators testifies to the immense popularity of greyhound racing during the inter-war years.

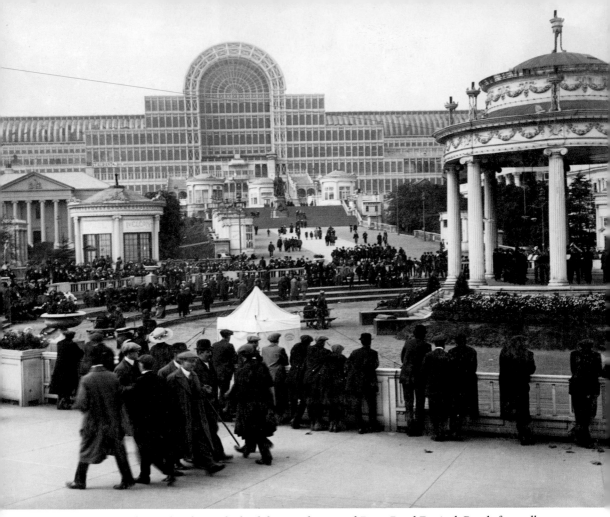

Crystal Palace in south London forms the backdrop to the annual Brass Band Festival. Bands from all over the country took part. In the circular bandstand on the right a Temperance Band are playing. Crystal Palace had been the venue for this annual festival since 1900, when there were approximately 20,000 amateur brass bands in the UK.

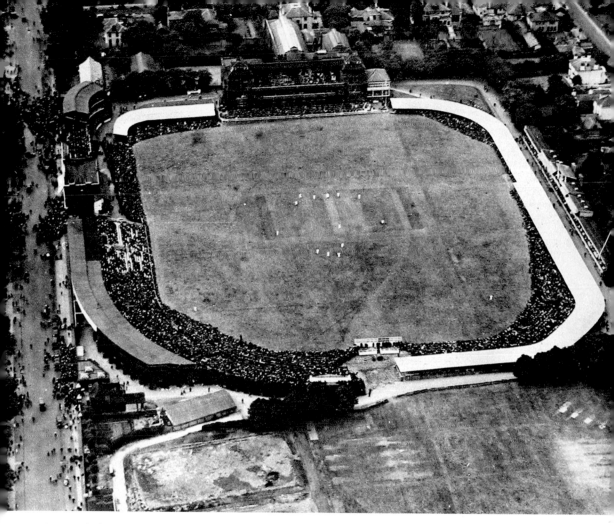

An aerial photograph of Lord's Cricket Ground during the second Test Match between England and Australia, 11 June 1921. On this day, 30,000 spectators crammed into Lord's, but hundreds of disappointed people were left outside the gates.

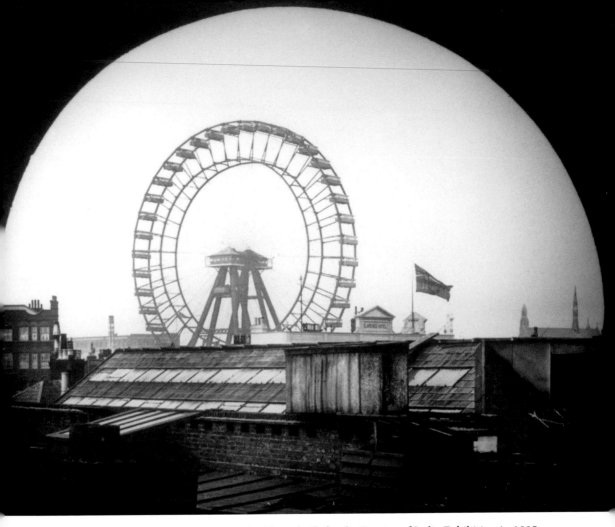

The Great Wheel at Earls Court in 1902. It had been built for the Empire of India Exhibition in 1895, remained in service until 1906 and was demolished the following year.

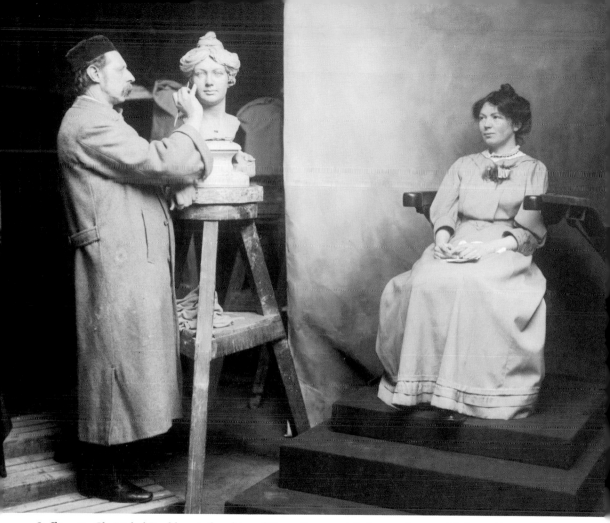

Suffragette Christabel Pankhurst, daughter of Emmeline, models for a sculptor at Madame Tussaud's.

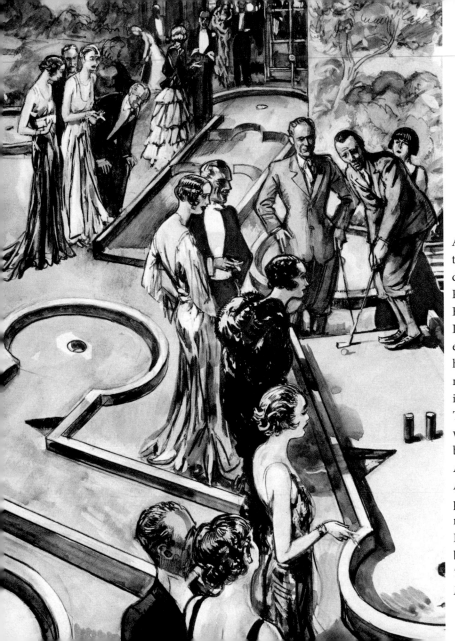

An attractive addition to the pleasures of dining at the Kit-Cat Restaurant in Haymarket, central London, was an entertaining nine-hole golf course in miniature, laid out in the Bray Room. The indoor course was inaugurated by the well-known American golfer, Arthur Havers, who played an exhibition round with Hugh Roberts. Illustration by Steven Spurrier in *The Illustrated London News*, 1930.

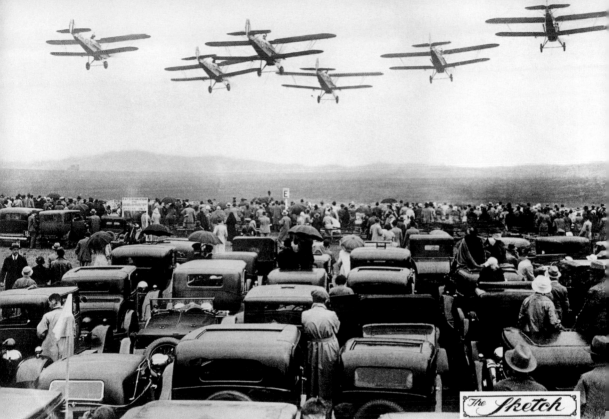

ABOVE: An aircraft squadron in formation flight at the Great Flight Festival in Hendon near London. Regimented rows of cars and their passengers are in attendance, 1933.

RIGHT: The cover of *The Sketch* illustrates the crowds watching an air display at Hendon airfield in the 1930s.

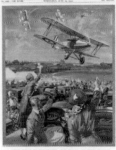

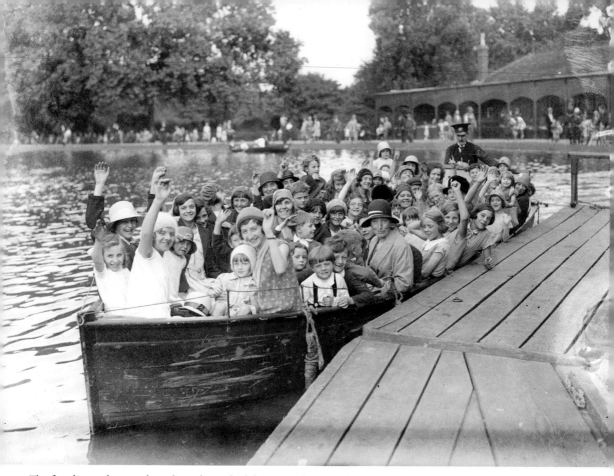

The first large pleasure-boat launch on the lake at Finsbury Park, north London, 1930s.

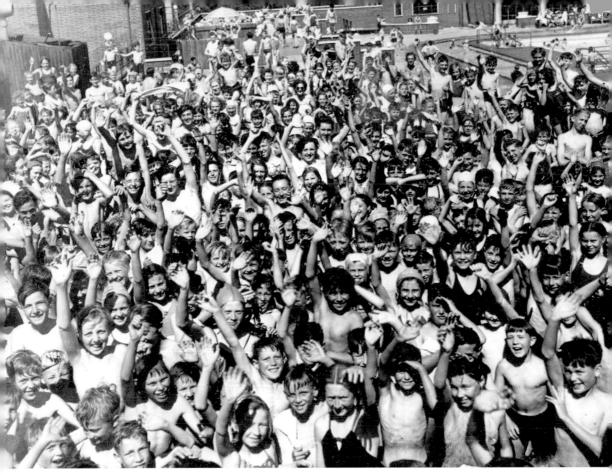

Crowds of children have fun in the sun at Kingsbury open air baths in Harrow. Opened in 1939, the pool was 165 feet (50 metres) long with a 10 feet (3 metre) deep diving area. The toddlers were not to miss out, having their own paddling pool in which to splash around. The terraces and promenade area were unusually situated on the roof of the dressing rooms, originally at ground level. The baths closed in the late 1980s after maintenance costs had risen to around £100,000 a year and the season had been reduced to only six weeks. The pool was later filled in by the local council and then demolished.

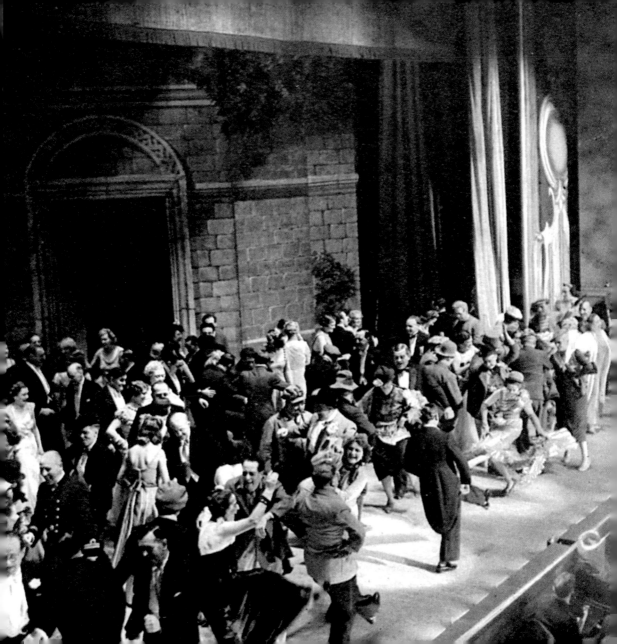

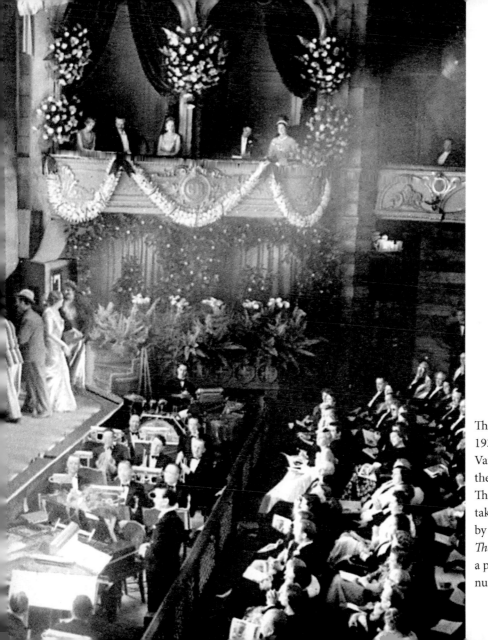

The grand finale at the 1938 Royal Command Variety Performance at the London Coliseum. The entire company takes to the stage led by Lupino Lane, doing *The Lambeth Walk,* a popular musical number.

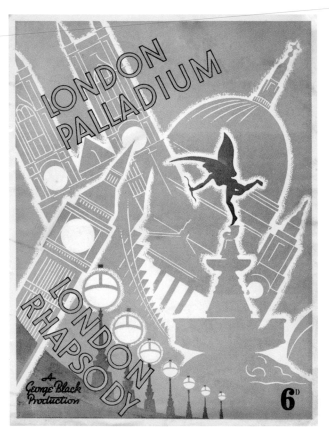

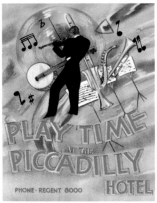

Above: The programme cover for the 1937 show *London Rhapsody* which featured the ever-popular Crazy Gang, at the London Palladium.

Top right: A programme for *Playtime at the Piccadilly* at the Piccadilly Hotel, 1930s.

Above right: A programme for a variety show at the London Palladium, 1932, under the direction of George Black.

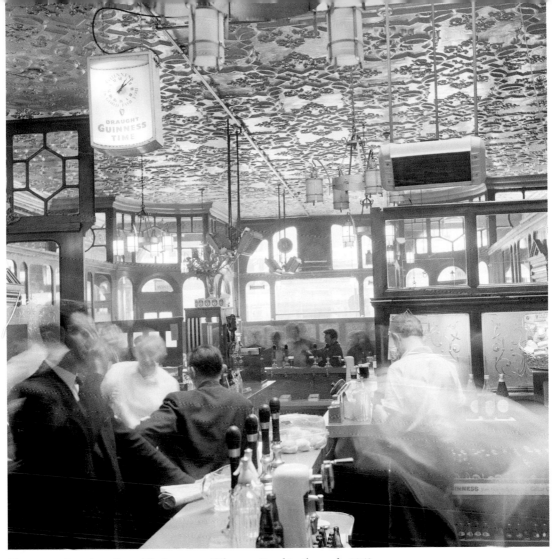

The ornate interior of a public house on Edgware Road in the early 1960s.

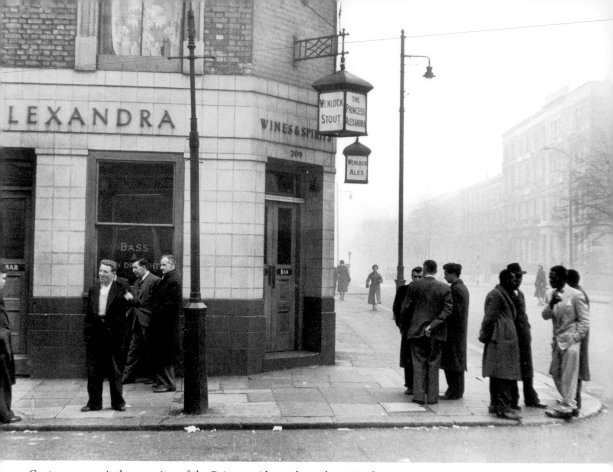

Customers await the opening of the Princess Alexandra pub in North Kensington, 1957.

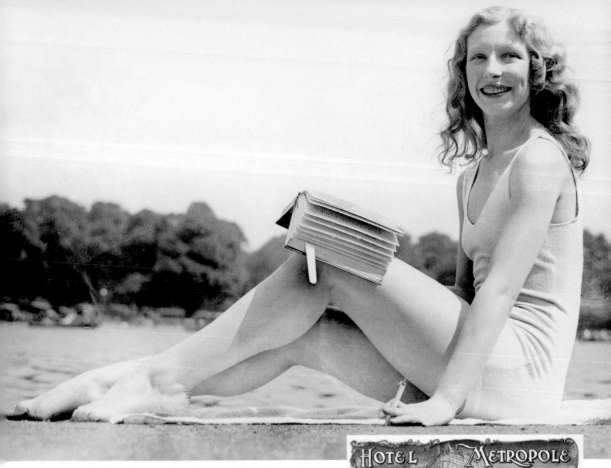

ABOVE: Hyde Park provides plenty of fresh air and open spaces in which to enjoy the sun, smoke a cigarette and read a book, 1932.

RIGHT: The Hotel Metropole on Northumberland Avenue in London, showing the dining salon, the lounge and the reading room.

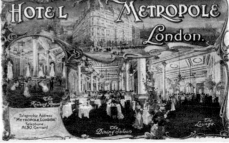

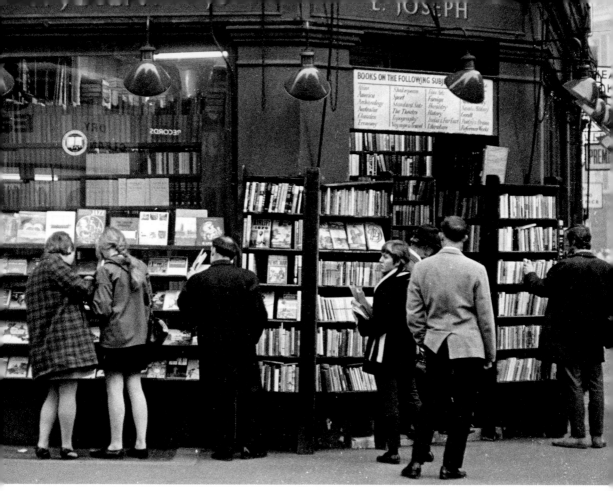

ABOVE: E. Joseph's second-hand bookshop at 48A Charing Cross Road, 1960s.

RIGHT: At a frozen pond on Hampstead Heath, skaters test the ice while others choose to watch before putting on their skates, 1960s.

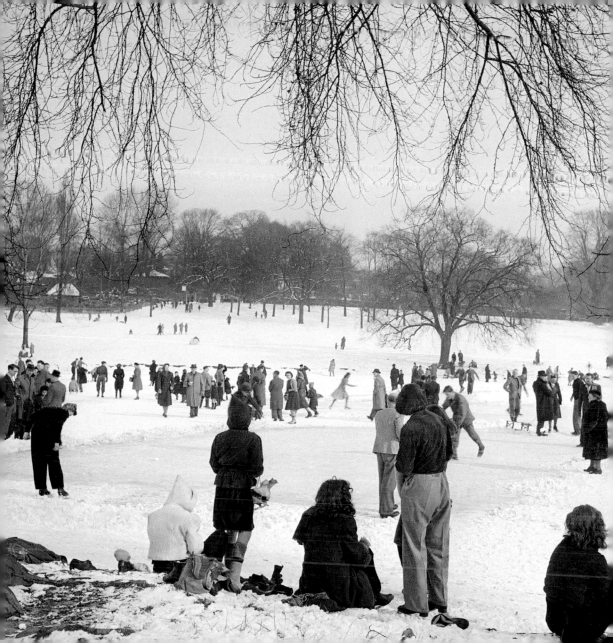

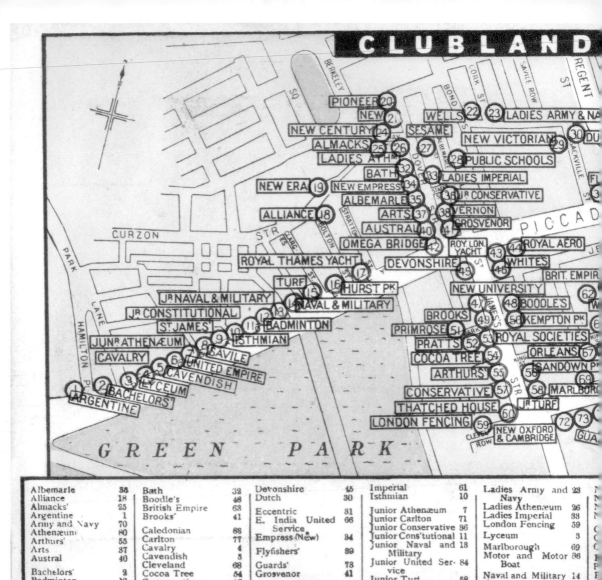

CLUBLAND

PIONEER 20
NEW 21
WELLS 22 23 LADIES ARMY & NA
NEW CENTURY 24 SESAME
NEW VICTORIAN 29 30 DU
ALMACKS 25 26 27
LADIES ATH 28 PUBLIC SCHOOLS
BATH 32 33 LADIES IMPERIAL
NEW ERA 19 NEW EMPRESS 34 36 JR CONSERVATIVE
ALBEMARLE 35
ALLIANCE 18 ARTS 37 38 VERNON
GROSVENOR
AUSTRAL 40 41
CURZON STR OMEGA BRIDGE 42 ROY LON. YACHT 43 44 ROYAL AERO
ROYAL THAMES YACHT DEVONSHIRE WHITES
45 46
17 BRIT. EMPIR
TURF NEW UNIVERSITY 62
15 16 HURST PK
JR NAVAL & MILITARY 14 47 48 BOODLE'S
JR CONSTITUTIONAL NAVAL & MILITARY BROOKS 49 50 KEMPTON PK
St JAMES' 13 PRIMROSE 51 ROYAL SOCIETIES
12 BADMINTON PRATTS 52 53
JUNR ATHENÆUM 9 ISTHMIAN COCOA TREE 54 ORLEANS 67
11
CAVALRY 8 SAVILE ARTHURS 55 56 SANDOWN P
7 UNITED EMPIRE 69
6 CAVENDISH CONSERVATIVE 57 58 MARLBOR
5 THATCHED HOUSE JR TURF
4 LYCEUM LONDON FENCING 60 72 73
3 BACHELORS 59 NEW OXFORD GUA
2 ARGENTINE & CAMBRIDGE
1

GREEN PARK

Albemarle	35	Bath	32	Devonshire	45	Imperial	61	Ladies Army and	23
Alliance	18	Boodle's	48	Dutch	30	Isthmian	10	Navy	
Almacks'	25	British Empire	63			Junior Athenæum	7	Ladies Athenæum	26
Argentine	1	Brooks'	41	Eccentric	31	Junior Carlton	71	Ladies Imperial	33
Army and Navy	70			E. India United	66	Junior Conservative	36	London Fencing	59
Athenæum	80	Caledonian	88	Service		Junior Cons'tutional	11	Lyceum	3
Arthurs'	55	Carlton	77	Empress (New)	34	Junior Naval and	18	Marlborough	69
Arts	37	Cavalry	4			Military		Motor and Motor	86
Austral	40	Cavendish	5	Flyfishers'	89	Junior United Ser-	84	Boat	
		Cleveland	68	Guards'	73	vice		Naval and Military	14
Bachelors'	2	Cocoa Tree	54	Grosvenor	41	Junior Turf	58	New	21
Badminton	12	Conservative	57			Kempton Park	50	New Era	19
Baldwin	75			Hurst Park	16				

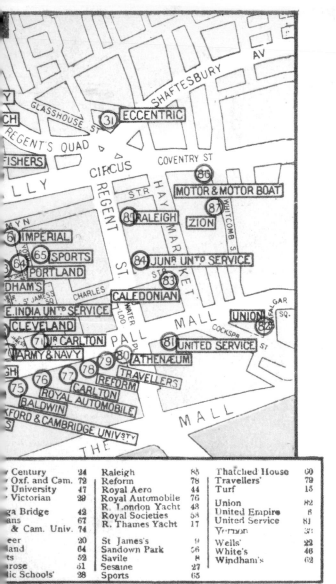

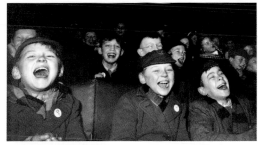

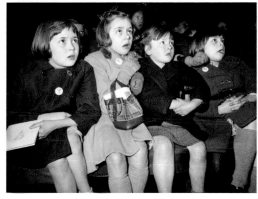

½ Mile COPYRIGHT

LEFT: A map of ladies and gentlemen's clubs of the West End of London, c.1910.

TOP: At a children's Saturday matinée in the 1950s, boys and girls look up at the screen and laugh. Two of the boys are wearing ABC badges, the name of the cinema.

ABOVE: Four girls look at the screen with intense and slightly fearful expressions on their faces, 1950.

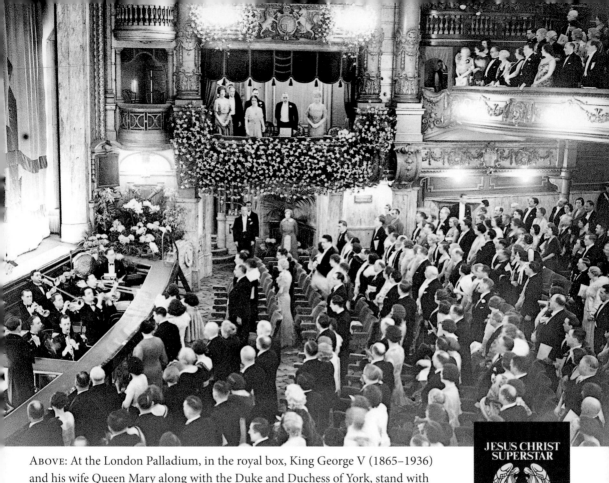

ABOVE: At the London Palladium, in the royal box, King George V (1865–1936) and his wife Queen Mary along with the Duke and Duchess of York, stand with the rest of the audience for the playing of the national anthem at the Royal Variety performance of 1933.

RIGHT: *Jesus Christ Superstar,* opened at the London Palace Theatre in 1972.

JESUS CHRIST SUPERSTAR

PALACE THEATRE

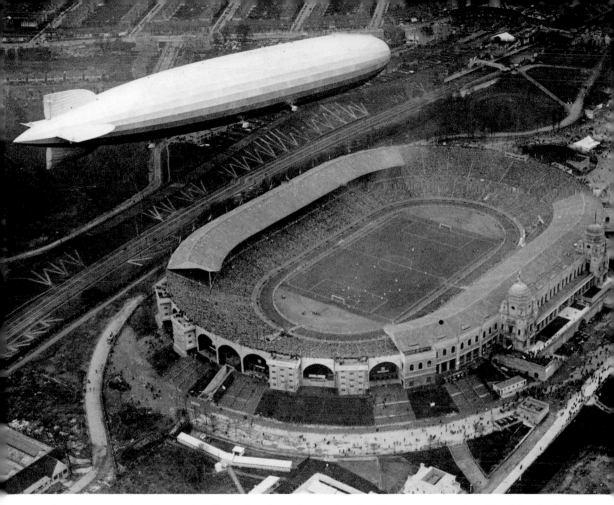

The German airship LZ 127 Graf Zeppelin above the FA Cup Final between Arsenal and Huddersfield Town at Wembley Stadium, London. Arsenal won 2-0, their first FA Cup win, 1930.

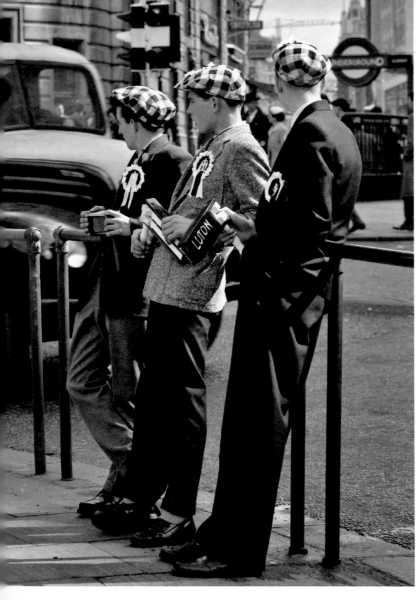

LEFT: Three football supporters on a London street, wear checked caps and rosettes and hold rattles.

BELOW: Before the Arsenal v Newcastle United FA Cup Final match at Wembley Stadium, the captains of Arsenal and Newcastle United greet each other, 22 April 1932. Newcastle were victorious winning 2-1.

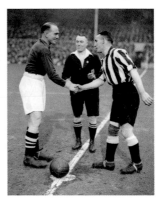

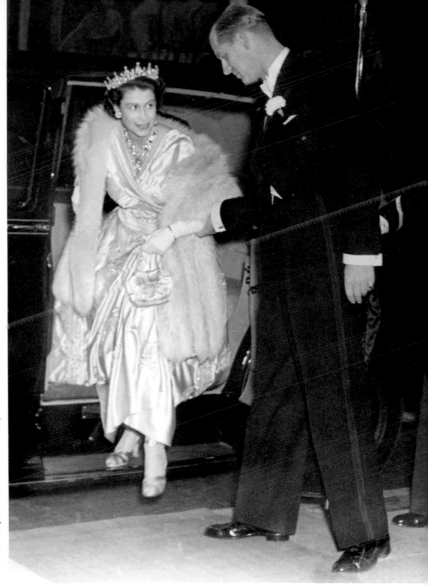

Princess Elizabeth (later Queen Elizabeth II) and her husband, Prince Philip, Duke of Edinburgh, attending the premiere of the Herbert Wilcox film, *The Lady with a Lamp* at the Warner Theatre in London on 22 September 1951. The premiere was in aid of the Royal College of Nursing Educational Fund and nurses from all over the world were present.

ABOVE: English silent film star and director, Charlie Chaplin (1889–1977), arrives in London to attend the British premiere of his film *City Lights*, 1931.

RIGHT: Society children riding in Rotten Row, Hyde Park, *c.* 1928.

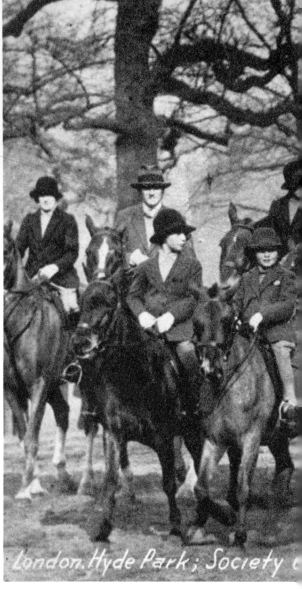

London. Hyde Park; Society

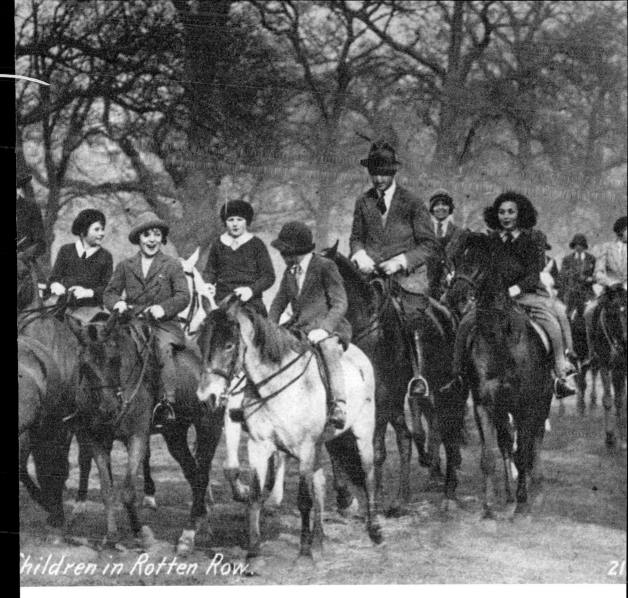

Children in Rotten Row.

21

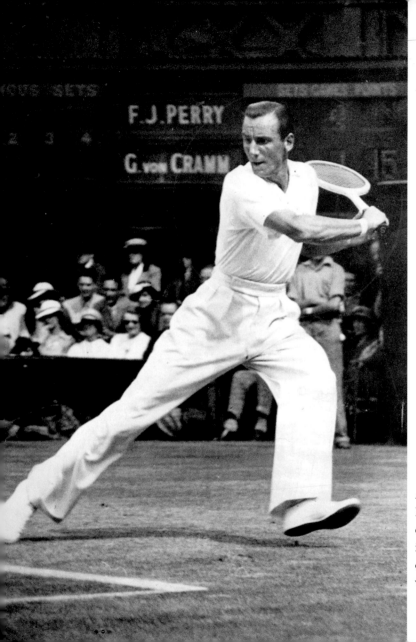

At Wimbledon in 1936, Fred Perry is seen during the final of the gentlemen's singles, in which he convincingly defeated German Gottfried von Cramm.

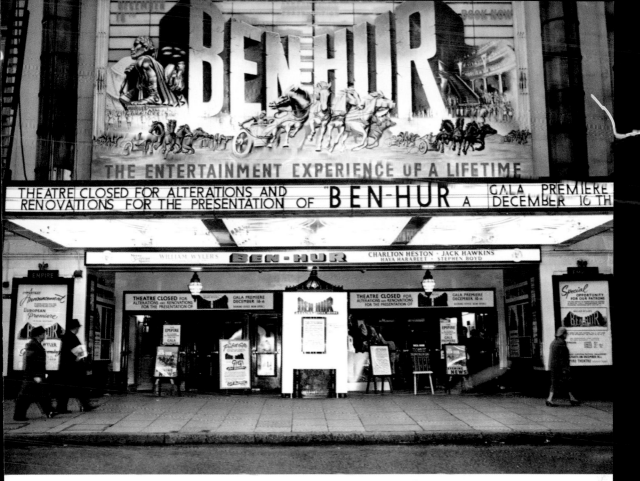

The Empire cinema in Leicester Square pictured in *1959*, advertising the forthcoming UK premiere of *Ben Hur*, the epic film starring Charlton Heston, which subsequently won eleven Academy Awards in 1960.

ABOVE: A couple in an intimate clinch on the dance floor at an unidentified London club in the 1950s.

RIGHT: The front cover of *The Sketch*, featuring an illustration of two elegant ladies among the blooms at the annual RHS Chelsea Flower Show.

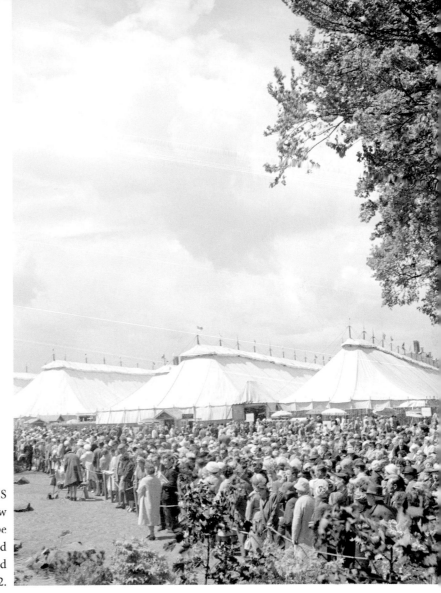

Visitors to the RHS Chelsea Flower Show crowd behind a rope barrier with lawn and shrubs to the left and pavilions behind, 1962.

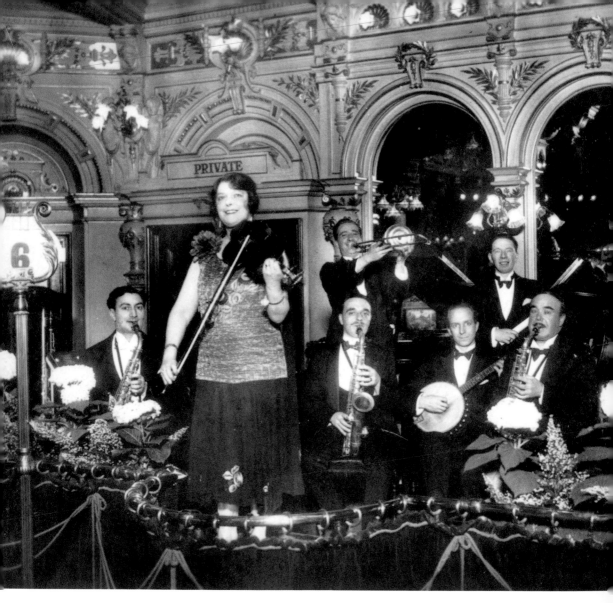

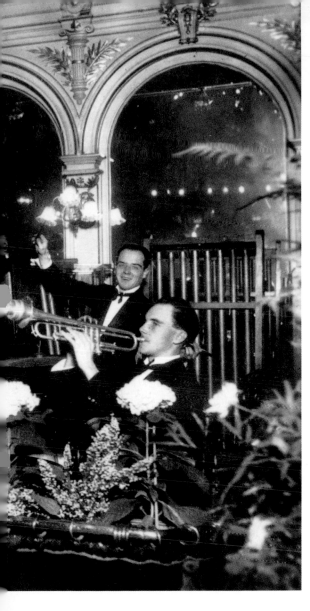

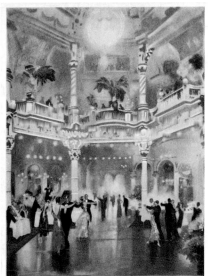

ABOVE: At Restaurant Frascati in Oxford Street, London W1, people take to the dance floor. Frascati's was a large, luxury restaurant offering cosmopolitan cuisine.

LEFT: Restaurant Frascati's Orchestra features Madame Cecile Couturier, the director, on the violin, 1920s.

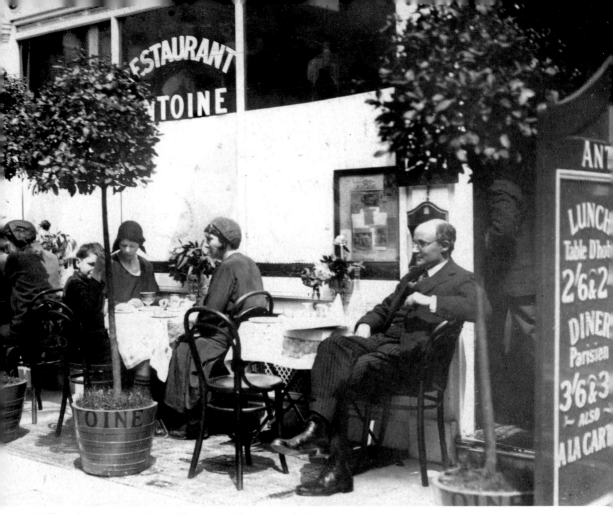

Well-to-do customers dine *al fresco* outside Antoine's Restaurant, 40 Charlotte Street, Soho, London, early 1930s.

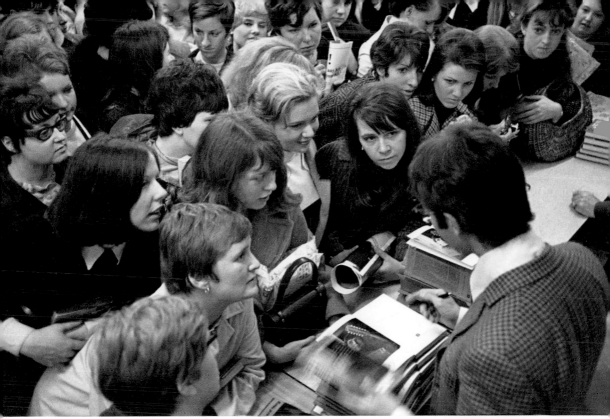

ABOVE: English pop singer Cliff Richard (b 1940) signs books at Pickering and Inglis in Ludgate Hill, London, in the late 1960s.

RIGHT: Shoppers hear the latest tunes from the hit parade in listening booths at a record store in London. Although the photograph dates from the early 1970s, the booths date from the late 1950s or early 1960s.

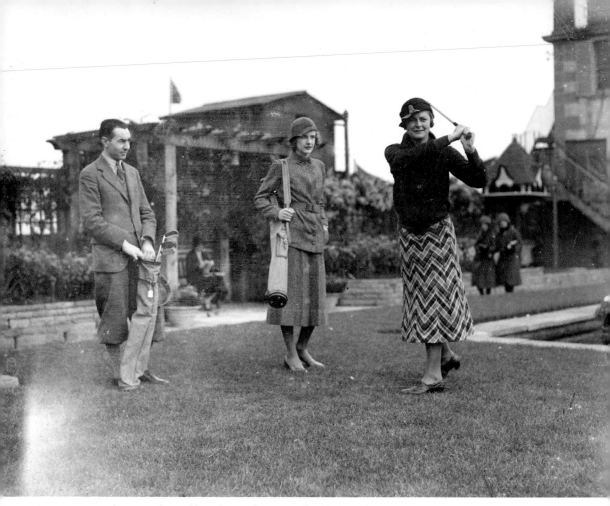

Two women and a man play golf on the roof terrace of Selfridges department store, Oxford Street, London, early 1930s.

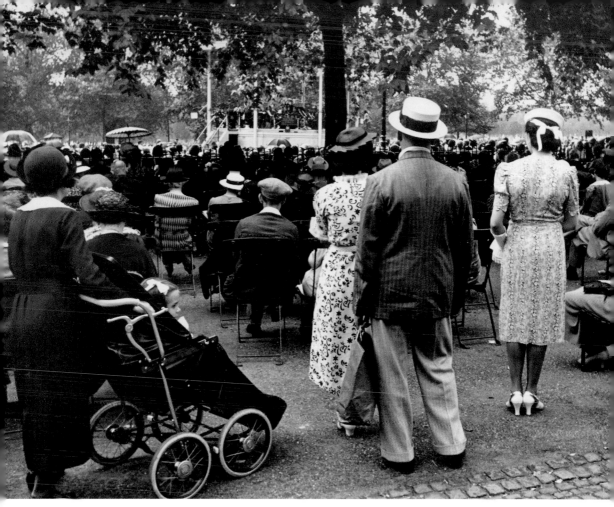

In the 1930s, an audience in a London park enjoys the music of a brass band playing on a bandstand.

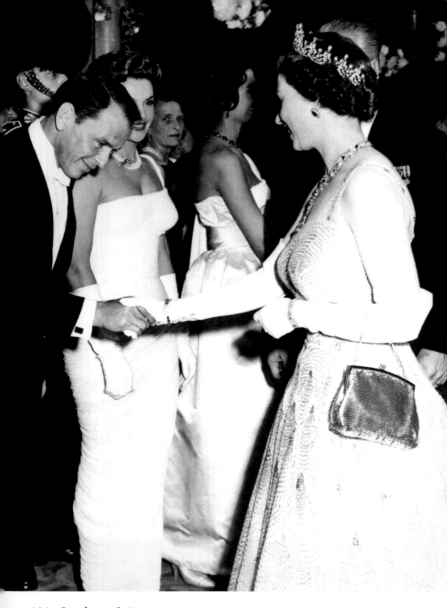

Frank Sinatra is presented to Queen Elizabeth II at the premiere of the Danny Kaye film, *Me and the Colonel*, in October 1958.

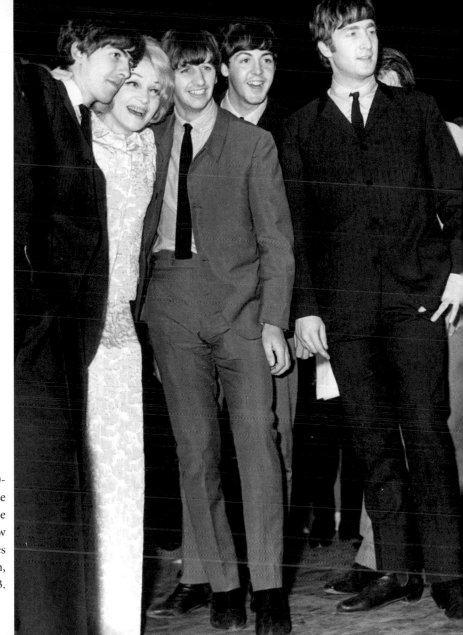

The Beatles (1960-1970), with Marlene Dietrich, during The Royal Variety Show at the Prince of Wales Theatre, London, 4 November 1963.

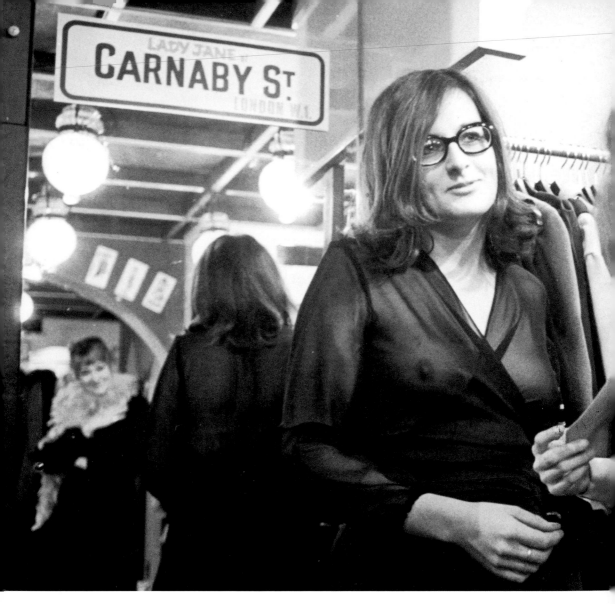

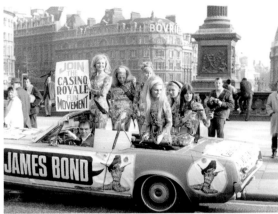

ABOVE: A publicity stunt in 1967 to promote the London distribution of the spoof film *Casino Royale*.

LEFT: In Carnaby Street, forever to be associated with 1960s youth culture, at the Lady Jane clothes boutique, a girl poses in the mirror as she tries on an outfit with a short waistcoat. Her friend wears a see-through chiffon blouse.

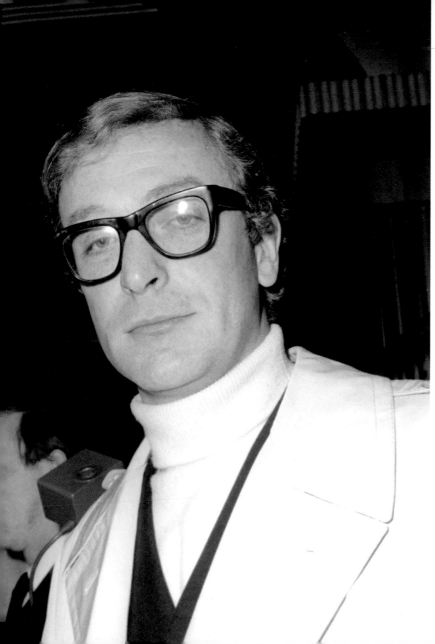

LEFT: British actor and quintessential Londoner Michael Caine (b 1933) at the premiere of the film *Here We Go Round the Mulberry Bush*, London, 1967.

RIGHT: American singer Barbara Streisand and Egyptian actor Omar Sharif with Princess Margaret at the London premiere of *Funny Girl c.*1969.

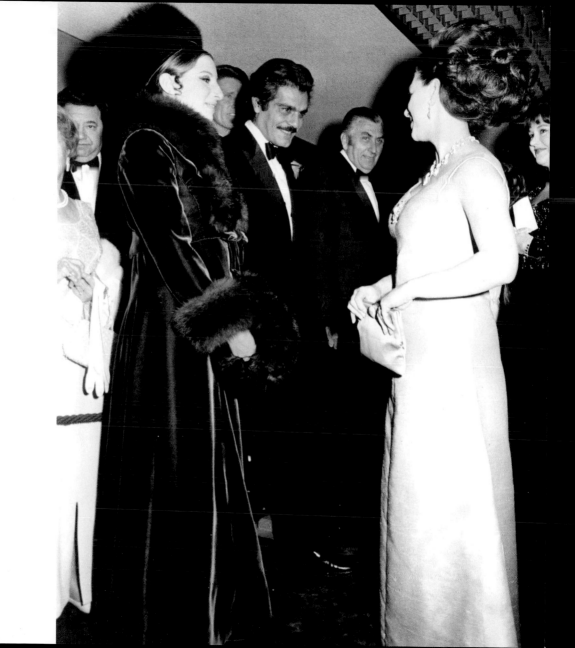

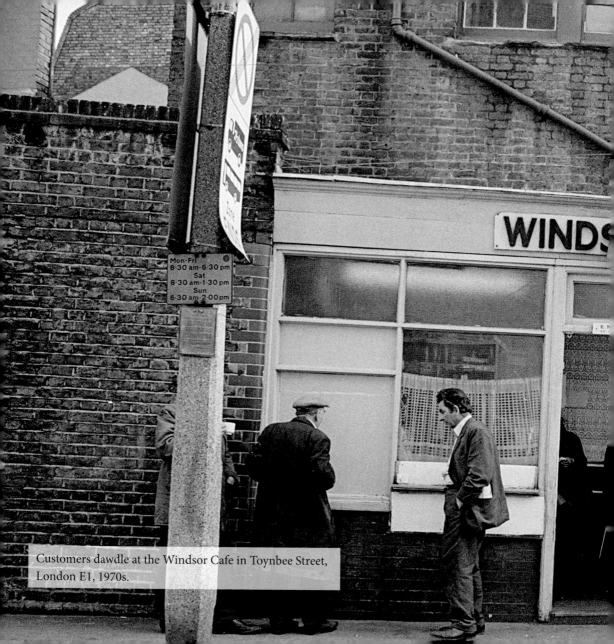

Customers dawdle at the Windsor Cafe in Toynbee Street, London E1, 1970s.

WHEN LONDONERS go home in the evening and close

their front doors, they shut out the sights, smells and sounds of the city. In London's streets all human life mingles: people from different cultures, religions, interests, talents, professions and ethnicities go about their business in one of the world's most cosmopolitan cities. Time-travel back to any year in the past century and the passing human traffic on the pavement might include street sellers, entertainers, tourists, shoppers, office workers, truants, artists or sandwich-board men. In homes, offices, museums, theatres and restaurants, Londoners begin to segregate into social groups, consciously or not, but outside, as people move from A to B, the streets offer up the broadest cross-section of London life.

There is a strong tradition of making a penny or two on the streets around the city. Street entertainers and buskers, such as musicians in tube stations or jugglers and comedians in Covent Garden, remain a vibrant part of London culture. It is a tradition that stretches back through the centuries and includes such amusements as Punch and Judy shows, performing monkeys, accordion players or pavement artists demonstrating their skills in chalk in exchange for coins before rain and footprints inevitably wash their work away. Barrel organs trundled London's streets in the early 20th century, amusing children, some of whom might beg to be allowed to pull the organ onto its next pitch in return for a small financial remuneration. London children, it seems, were born with the knack of 'turning a penny'. Soapboxes made good buggies for playing out in, but could be adapted for profitable activities such as hawking firewood or collecting rags to sell to dealers. The streets saw plenty of elderly enterprising characters too. In 1935, 88-year-old Mr Edwin Crocker was still doing a brisk trade as the 'Telescope Man', offering visitors a chance to look through his telescope at the face of Big Ben for a penny a time. He had been working his pitch for 40 years and insisted to enquirers that he loved the sound of the traffic too much to retire! Costermongers and street sellers were a vital part of the London economy at one time. In 1931, it was recorded there were at least 19,000 at work in the city, selling everything from toys to fruit.

Street markets have always shown wheeling and dealing Londoners in their most natural habitat, tempting customers with a showman-like display of cheeky banter and witty patter. This is the territory of the true East Ender, the Cockney 'wide boy', the 'spiv'—always on the look out for a deal, ducking and diving and 'having a dabble'. Plenty of these types have held pitches at Petticoat Lane market in

Wentworth Street in the East End over the years, which, as its name suggests, has peddled clothes, textiles and bric-a-brac to bargain hunters since the early 17th century. Close by, Sclater Street was once home to a bird market, while Club Row, between Shoreditch and Bethnal Green, was famous for selling dogs and puppies every Sunday. The writer Kaye Webb visited Club Row with her husband, the artist Ronald Searle in 1953, for their book, *Looking at London and People Worth Meeting*. She wrote a delightful account of the scene:

> There you may find them – the unclaimed pets of a hundred homes· new-born litters of puppies tumbling over each other in children's cots [the most popular form of window display]: 'mixed bags' of less lively youngsters huddling docilely together in laundry baskets; lively-looking sheepdogs, greyhounds and bulldogs straining at the ends of leashes and furry little faces peering incongruously from the jackets of hawkers, who often look as if they'd be happier in the boxing ring

In 1983, new laws preventing the street sale of live animals sounded the death knell for Club Row and it closed. In the early 20th century, the huge Caledonian ('Cally') Road Market in North London, a cattle market during the week, was given over to traders on weekends who dealt in junk, antiques and curios. Surprisingly, the upper classes became patrons of the Cally Road market, finding that rummaging for treasures among the North London proletariat quite the amusing and novel pastime. It even became the location for a great fundraising sale in June 1916, attended by notables such as the Grand Duke Michael and Lady Curzon. Sadly, the market was badly damaged in the Second World War. Over in West London, Portobello Road began to host a different, more arty and bohemian breed of trader compared to the cockney geezer of the East End market. Beginning as a fruit and vegetable market in the 19th century, in the 1940s and '50s dealers in antiques joined the standard produce sellers, attracted by the picturesque location, in part, and today, Portobello is a major draw for tourists from around the world.

A pleasant half-hour stroll from Portobello through Hyde Park, in its north east section, close to Marble Arch, is Speaker's Corner, where orators speak on any subject they like. Marx, Lenin and George Orwell have all stood on the proverbial soapbox at Speaker's Corner where most topics are

welcome but profanities may result in arrest. Religious preaching, too, has been a feature of London's streets. In the West Indian community of Brixton in the 1950s, the photographer Maurice Ambler captured preachers giving their rousing sermons on the street, accompanied by gospel music, and 15 years later was photographing Hare Krishna followers chanting their way along Oxford Street. These sights on London's streets are proof of its tolerance, vibrancy and ever-growing multiculturalism.

Away from the West End, the streets around inner-city residential areas of London were often the liveliest. Here, where housing was overcrowded and unsanitary, and large families often squeezed into two-room apartments in what were known as tenement buildings, gardens were an unattainable luxury and residents unsurprisingly spilled out onto the streets. Women chatted on doorsteps and children played in the largely traffic-free roads. These were some of London's most impoverished areas—multi-occupation being its most dense in Islington, Hackney, Willesden and Paddington. One of the worst areas was North Kensington including Southam Street where the late photographer Roger Mayne famously captured the people of those slums in the 1950s, in the years before their homes were bulldozed and cleared. There is a danger in looking back at these times with a rose-tinted nostalgia. Life was hard; poverty was debilitating and yet, it is an irony that those who came from these deprived backgrounds and spent their days playing on those streets, grew up in some of the most close-knit communities in London.

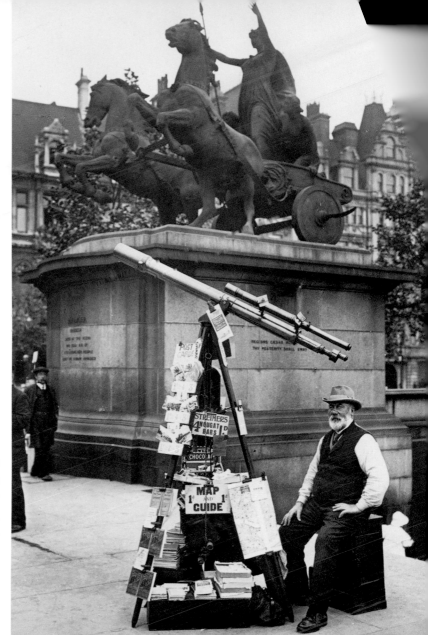

A photographic postcard depicts 'Big Ben's telescope man' under the Boadicea Statue, Westminster. The statue was sculpted wby Lord Thomas Thorneycroft (1815–65), but only cast in 1902.

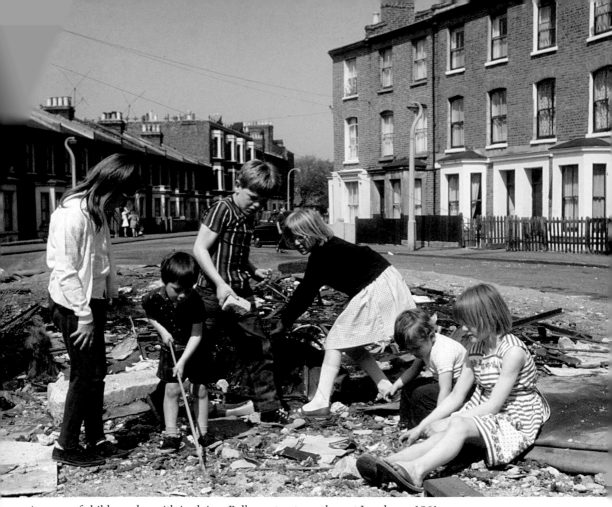

A group of children play with junk in a Balham street, south west London, *c.*1961.

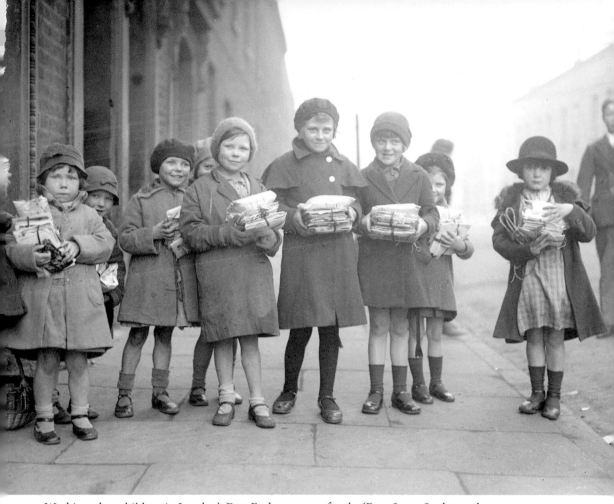

Working-class children in London's East End, queue up for the 'Fern Street Settlement'. In exchange for a farthing (quarter of a penny), the children received bundles of items that would delight them and included toys that they could call their own, *c.*1930s.

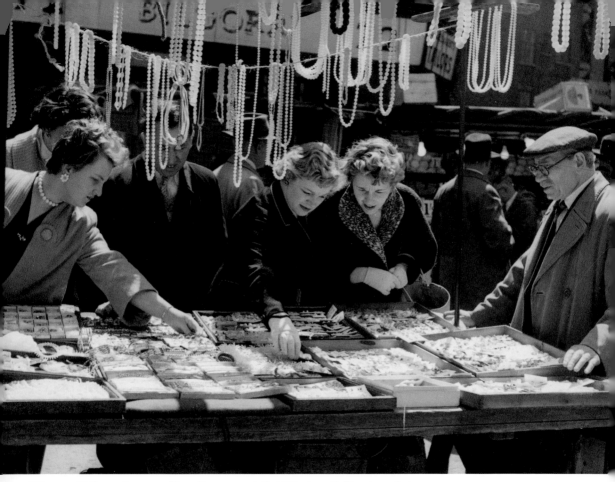

Women sift through trays of jewellery on a stall at Wentworth Street market, London, 1950s.

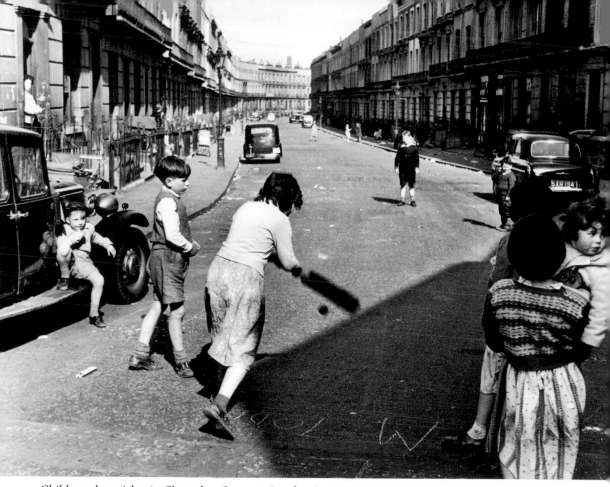

Children play cricket in Clarendon Crescent, London, in 1957
with no fear of disruption from traffic.

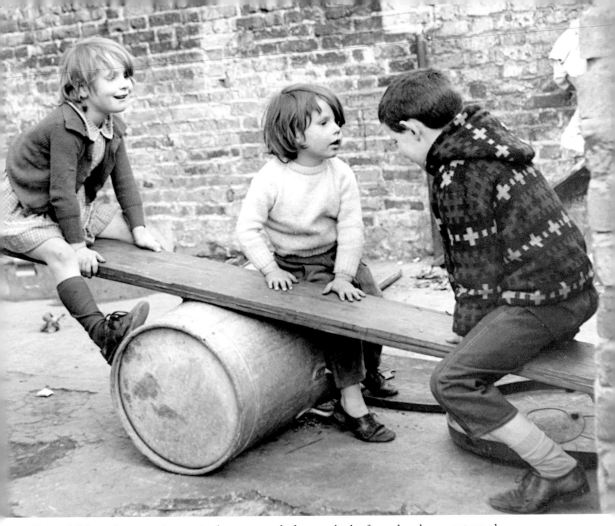

Three children play on an improvised seesaw made from a plank of wood and an overturned dustbin, on a Balham street, south west London, 1950s.

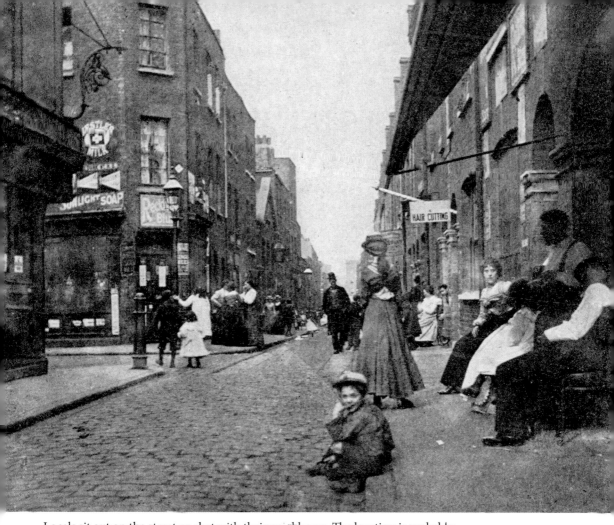

Locals sit out on the street or chat with their neighbours. The location is probably at the corner of Old Montague Street and Dunk Street in the Whitechapel area of East London in the early 1900s.

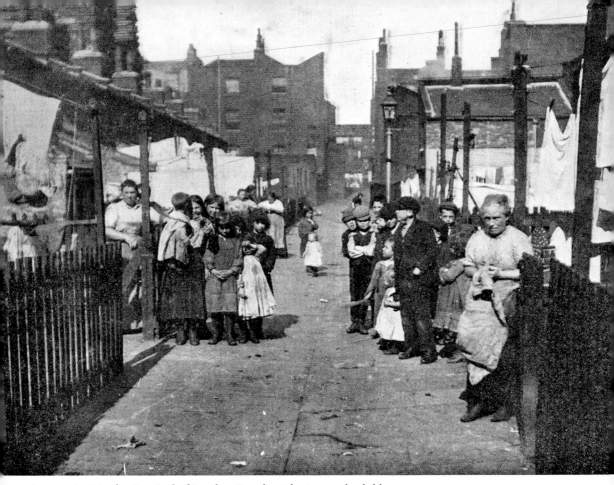

A poor street in the East End of London. Local residents, mostly children, look suspiciously toward the camera. Washing is hanging up to dry in each backyard, early 1900s.

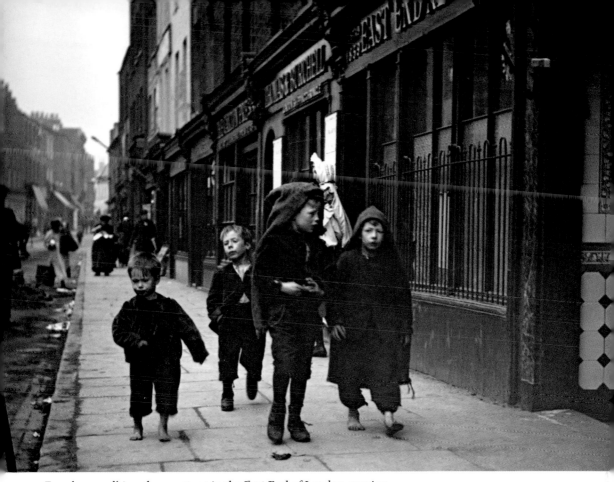

Four boys walking along a street in the East End of London, passing
the premises of the *East End News*. Two of them have bare feet.

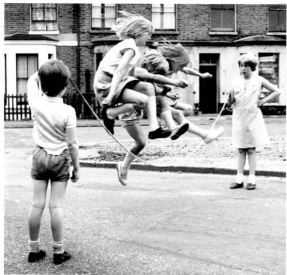

ABOVE: A group of children skip in the road on a Balham street, south west London.

RIGHT: The Whitechapel street market.

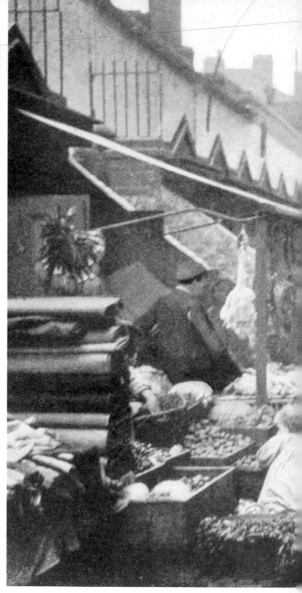

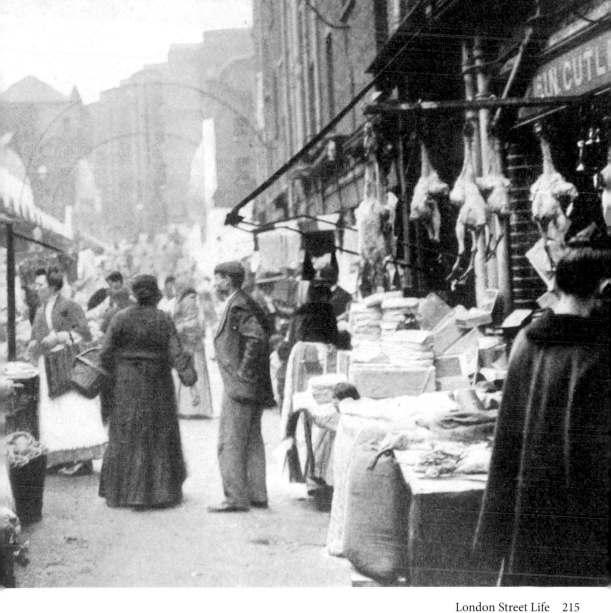

London Street Life 215

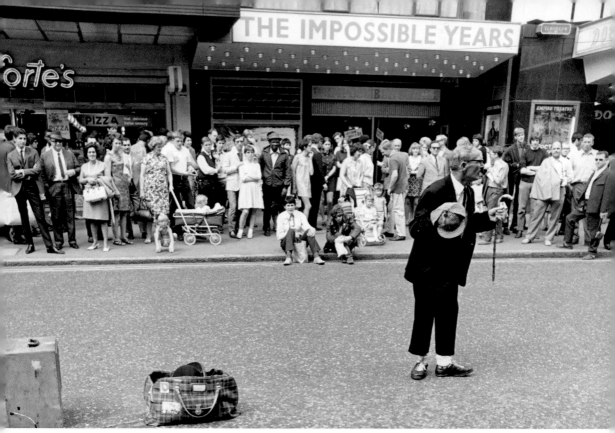

ABOVE: A street entertainer performs a trick involving a tartan bag and a wooden box, much to the amusement of the tourists in Leicester Square, 1966.

RIGHT: A contortionist attempts to escape from a bound sack in Charing Cross Road. He is drawing quite a crowd as he attempts this feat.

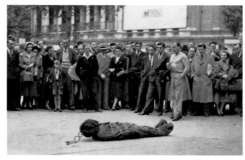

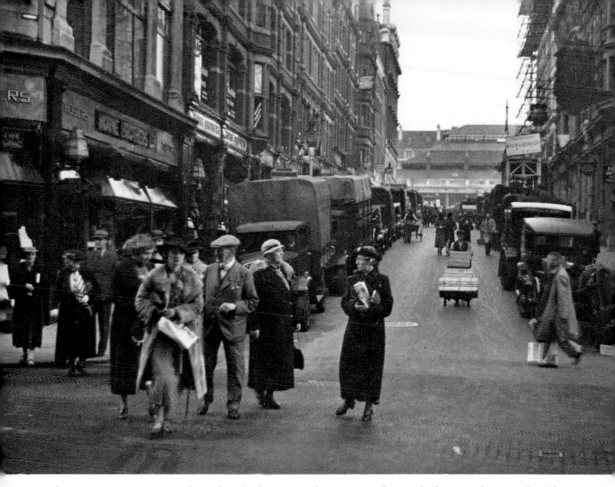

A busy street scene in central London, looking toward Covent Garden. Parked cars and vans unload for the market and well-dressed people mill about, 1930s.

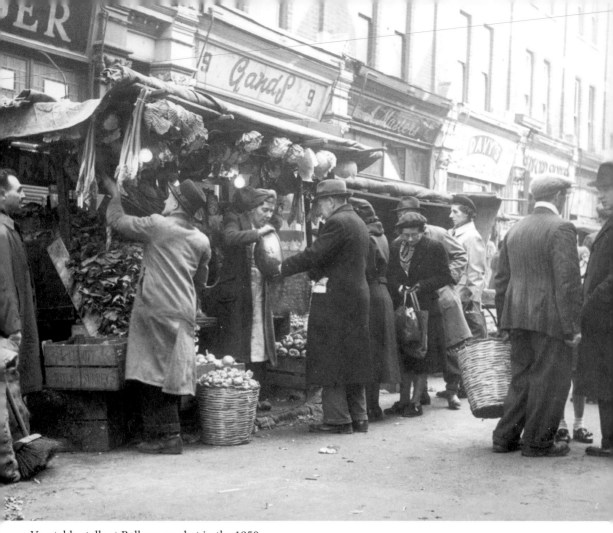

Vegetable stalls at Balham market in the 1950s.

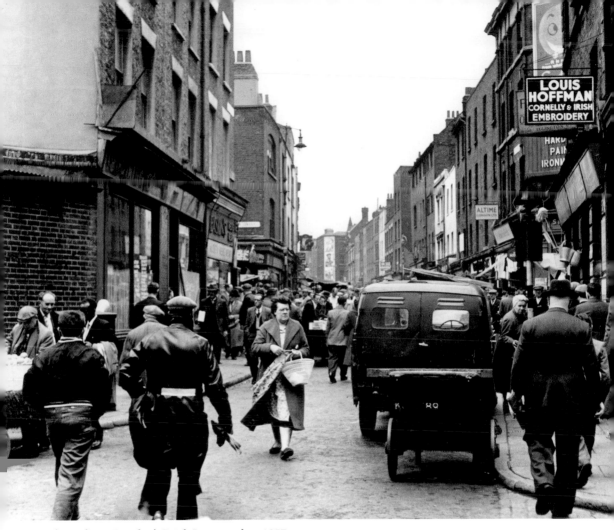

A busy day at London's Brick Lane market, 1957.

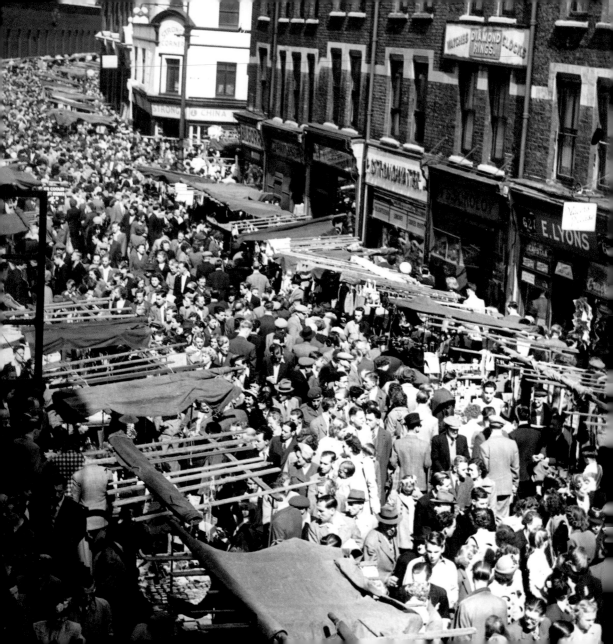

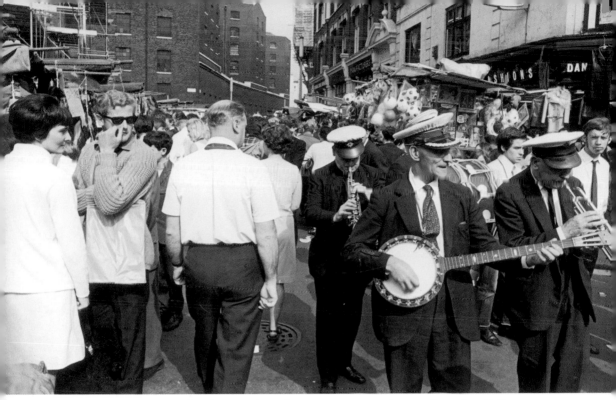

ABOVE: An impromptu jazz band passes through Petticoat Lane market on a busy day, 1960s.

LEFT: Crowds of shoppers throng the street at Petticoat Lane market.

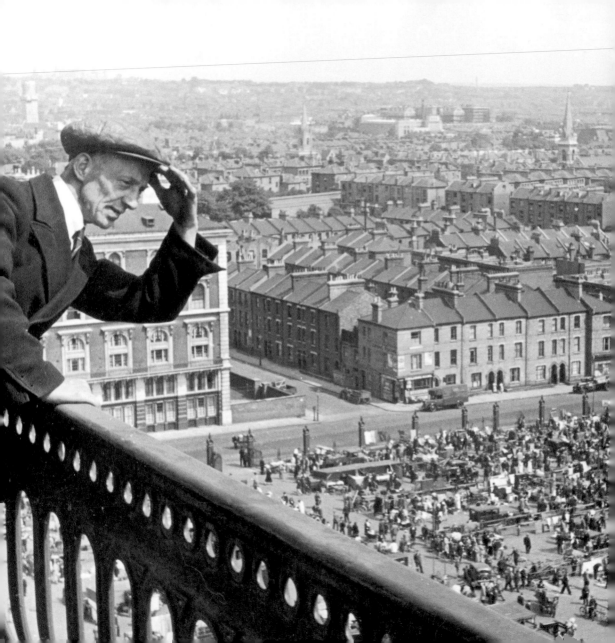

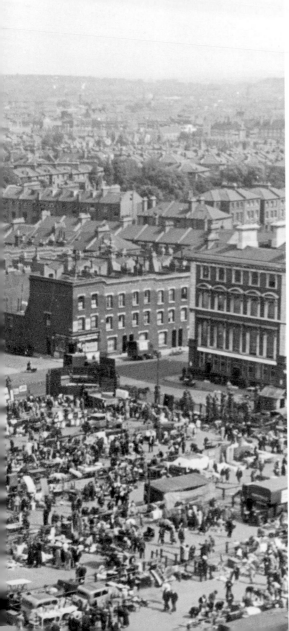

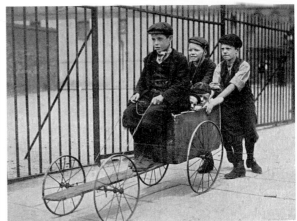

ABOVE: Street boys push, drive or ride in their homemade soapbox racer go-cart, fitted with perambulator wheels.

LEFT: A man looks down over the bustling old Caledonian Road market, North London.

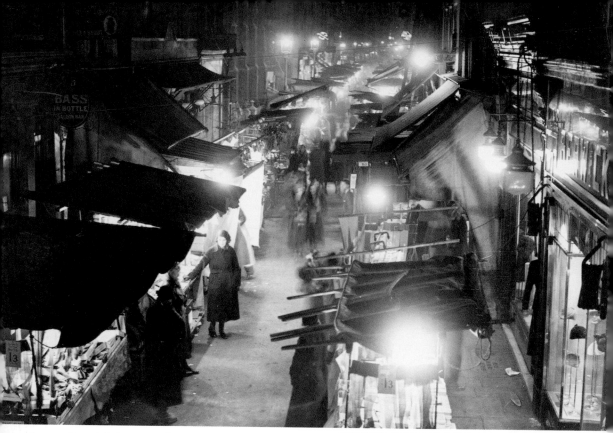

ABOVE: Berwick Street market, in the heart of Soho, doing a brisk trade just before Christmas, December 1933.

RIGHT: Children (mostly working boys) watch a Punch & Judy Show before the National Portrait Gallery, Trafalgar Square. There is a statue of the famous actor Sir Henry Irving in the background.

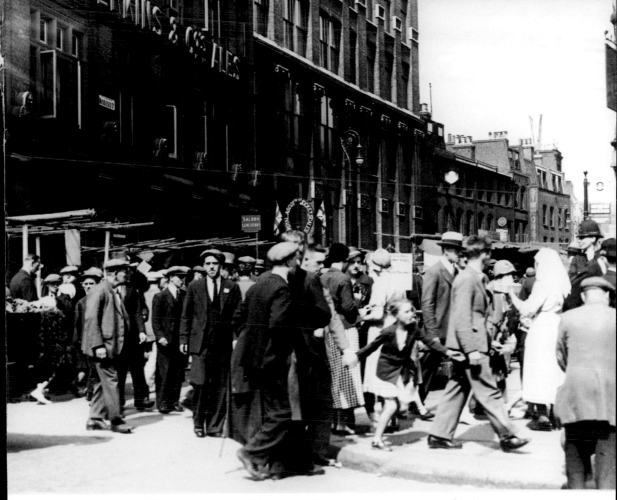

A busy day on Middlesex Street, part of the famous Petticoat Lane market, East London.

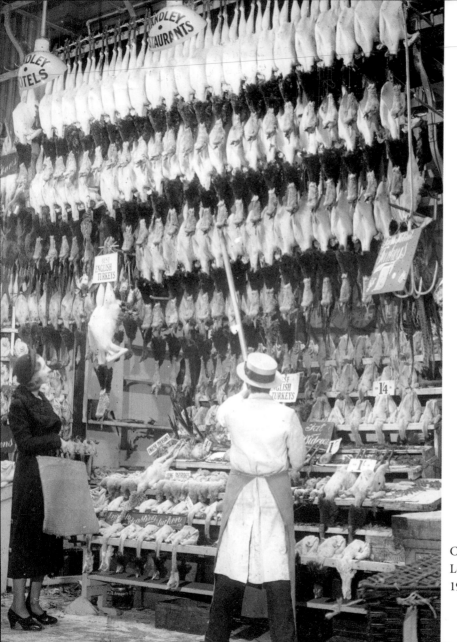

Christmas turkeys at
Leadenhall market,
1937.

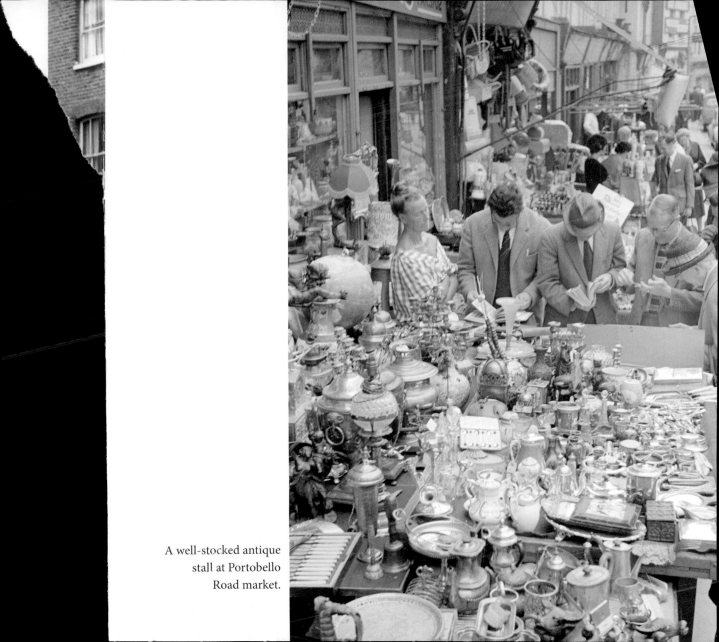

A well-stocked antique stall at Portobello Road market.

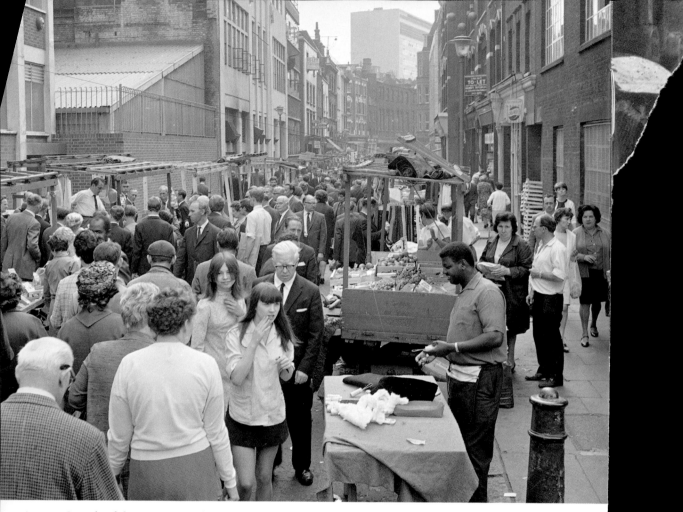

ABOVE: Crowds of shoppers at Leather Lane street market in
Camden in the 1960s.

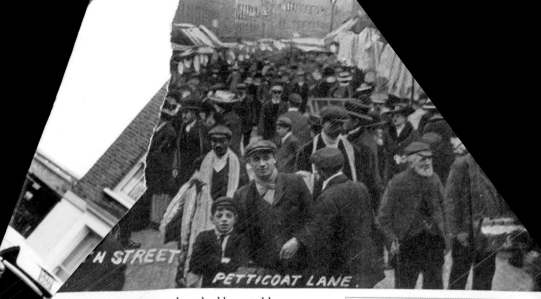

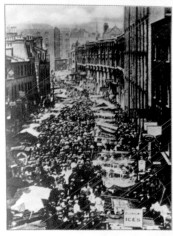

...d-hand clothes and bric-a-brac had been sold
...Lane since the early 17th century. An influx of
...nt Huguenots and later immigrants Jews developed
...ufacturing in the area and maintained the traditions of
...pite a severe decline following the Second World War,
...lux of Asian immigrants in the 1970s once again
...ea's vitality.

...ama looking down on the market reveals the
...ity of this method of shopping for goods and

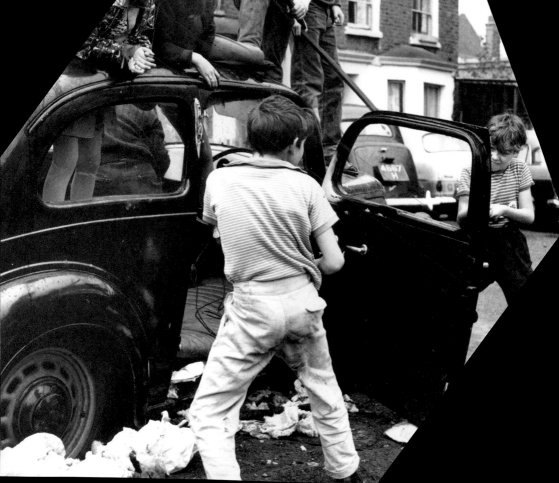

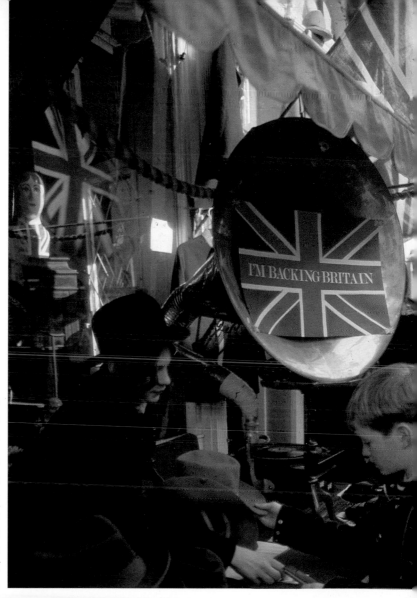

LEFT: Children play with an abandoned car in a Balham street, south west London.

RIGHT: At Portobello Road market, the words on a flag inside the horn of a gramophone read 'I'm Backing Britain'. In 1968 this was a short-lived campaign to promote the purchase of British-made goods.

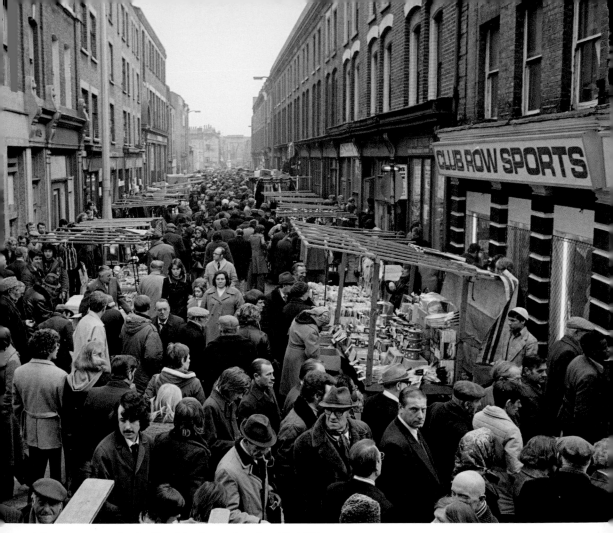

A busy street market in Cheshire Street, London E1, 1970s.

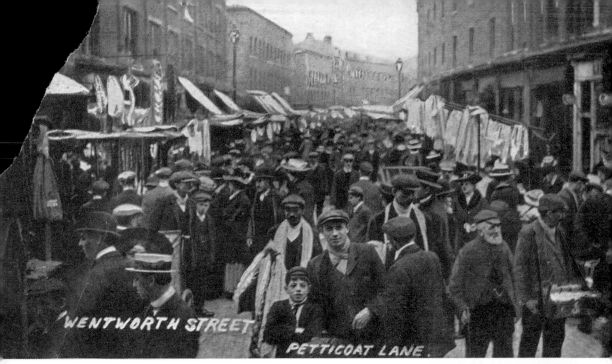

ABOVE: Second-hand clothes and bric-a-brac had been sold in Petticoat Lane since the early 17th century. An influx of immigrant Huguenots and later immigrants Jews developed the manufacturing in the area and maintained the traditions of trade. Despite a severe decline following the Second World War, a further influx of Asian immigrants in the 1970s once again restored the area's vitality.

RIGHT: This panorama looking down on the market reveals the extent of the popularity of this method of shopping for goods and finding a bargain.

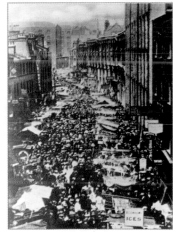

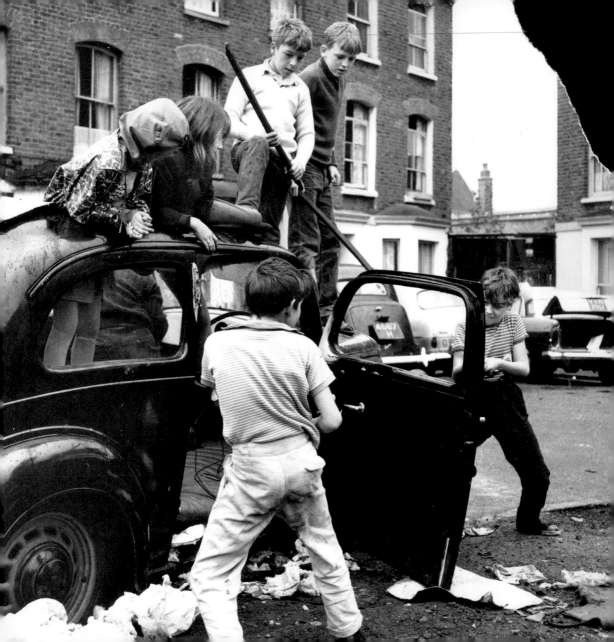

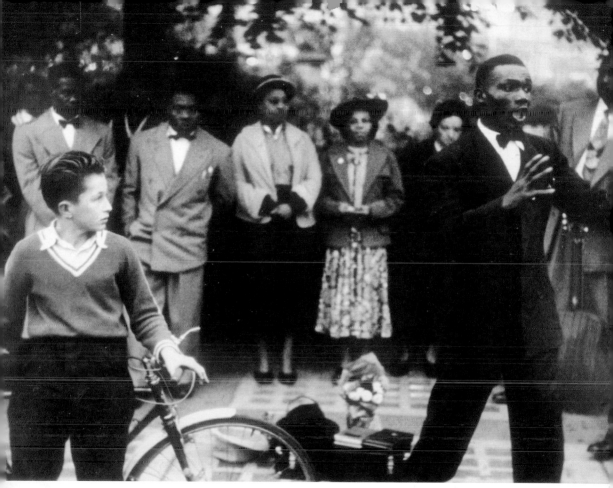

West Indians use music to back up their gospel service in the streets of Brixton, London, 1955.

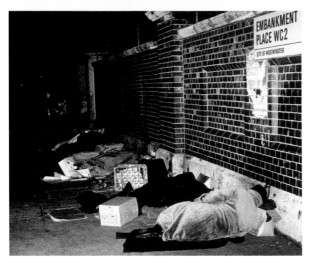

ABOVE: Homeless people sleep in Embankment Place, central London, in a former 'dormitory' area. They are disturbed at 4 am by street cleaning carts and are dispersed earlier during the tourist season, 1970s.

RIGHT: Four girls with their dolls, sitting on the kerb in a Balham street, south west London, 1960s.

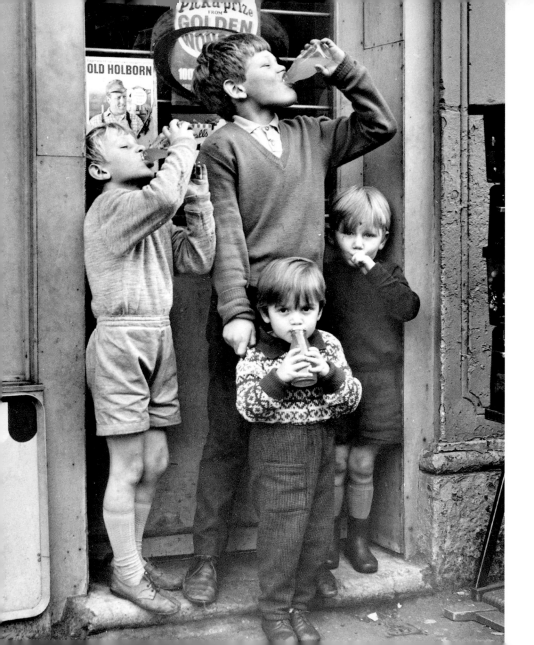

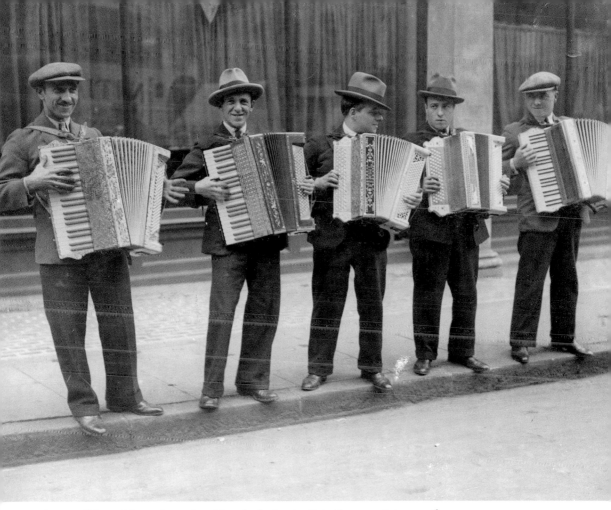

ABOVE: Selected from the ranks of London's street artists, these musicians perform on the kerb for a BBC broadcast, 1931.

LEFT: Four boys on the doorstep of a sweet shop with bottled drinks in Balham.

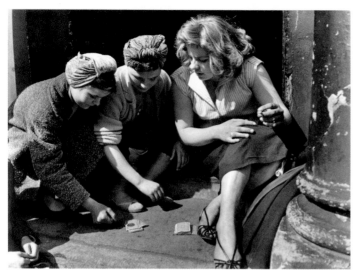

ABOVE: Three young women play cards on the doorstep on Southam Street, London, 1956.

RIGHT: Young people hang around Piccadilly Circus in London, 1960s.

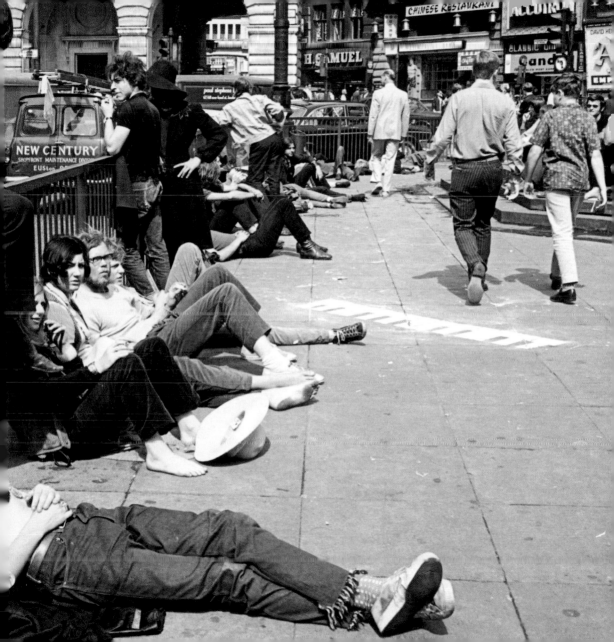

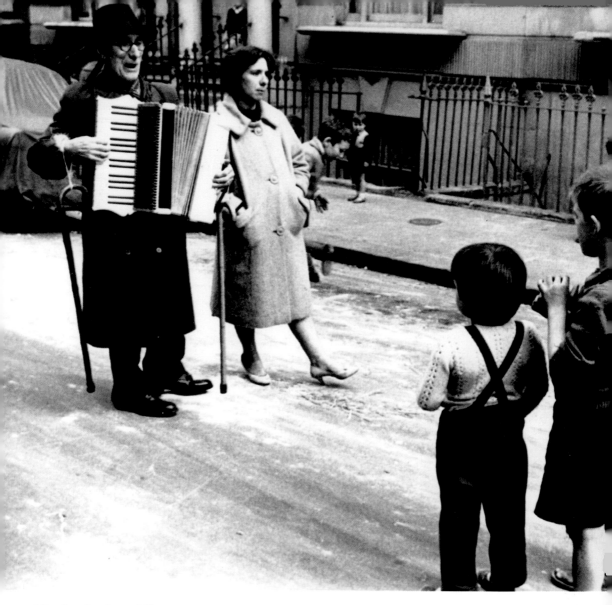

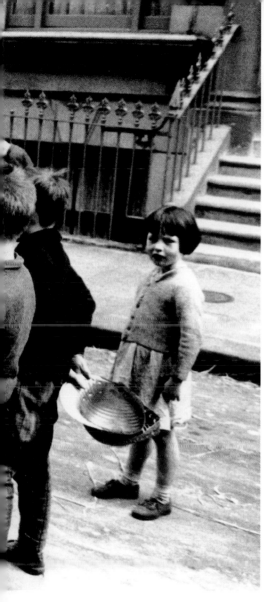

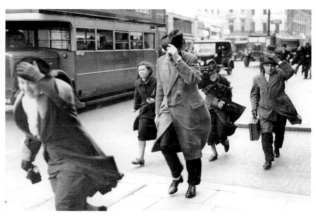

ABOVE: Pedestrians hold their hats in stormy weather, 29 January 1938.

LEFT: An elderly man plays the accordion before an audience of intrigued street children in St. Stephen's Gardens in W2. The man sings as he plays, and has two walking sticks tied to his hands by strings to support him when he's not playing, 1961.

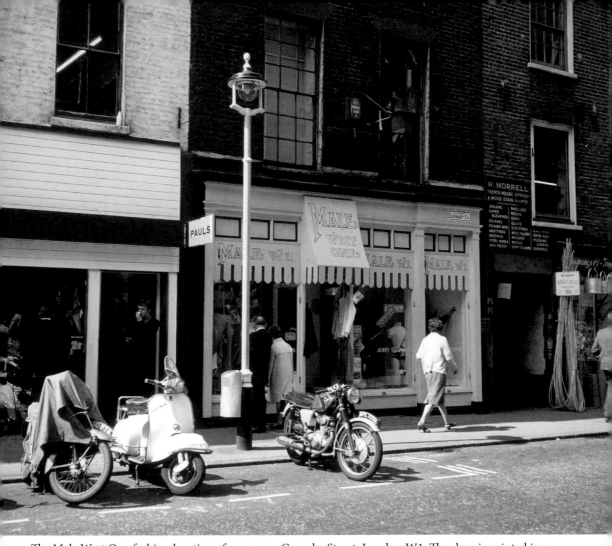

The Male West One fashion boutique for men on Carnaby Street, London W1. The shop is painted in a bright canary yellow colour, whereas upstairs looks dilapidated, 1960s.

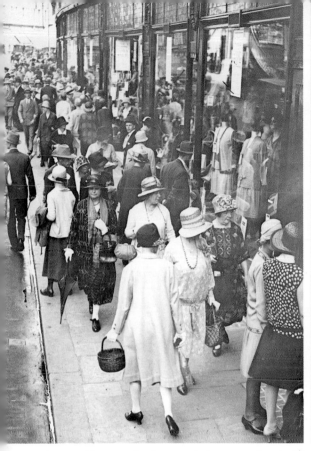

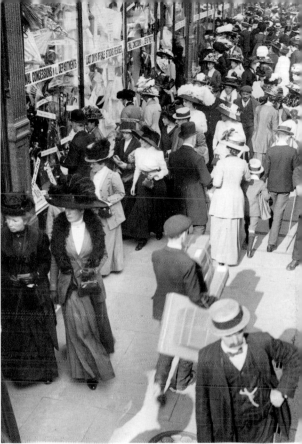

ABOVE: Shoppers in the crowded streets of central London, 1920s.

ABOVE RIGHT: London shoppers during the sales, 1908.

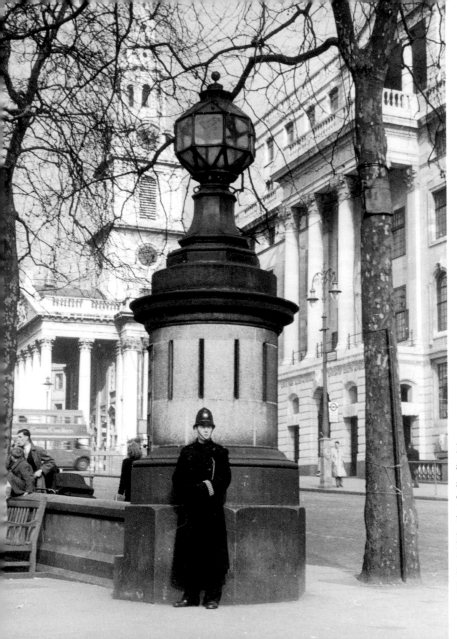

Police boxes once
adorned the East
and West corners of
Trafalgar Square and
were the smallest
police stations in
London. The lamps
at the top came from
HMS *Victory*.

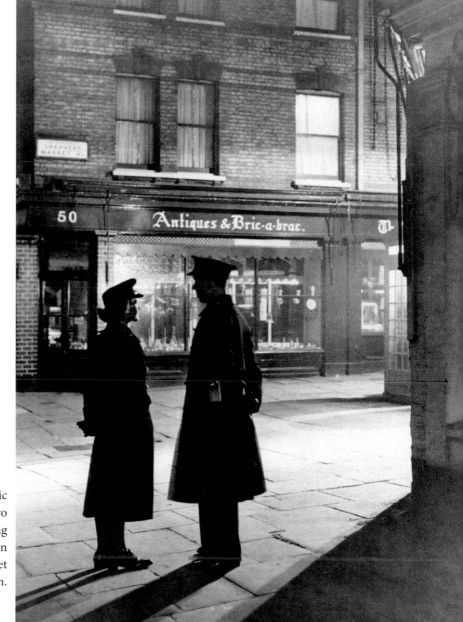

An atmospheric scene showing two police officers standing at a street corner on Shepherd's Market in London.

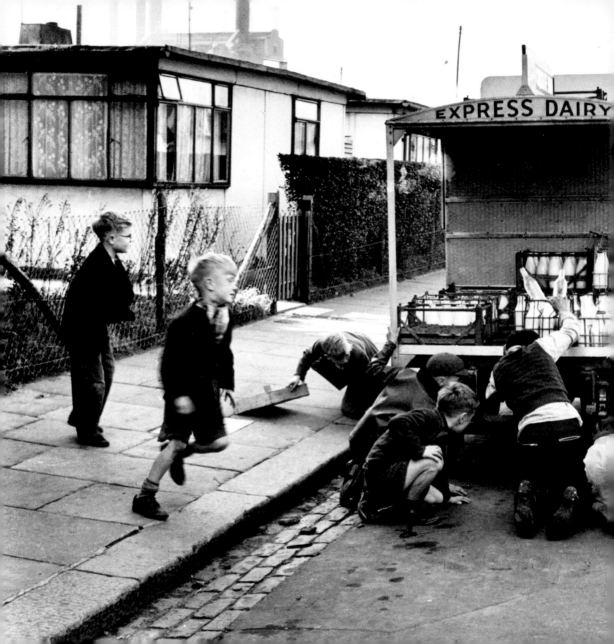

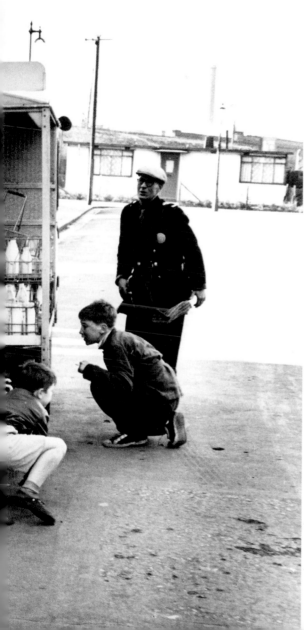

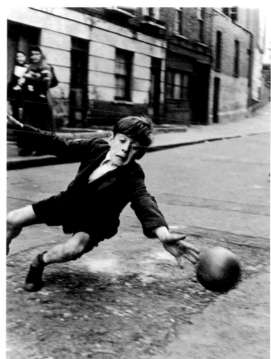

ABOVE: A boy throws himself into saving a goal during a game of street football on Brindley Road, London.

LEFT: A milkman harassed by children as he delivers to 'prefabs' in Battersea, London, 1957.

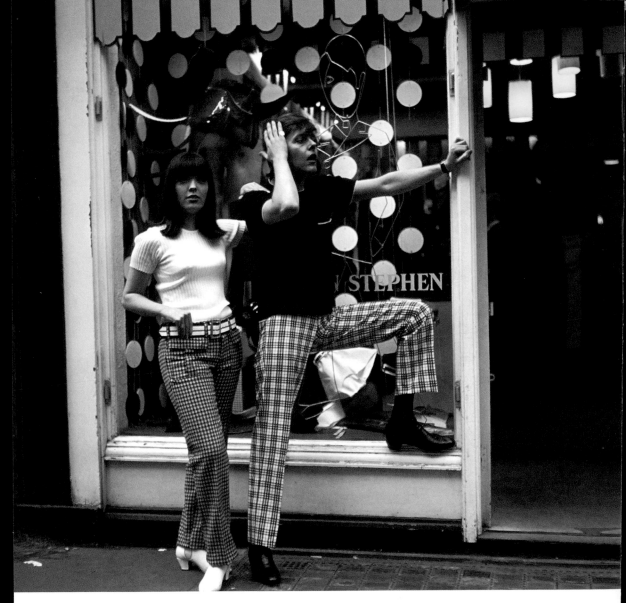

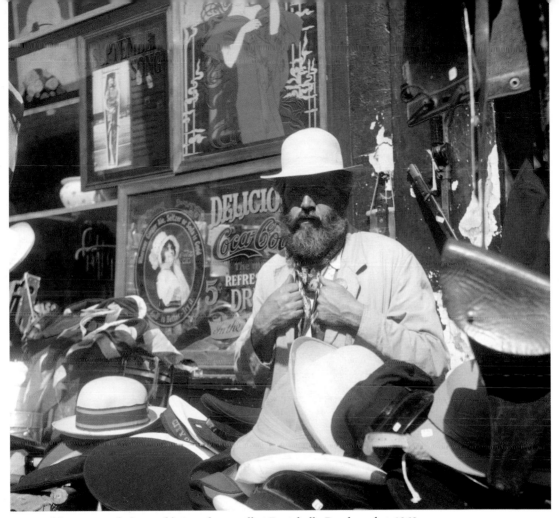

ABOVE: The owner of a hat and bric-a- brac stall at Portobello Road market, 1960s.

LEFT: A couple pose in the latest fashions outside a London boutique, 1960s.

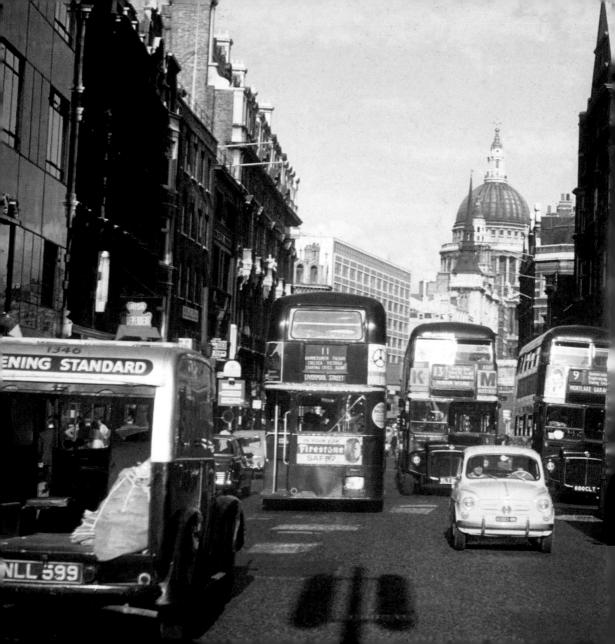

The red double decker bus is synonymous with London, and an inexpensive means of seeing the city.

LONDON TRANSPORT

THERE CANNOT be many places around the world where the public transport system is so recognisably part of that city's identity. New York may have its yellow taxi, but London has its familiar, retro-shaped black cab, the iconic, red double-decker bus, not to mention the world's oldest underground rail network: the tube.

Londoners have a love and hate relationship with its public transport. When it works, it is the most gloriously efficient way of getting about town. Whizzing underneath the London streets on the tube from station to station at quiet points during the day is a pleasure; standing squeezed in with fellow commuters, sardine-like, in a Central Line carriage during rush hour while the driver apologises because the train is 'held at a signal' or worse, is quite the opposite. Nevertheless, the city takes pride in its underground. The famous logo, the red roundel and blue bar, first designed in 1933 for London Transport and still going strong today for the re-branded Transport for London, is intrinsically emblematic of London. The equally famous London tube map drawn by Harry Beck has helped tube users navigate a spidery web stretching out beyond the city itself into the outer suburbs of Essex, Buckinghamshire and Middlesex, ferrying commuters in and out on a daily basis, year after year. It was the vision of Frank Pick, London Transport's managing director in the first half of the 20th century, who developed a concept of 'total design' for London's transport system, engaging leading artists, designers and architects to create a consistent look that brought a modern, cohesive style across the network and included its posters, leaflets and stations, right down to seat upholstery. Even the original font— Johnston typeface—is still used in its signage, proving that good design lasts beyond current trends.

Sitting on the top deck of a London bus—ideally nabbing the seats at the front—brings out the enthusiastic child in all but the most jaded of London residents. From a high vantage point, you are privy to the elaborately carved and embellished upper storeys of buildings, you can spot blue plaques commemorating the presence of notables at random houses along the route and get a sense of how this vast city is stitched together, impossible when travelling underground.

Horse-drawn 'omnibuses' were first introduced to London by George Shillibeer in 1829 and would be a defining image of the increasingly chaotic 19th-century London thoroughfares until the introduction of motor-buses by the London General Omnibus Company (LGOC) in 1904. A year later, the confusingly similar London Motor Omnibus Company pioneered the Vanguard bus introducing

route numbers (many still followed today) as well as new routes. Other companies sprang up in competition but were eventually absorbed into the LGOC, which in time came under the control of the Underground Electric Railways Company. In 1911, the LGOC ran its last horse-drawn bus service, but within three years, many of its 'B' type motor-buses would be requisitioned for war use, both at home and on the Western Front, earning them the name of Old Bill after the famous war-time cartoon character. Such was the reduction in available transport stock in the capital towards the end of the war, Londoners were ferried unceremoniously about in open-top lorries. Today, despite the presence of bus lanes throughout the city and dot matrix signs advising bus queues of estimated arrival times, road works, volume of traffic and inevitable accidents occasionally conspire to make buses a frustrating mode of transport for those in a hurry, but a gratifying one for those with the leisure to enjoy the journey.

In contrast, a taxicab is a swift and reliable, if expensive, alternative (though not immune either to the vagaries of London's roads). London's cabbies are the *crème de la crème*; studying 'the Knowledge' of London's tangled, near-infinite system of streets, for at least three years before they gain their licence.

London has had taxis for more than 300 years, first appearing in the 17th century and gradually evolving into horse-drawn hansom (two-wheeled) or 'growler' (four-wheeled) carriages. Motor cabs were introduced in small quantities at the end of the 19th century; the first were electric-powered and known as 'hummingbirds' due to the noise they made. By 1906, petrol cabs were plying their trade on London's roads, regulated by the Public Carriage Office, which ruled London cabs must be able to turn within a circle of no more than 25 feet. The introduction of taximeters in 1907 meant a standardisation of fare calculation (based on a combination of time and distance) and also led to the adoption of the name taxicab, simply shortened later to taxi.

Driving in London is not for the faint-hearted; or for the impatient but some of the pictures in this chapter will prove that it was ever thus. Throughout history, traffic jams have been one of the city's major problems. The introduction of the first section of the Metropolitan Railway in January 1863 'brought instant and sensible relief to a most appalling street congestion'. But it was not to last. It was recorded in 1938 that traffic speeds in central London had dropped below those of the horse-drawn era. A decade later, in *The Wonderful Story of London*, edited by B. Webster Smith and published in 1949, the comments on London's roads sound all too familiar to contemporary ears: 'Londoners of Elizabethan days complained bitterly of the congestion of their streets. No doubt their ancestors complained with

equal virulence. Londoners of today are still complaining. The problem is yet unsolved. It grows rather than decreases in intensity.'

Since the public transport boom in the years leading up to the First World War, there have certainly been repeated attempts to ease, control and corral traffic and ensure the safety of pedestrians—traffic lights, central London car parking proposals, the introduction of parking meters (the first were installed in Grosvenor Square in 1958) and, in recent years, a congestion charge for motorists wanting to pass through central London during the week and the introduction of cycle superhighways to encourage more commuters to take to two wheels. Zebra crossings were introduced in 1951 and one particular in north west London passed into pop culture legend when The Beatles chose to walk over and were photographed doing so; the photograph was later used on the cover of their 1969 album, 'Abbey Road'.

Getting around the city is only part of the London experience; arriving or departing is another. London's railway stations have a rich history all their own and are among some of the architectural treasures of the city. From St. Pancras with its romantic, neo-Gothic red brick, and Great Northern Hotel to Waterloo and its Victory Arch in the Imperial Baroque style, London's stations both hum with the bustle and activity of the present, but also echo with the ghosts of past travellers. Generations of Londoners have passed through its stations and ridden its tube and buses, moving through the metropolis as it moves them along on their daily lives.

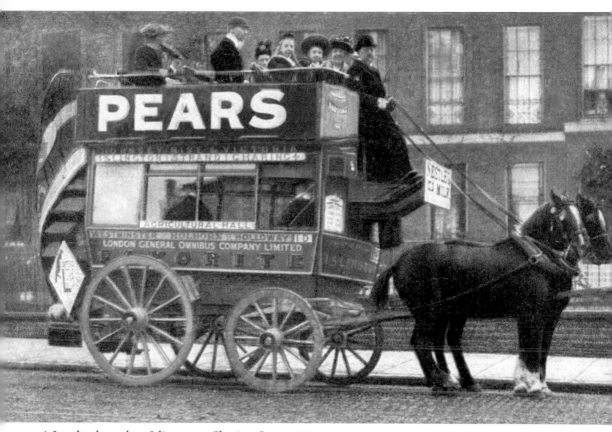

A London horse bus: Islington to Charing Cross, 1905.

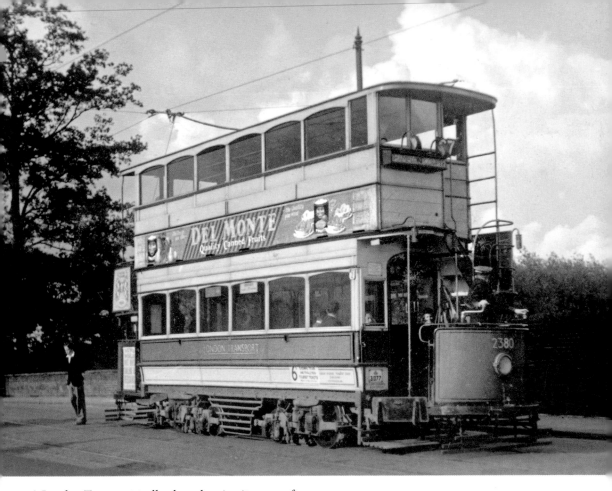

A London Transport trolley bus, drawing its power from
overhead lines, serves Hampton Court.

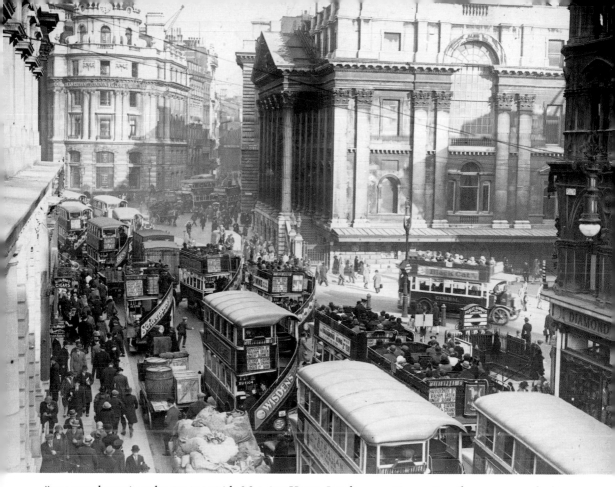

Seventeen buses jam the street outside Mansion House, London…not to mention the wagons, parked or moving. Quicker to take the underground…

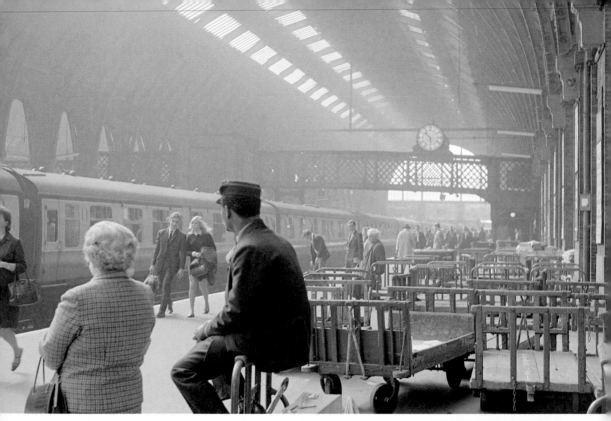

ABOVE: A platform attendant perches on a luggage trolley as he waits to help a passenger onto a train, 1960s.

RIGHT: The hustle and bustle of Oxford Circus, central London, mid 1960s.

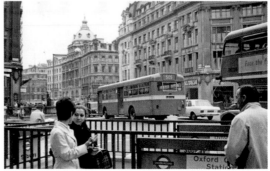

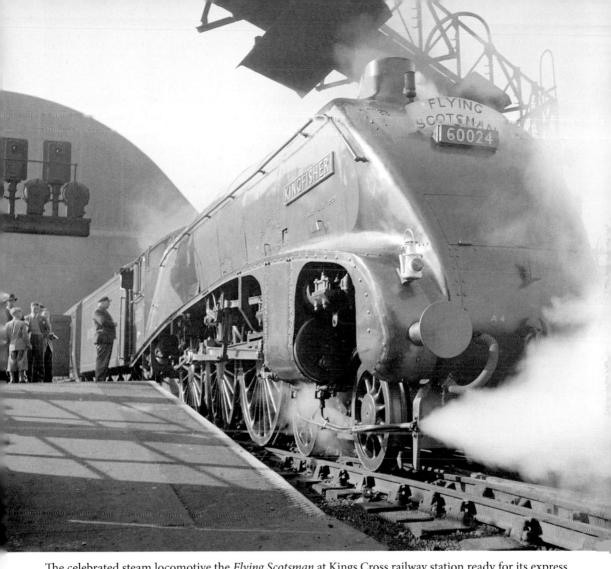

The celebrated steam locomotive the *Flying Scotsman* at Kings Cross railway station ready for its express service up the east coast of the country to Edinburgh – a sight to behold.

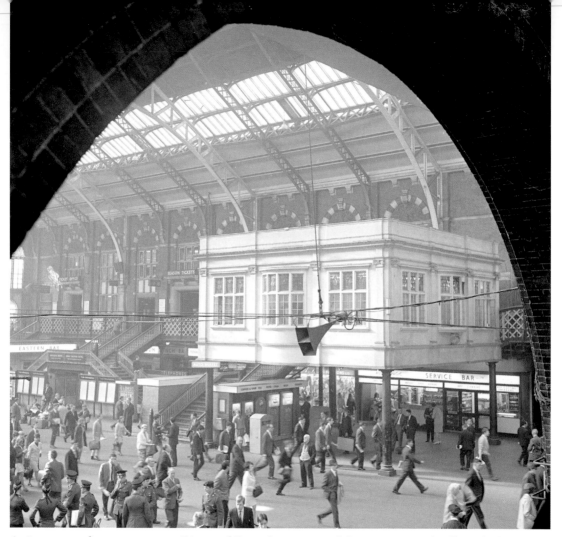

A view across a busy concourse at Liverpool Street Station toward the stationmaster's office, which is elevated on stilts, 1960s.

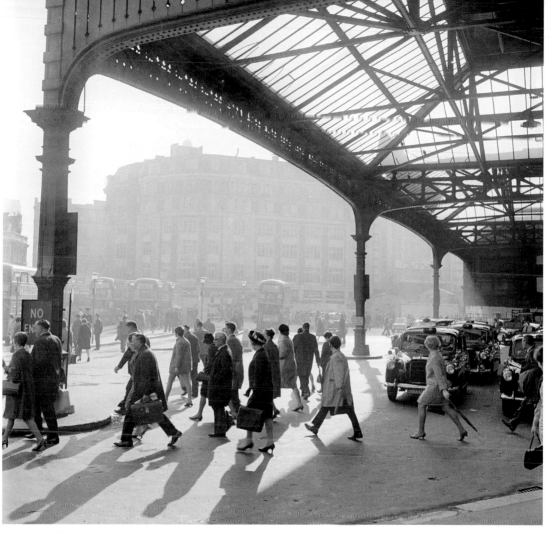

Passengers leave Victoria Station; a hive of activity goes on around them, with double decker buses parked in front of the station and taxis waiting beneath the forecourt canopy, 1960s.

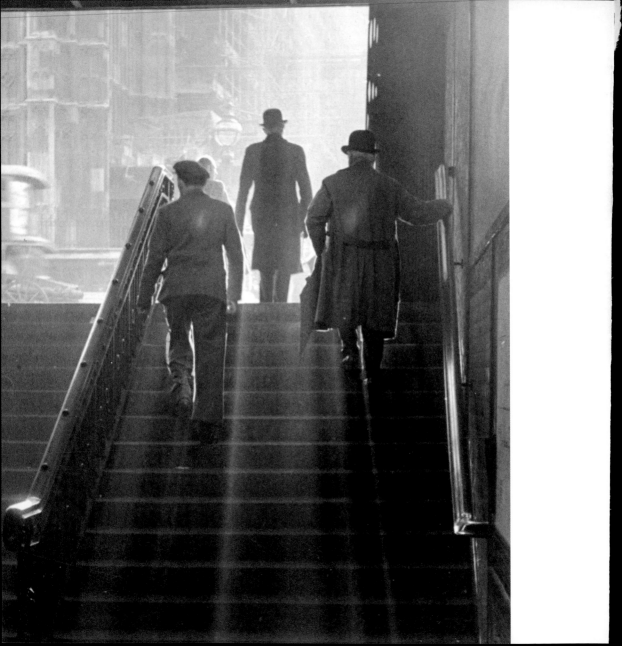

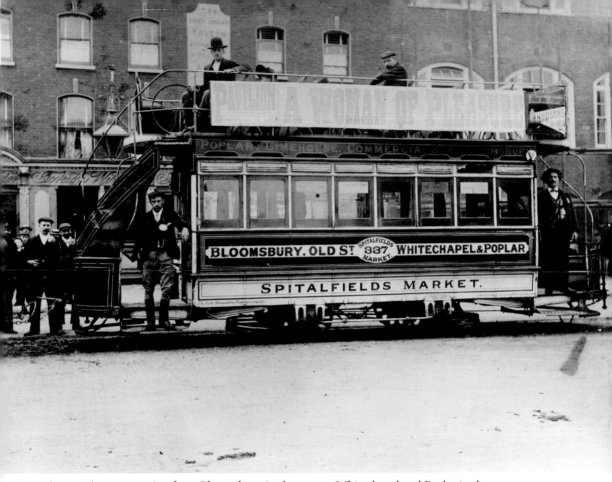

ABOVE: A tram running from Bloomsbury in the west to Whitechapel and Poplar in the east by way of Spitalfields market, 1907.

LEFT: Commuters emerge into sunlight as they climb the steep steps leading out of Westminster underground station.

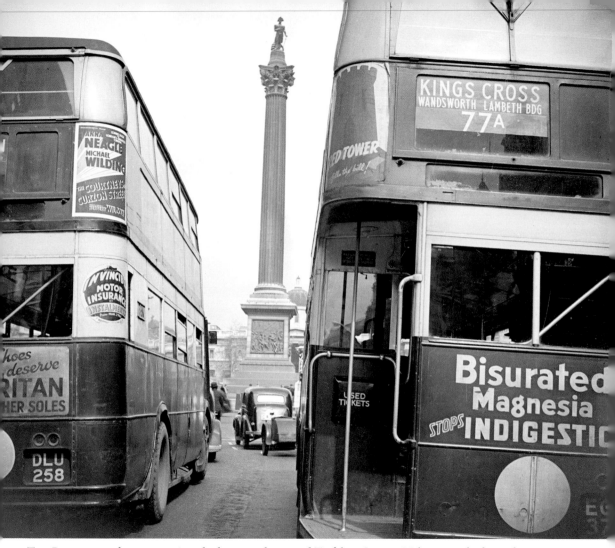

Two Routemaster buses negotiate the busy roads around Trafalgar Square. Nelson, perched atop his column, surveys the scene from his lofty vantage point.

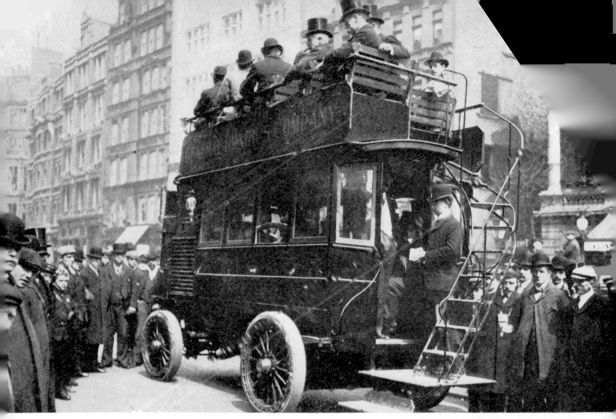

ABOVE: A motor omnibus causes considerable interest on a London street in 1903.

RIGHT: A horse drawn omnibus from around the turn of the century, servicing the West Kilburn to London Bridge route.

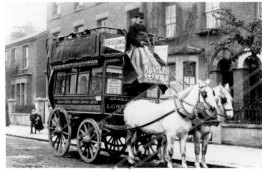

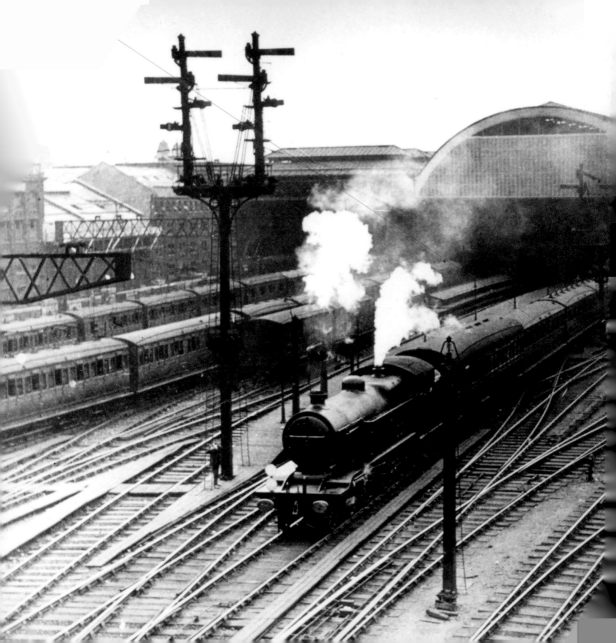

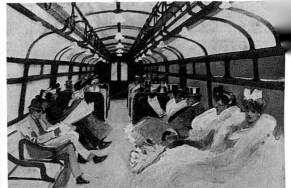

ABOVE: Beautifully dressed passengers travel on the underground in 1910 as depicted on this postcard. The card states: 'The Bakerloo & Piccadilly Tubes afford the maximum of speed, safety, comfort and convenience in all weathers'.

LEFT: Steam trains leave platforms 9 and 10 of London Bridge station. Passenger carriages can be seen on the left and cargo trucks on the right.

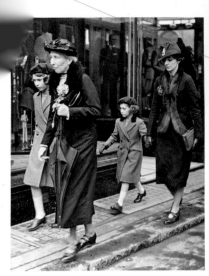

ABOVE: The two princesses leaving the station accompanied by Lady Helen Graham and their nurse.

RIGHT: A much publicised first trip on the London Underground for Princesses Elizabeth (later Queen Elizabeth II) and Margaret Rose, who made the journey on a District Line train from St. James's Park station with their governess on 15 May 1939.

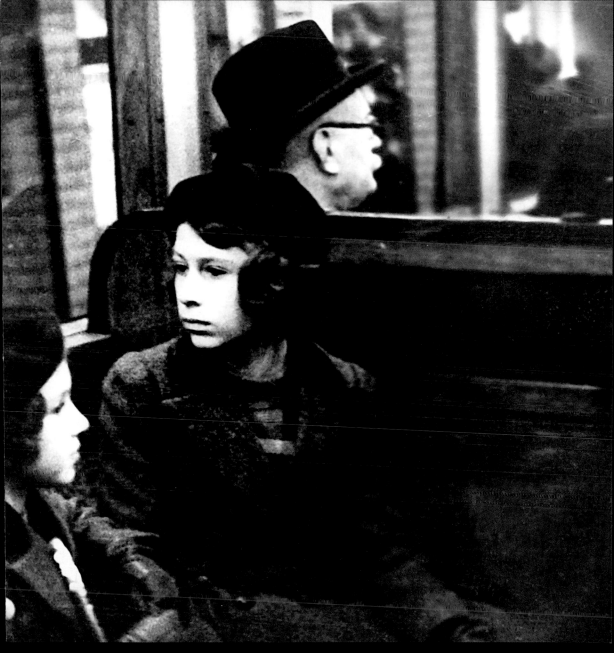

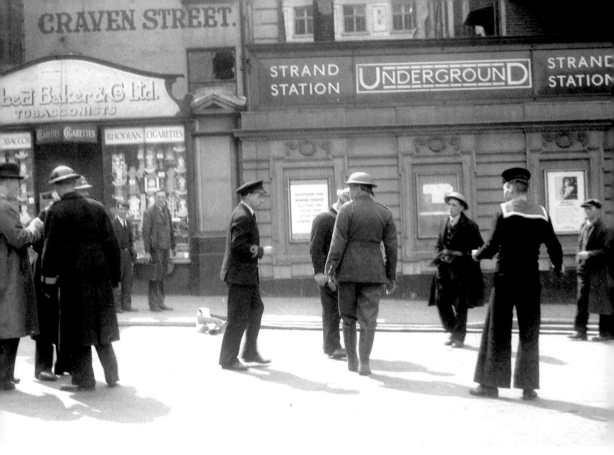

Outside the Strand Underground station during the Second World War, when it was used to shelter Londoners from air raids. Later known as Aldwych station, it had comparatively low passenger numbers since it first opened in 1907. Some of its running tunnels were used to shelter artworks from public museums and galleries during the war. It closed in 1994, but remains a popular location for film and television shoots.

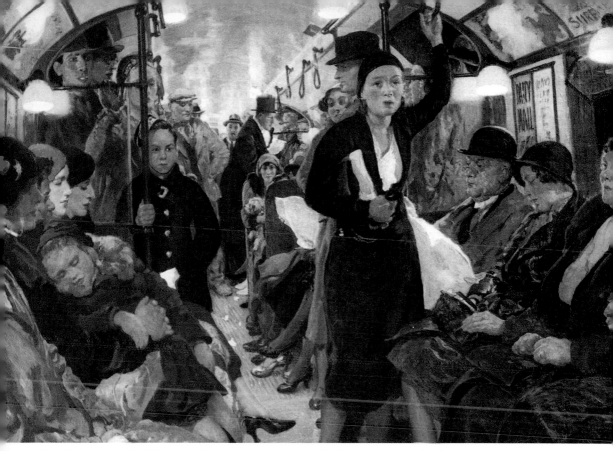

The Underground by T C Dugdale. When straps were added to underground railway carriages in the early 1900s, there was an outcry among travellers who felt that having to stand for any distance was unfair.

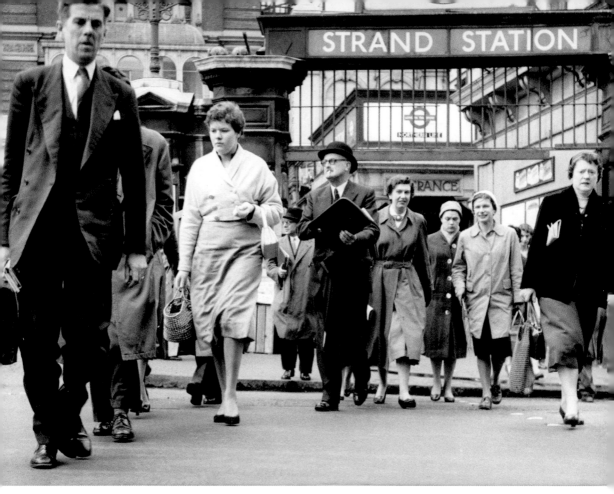

Commuters exit the Strand underground station to begin their day in the city centre, 1950s.

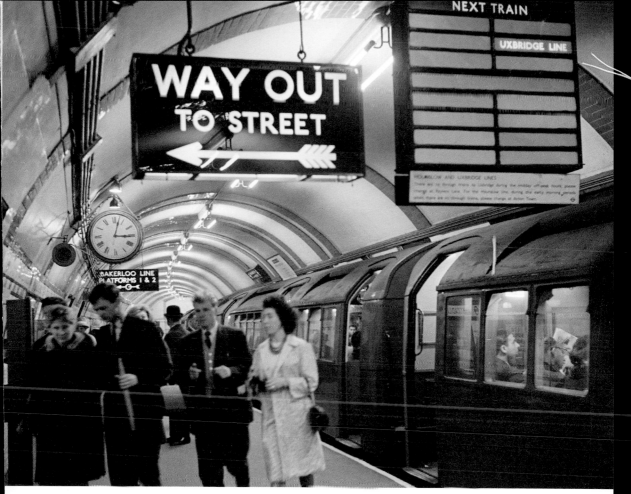

Passengers exit a Bakerloo line train at Piccadilly Circus, 1960s. Little has changed on some platforms since this photograph was taken.

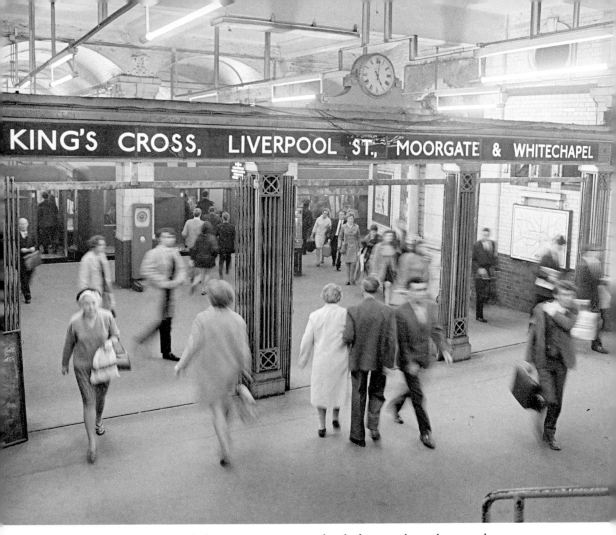

ABOVE: Passengers walk through the entrance gate toward a platform on the underground network inside Baker Street station.

RIGHT: A young couple share a private moment at Bond Street tube station.

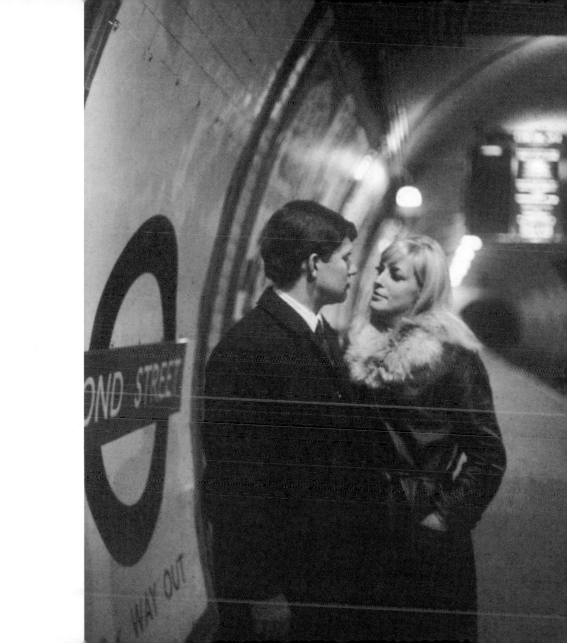

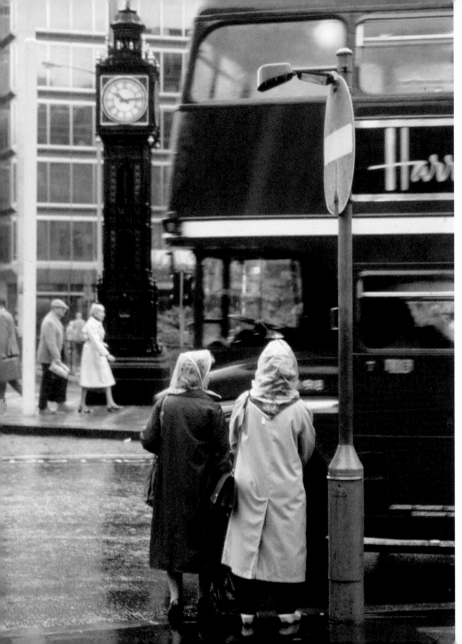

Come rain or shine,
a London bus
leaves Victoria on a
drizzly day.

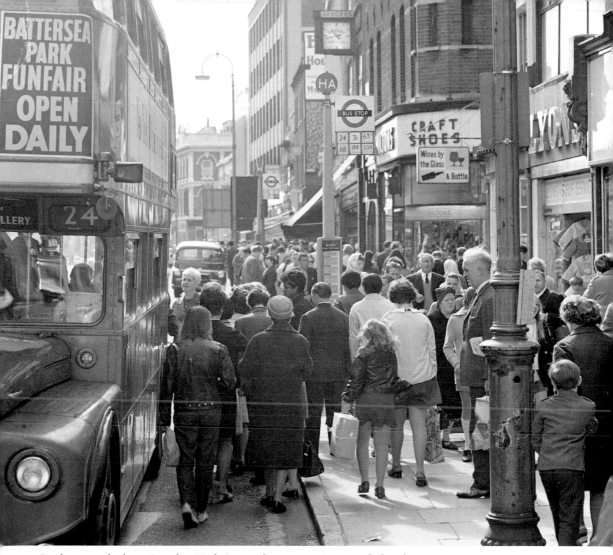

Looking north along Camden High Street, the pavement is crowded with pedestrians milling onto the road and into the path of traffic.

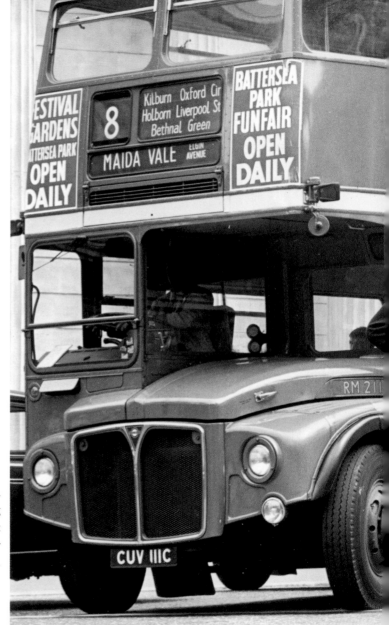

A policeman keeps his eye on a crowd of young sightseers, keeping them on the pavement and well out of the path of the No. 8 Routemaster bus to Maida Vale, London.

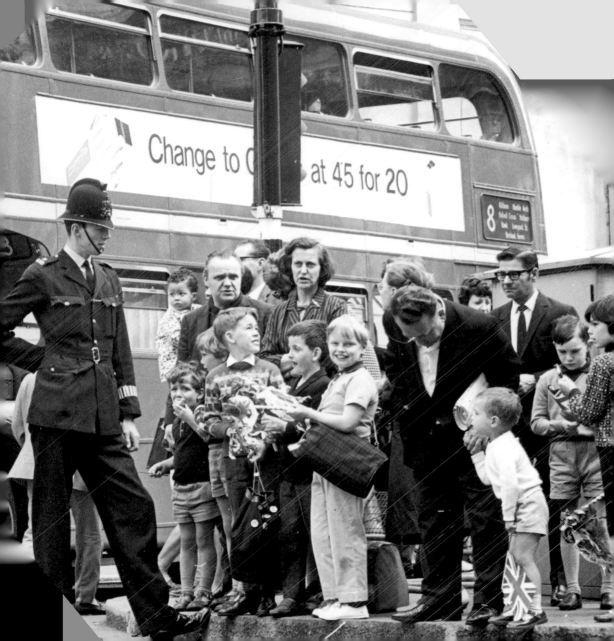

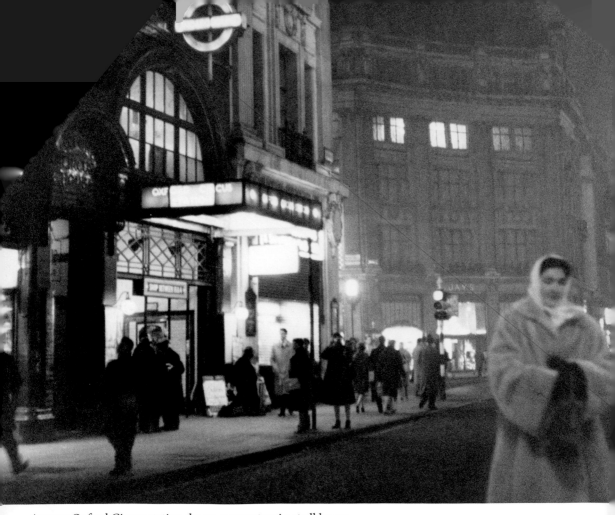

ABOVE: Oxford Circus station draws commuters in at all hours.

Right: A view through the traceried entrance at Waterloo Station to the taxi rank beyond, 1960s.

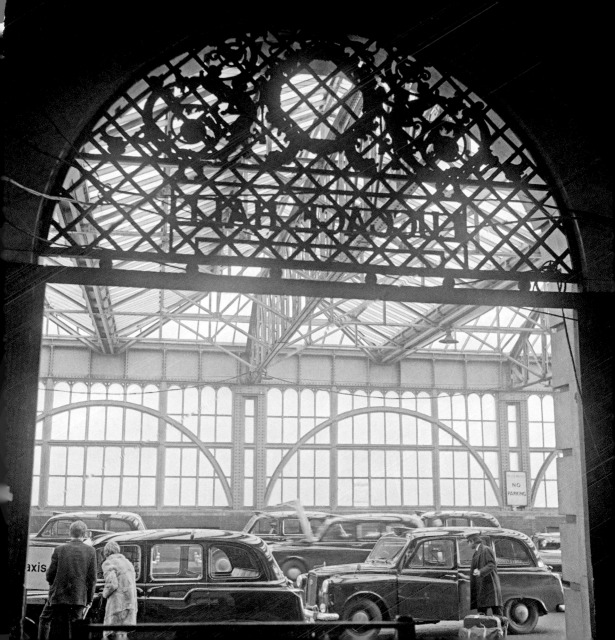

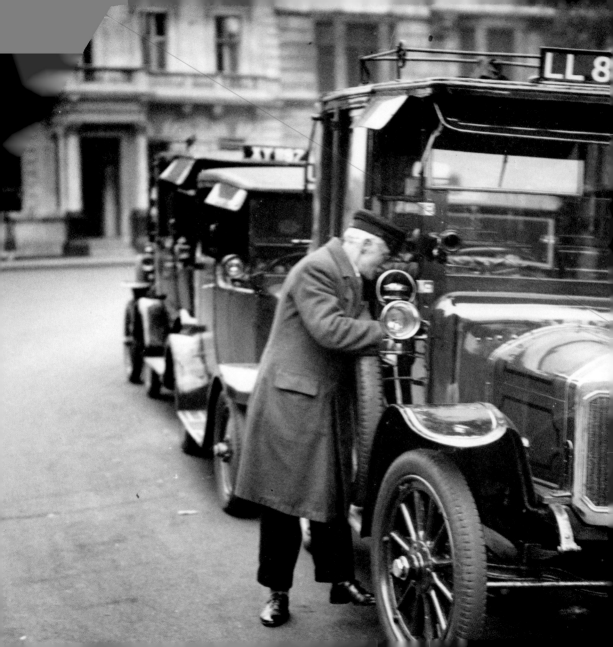

A taxicab driver with his
older style vehicle, at the
front of a taxi rank in a
London square, 1931.

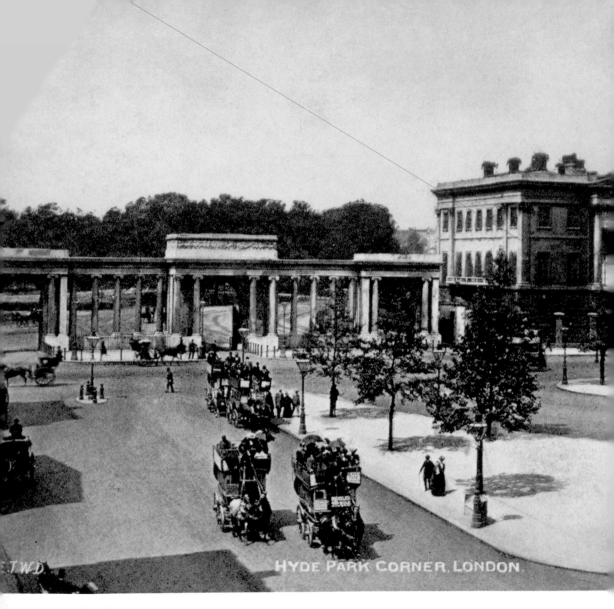

HYDE PARK CORNER, LONDON.

TWD.

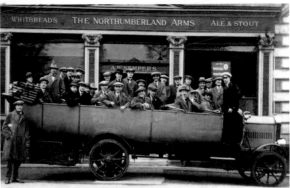

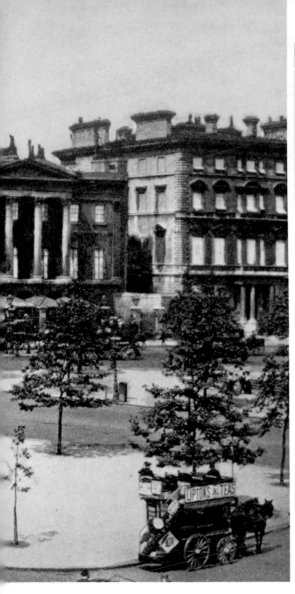

ABOVE: The immensely popular 1921 Charabanc bus outside the Northumberland Arms on Tottenham Court Road.

LEFT: Hyde Park Corner, 1900, is barely recognisable today but for the architecture of the buildings. Today this tranquil scene has been replaced by a busy roundabout.

This mini, with its 1275 cc engine and the amusing number plate 'JOB 999E', was specially adapted for police duties, ideal for traffic control in congested areas, 1960s.

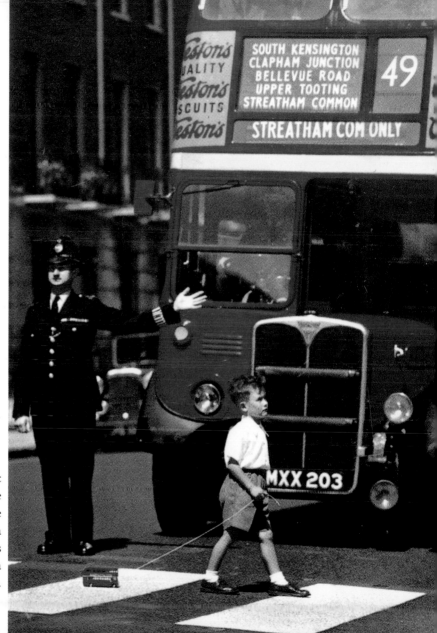

A police officer on traffic duty holds back the flow of vehicles while a young boy, pulling a toy London bus, makes his way across the zebra crossing, *c.* 1960s.

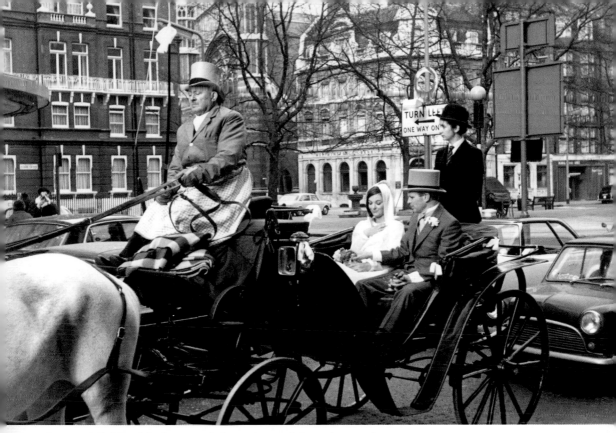

ABOVE: A fashionable, just-married couple travel through central London in a horse-drawn carriage in the 1960s. The bride is wearing a snood-style veil and the groom is in top hat and tails.

LEFT: The magnificent construction of St Pancras station is plain to see from this elevated view.

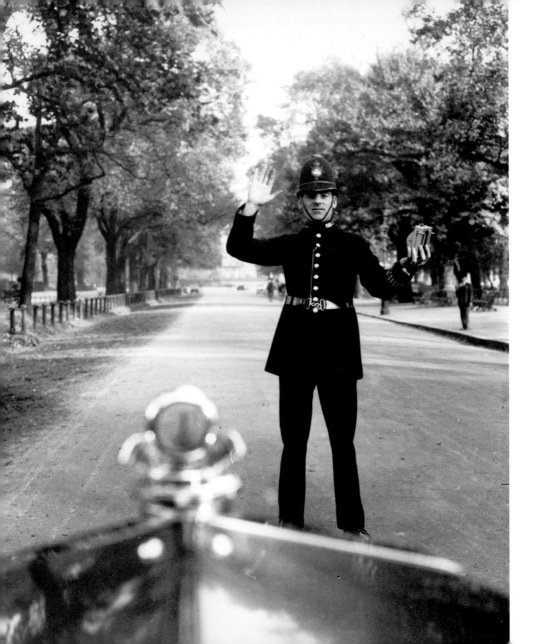

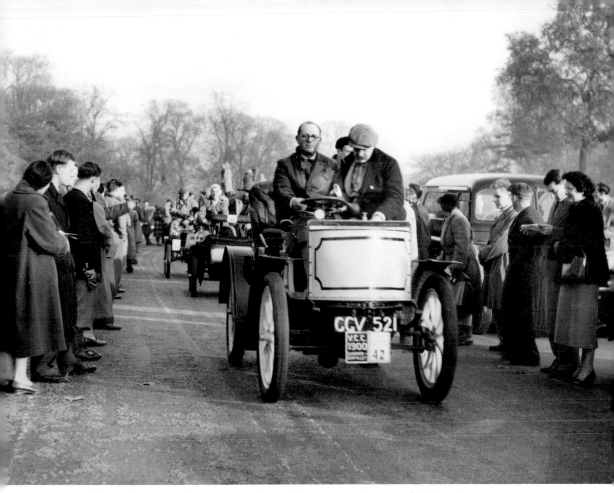

ABOVE: The London to Brighton Veteran Car Rally is an annual event, which begins at sunrise in Hyde Park.

LEFT: A police officer holds up his right hand to stop a motorist. He is holding a small machine in his left hand, possibly used for measuring speed of travel, 1920s.

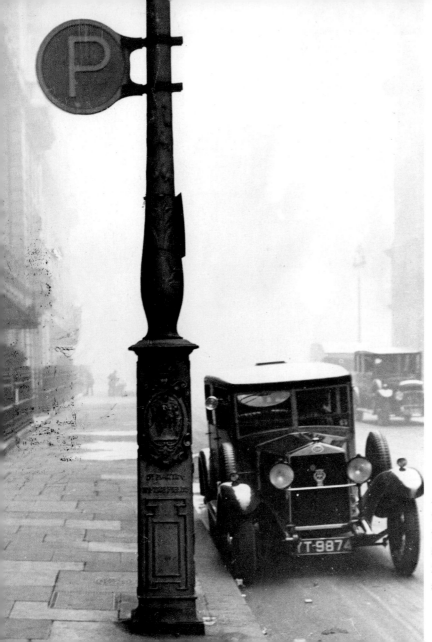

A new road sign indicates that motorists may park their cars in the adjoining space. Compared to 21st-century streets, this appears almost deserted.

An eagle-eyed
traffic warden about
to put a ticket on
someone's car, 1960s.

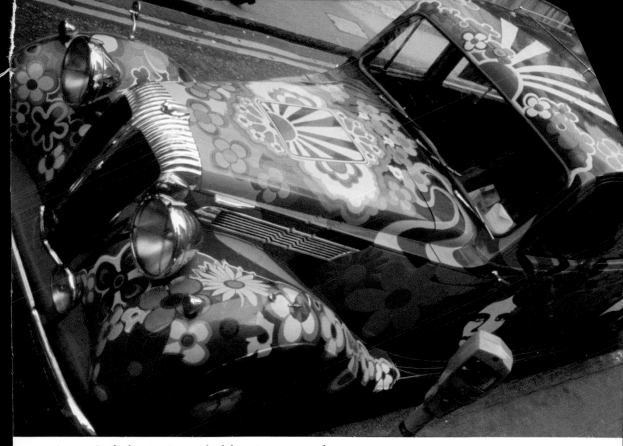

ABOVE: In the late 1960s, psychedelic art was a new phenomenon.

LEFT: The glamour of travel by air! A Bentley is parked on the runway in front of the terminal building at Heathrow Airport with the propellers of an aircraft visible in the foreground.

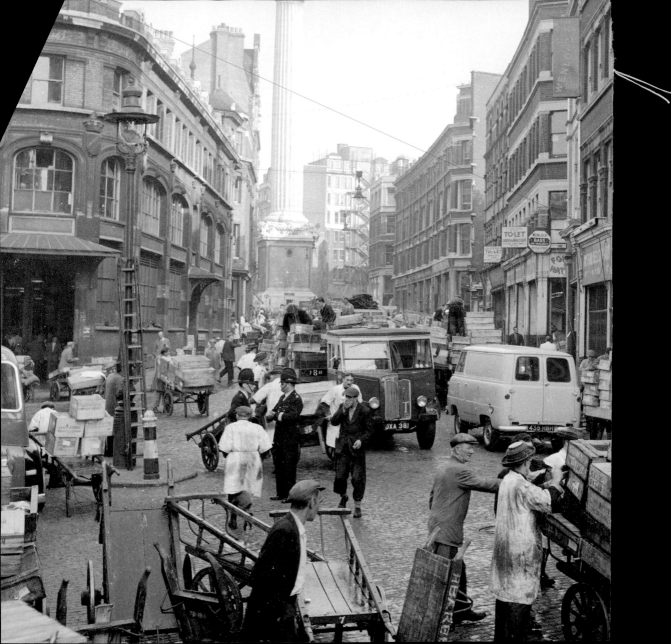

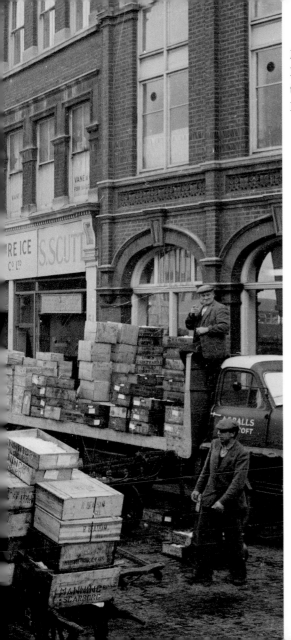

Market porters at the corner of Botolph Lane and Lower Thames Street in the City of London, busily transporting their boxes of fish by hand or on carts to Billingsgate fish market.

LONDON AT WORK

THE LEGEND (and favourite pantomime tale) of Dick Whittington, the

poor boy from Gloucester who came to London to seek fame and fortune with the help of his cat, is based on the real life of 14th century businessman, benefactor and Lord Mayor, Richard Whittington. In the story, Dick's initial optimism is dashed as he faces hardship and failure and, deciding to give up, trudges out of London up Highgate Hill before he hears the call of the Bow Bells pulling him back and filling him with a determination to try once more. The real life Dick was actually the son of a gentleman and made his fortune trading in cloth and money lending; he was personally acquainted with three kings. During his lifetime, and after his death, he paid or left endowments to finance the rebuilding of the Guildhall and Newgate Prison, a hospital ward for unmarried mothers, almshouses and drinking fountains around the city, thus ensuring his name would be enshrined forever as one of London's most famous adopted sons. Travel to Archway tube station today and walk up Highgate Hill and by the hulking hospital, which was named after him; there is also a small statue of a cat, commemorating his legendary feline companion.

The tale of Richard Whittington (real, or his imaginary alter-ego) stands as an exemplary case study of one of London's most successful job seekers. The streets may not quite be paved with gold in London, but over the centuries, millions have followed in his footsteps, drawn to London as the country's epicentre of trade, commerce and opportunity.

Once upon a time, London was something akin to a huge department store, divided up according to specific trades and areas of commerce. Haymarket, today lined with shops and theatres, was once a market of hay and straw. Cornhill in the City was a corn market but was later known for its second-hand clothes businesses, where it was said one might buy a garment which only hours before had been the spoils of a robbery. The occupations of Bread Street, Ironmonger Lane and Milk Street, also in the City, are self-explanatory. Poultry was home to poulterers who then dispatched fowls to the grisly-named Scalding Alley to be prepared for the dinner table. These earthy trades disappeared centuries ago; the historic street names the only clue to the City's past activities. Now smartly-suited financial traders and office workers populate these streets, though sadly, the quintessential City gent complete with bowler hat, once a familiar sight in the Square Mile, is now also long gone.

The city's wholesale markets left their central London locations comparatively recently. Covent

Garden's flower market was a picturesque destination for early risers until it was removed to Nine Elms, near Vauxhall, in 1966. Its piazza, based on the original 17th century design by Inigo Jones, was regenerated and today houses shops, restaurants and market stalls catering for tourists (and Londoners) who gravitate toward the area. Billingsgate fish market once swarmed with porters and traders around its building on Lower Thames Street. It relocated to Docklands in 1982. Spitalfields and Borough markets have reinvented themselves as markets for the discerning 21st-century London dweller. Borough is now known as the 'larder of London', but Spitalfields' fruit and vegetable stalls have been replaced by fashionable boutiques and upmarket chain restaurants. Smithfield meat market, between Farringdon and Barbican, remains true to its original purpose, and wholesale cut meat is still bought and sold from the building designed by Sir Horace Jones in the 1860s (he also designed Billingsgate and Leadenhall markets, as well as the iconic Tower Bridge).

Other London areas have maintained their speciality, too, though, in some cases, tenuously. Charing Cross Road is still known for its bookshops even if the number has dwindled over the years, Hatton Garden for its diamonds, and anyone in need of a guitar should visit Denmark Street near to Cambridge Circus. Commercial Street and surrounding areas of the East End have been known for textiles and clothing ever since the Huguenot weavers first inhabited Spitalfields. The arrival of the Jewish community and, later, the influx of Bangladeshi immigrants in the 1970s has ensured this tradition continues. At the luxury end of London's economy, the great auction houses of Sotheby's and Christie's in Mayfair have been in business since 1744 and 1766 respectively. Fortnum & Mason on Piccadilly is even older, established by a royal footman and his landlord in 1705.

Some occupations, both obsolete or still in existence, are characteristically 'London'—the London bobby, the newsvendor, the bus conductor, the flower seller, the London cabbie and the much-maligned traffic warden (or 'traffic enforcement officer' to use modern parlance). As London's population expanded and its boundaries spread further, demand for professional services grew. London was already the centre of the legal and banking professions and Peter Ackroyd, 'London's laureate', describes the late 19th-century city as, 'the progenitor of commerce, and the vehicle of credit, throughout the world'. But rapidly it was also becoming the leading centre of the retail industry and of entertainment, culture and journalism. London is the home of the BBC, which made its first broadcast from Alexandra Palace in North London in 1935. Fleet Street, known as 'the Street' by journalists, was home to national

newspapers until they moved out to Docklands in the '80s. Last century, thousands of printers and compositors were employed in Fleet Street with more printing firms in Long Acre, Covent Garden, but new technologies and the cheaper costs of printing overseas have made their roles extinct.

The advent of electric light in the city in the 1890s meant that work was no longer restricted to daylight hours and workers in the City soon travelled, on the growing public transport system, from the suburbs, to make London into what an Edwardian guidebook described as, 'a very city of clerks'. Waves of immigrants too have added yet more layers to the city's working landscape.

London's relentless growth has resulted in a self-perpetuating job market. Already wealthy upper classes employed servants, cooks and nannies for their children. But workers had wages to spend. They needed food, clothes, homes to live in and transportation. They wanted entertaining and pampering. And so, in turn, London's working population created openings for shop assistants, hairdressers, waiters, barmaids and musicians—one army of workers serving another in a perpetual circle of activity. Huge department stores such as Harrods and the pioneering Selfridges, opened by the maverick American retail magnate Harry Gordon Selfridge in 1909, catered for every imaginable whim and desire. They stand today as a testament to London's healthy economy as well as Londoners' ingrained weakness for shopping. Purveyors of less opulent goods still knew the importance of seducing shoppers and the busy and extravagant window displays of the 20th century, whether they belong to a butchers, grocers, sweet shops or drapers, stir up a nostalgia for a time when shops offered personal service and sent you away with your purchases neatly wrapped with string and brown paper.

London can be a treadmill for its workforce—incessant, tiring, draining. But there is also something vital and exhilarating about being part of its drive and energy. London's workers have, and always will be, its lifeblood.

Everything
for Rail, Road, or River.

Hampers, Flasks,
Luncheon Baskets,
Camp Equipment,
and Everything for the Open Air Life.

at SELFRIDGE'S
OXFORD STREET, LONDON, W.1.

The Children simply love
sweets from

SELFRIDGE'S

SELFRIDGE & C⁰ LTD OXFORD ST W.1.

LEFT: Selfridge's knew its customer, catering for 'the open air life', with the offer of hampers, flasks, luncheon baskets and camping equipment on sale in it's store.

RIGHT: Two children share a generous box of chocolates in this advertisement for Selfridge's confectionery department.

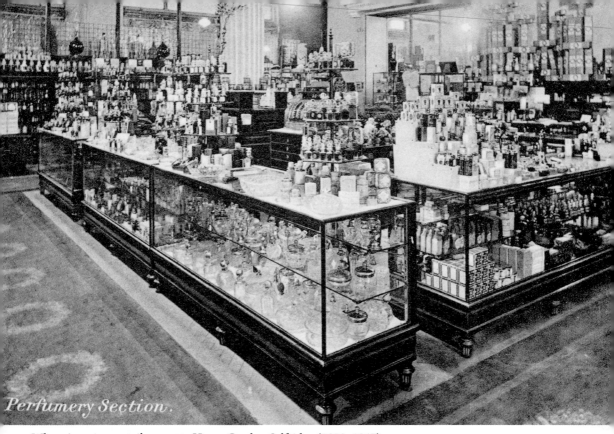

Perfumery Section.

When American retail magnate Harry Gordon Selfridge (1858–1947) founded his department store in Oxford Street in 1909, he created a complete shopping experience in which merchandise was placed on open display. The perfume section was placed front centre (still in evidence in every department store today).

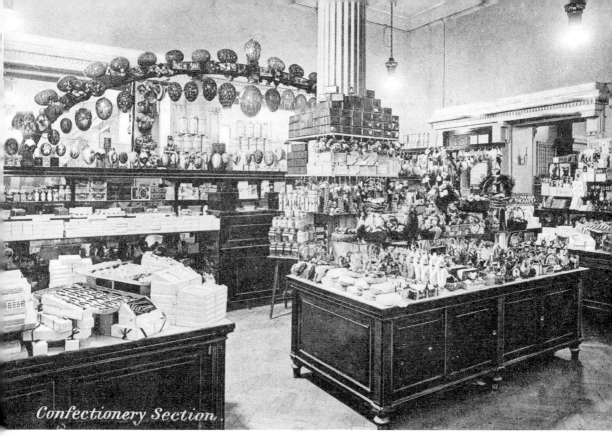

Confectionery Section

The confectionery section of Selfridge's & Co in Oxford Street was a
feast for the eyes and an enticement to make a purchase.

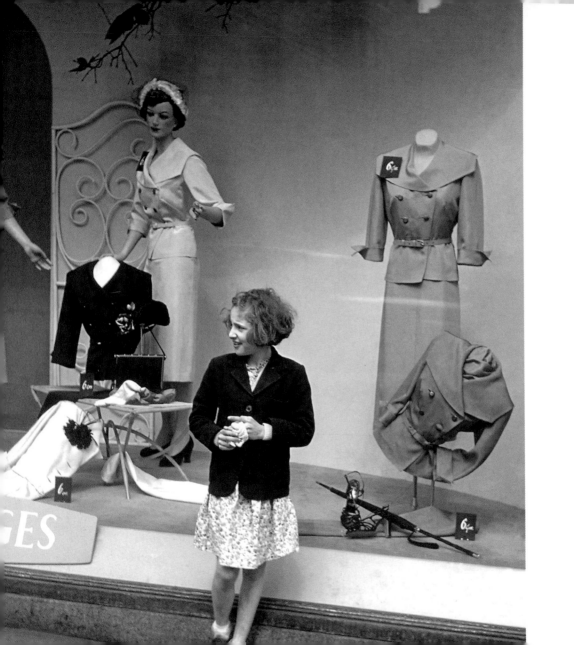

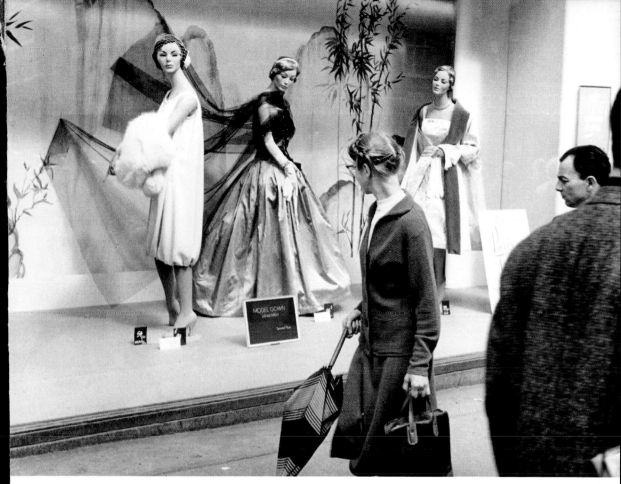

ABOVE: Pedestrians pass a window display at Selfridges. Three elegant mannequins model the latest Paris fashions.

LEFT: A young girl poses for her photograph outside Selfridges department store in central London, *c*.1952.

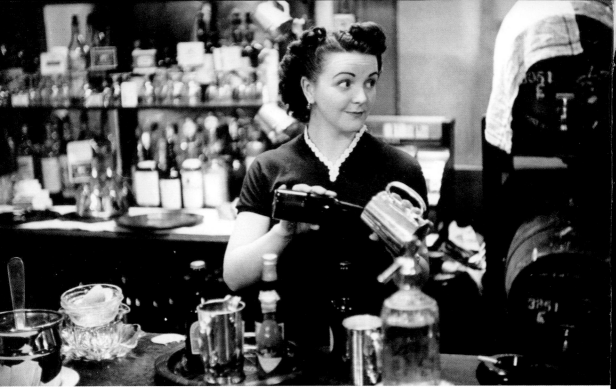

ABOVE: A young barmaid at work at a pub in Soho, pouring beer from a bottle into a tankard, early 1950s.

RIGHT: The Lion Brewery Company traded for almost 100 years, before it was absorbed into another larger brewing business in 1924. A pair of lions immortalised in the advertisement and company name were carved in stone and once stood outside the company building (later demolished). The lions were saved however, and one can now be seen at Twickenham stadium and the other at Westminster Bridge.

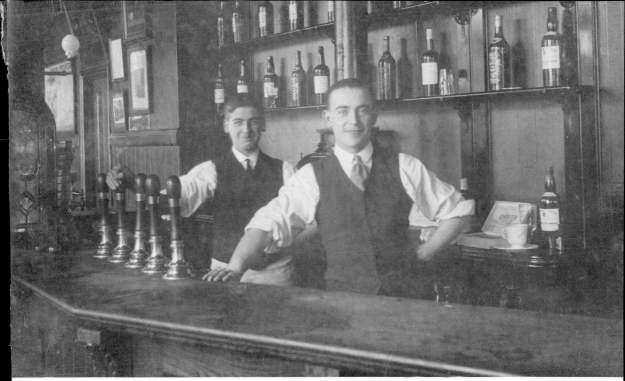

ABOVE: The barmen of The Wellington, Wood Green, 1910.

RIGHT: Arthur Lasenby Liberty opened his first store in London in 1975 selling luxury goods to a discerning clientele. The distinctive store trades today.

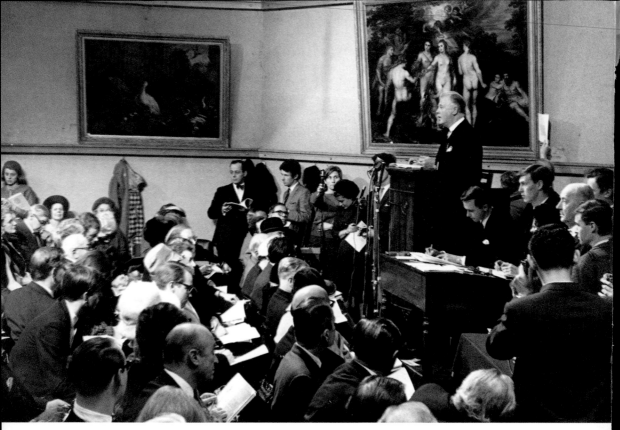

ABOVE: The sale of a Rubens' painting at Christie's auction house in London attracts significant interest. Christie's was the world's first fine art auction house, established in the 18th century.

RIGHT: Bidders pay rapt attention in a Sotheby's auction room, early 1960s.

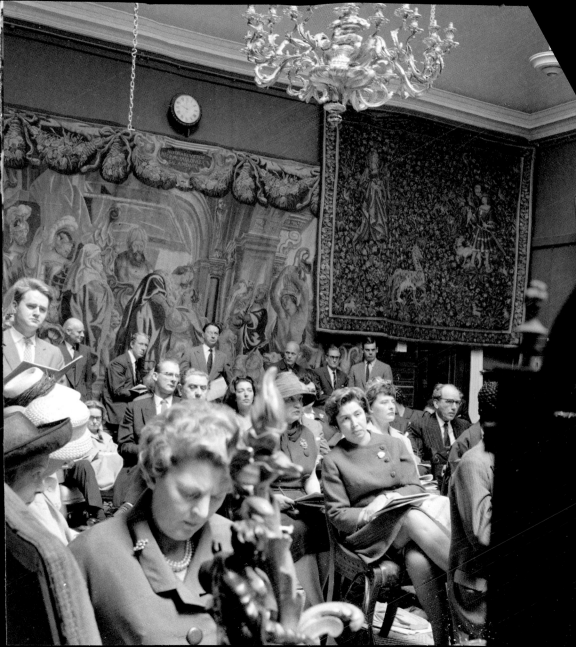

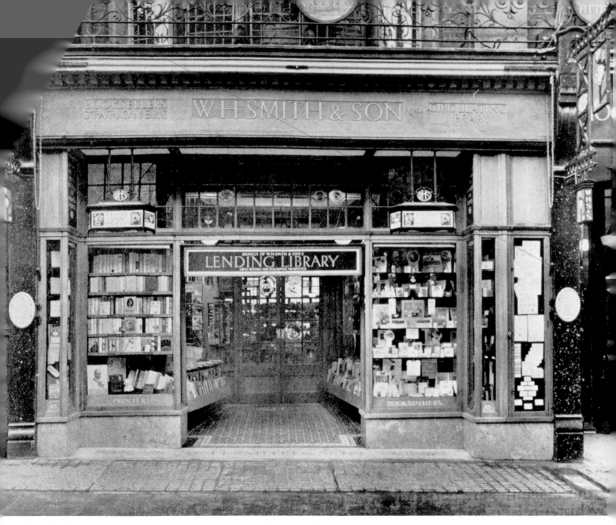

The W H Smith & Son bookshop and lending library in Wigmore Street, London.

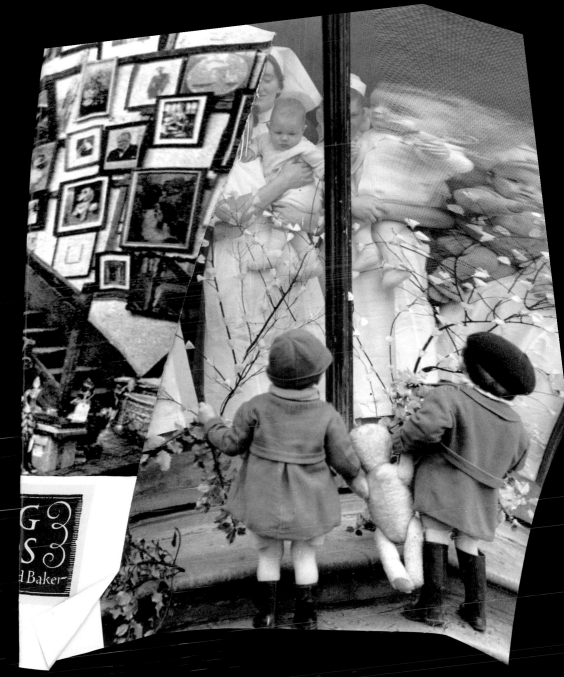

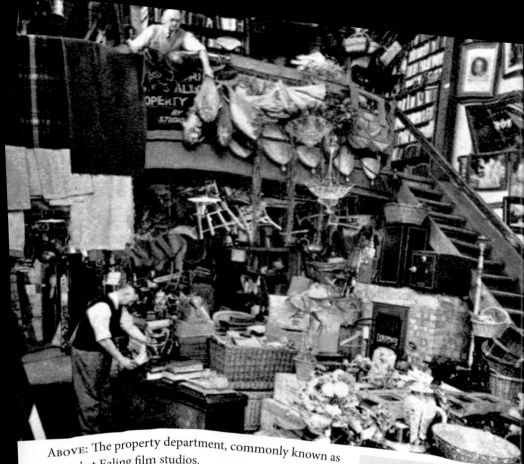

ABOVE: The property department, commonly known as 'props' at Ealing film studios.

RIGHT: Ealing Studios, Ealing.

At the Troxy cinema in Stepney uniformed staff have a tea break.

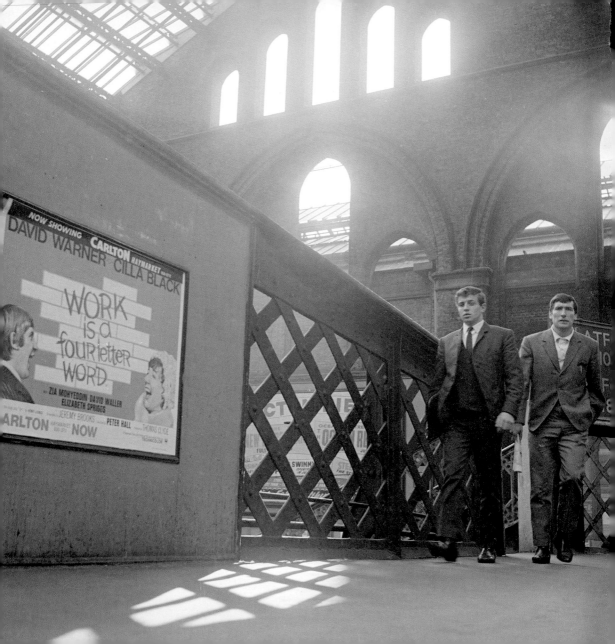

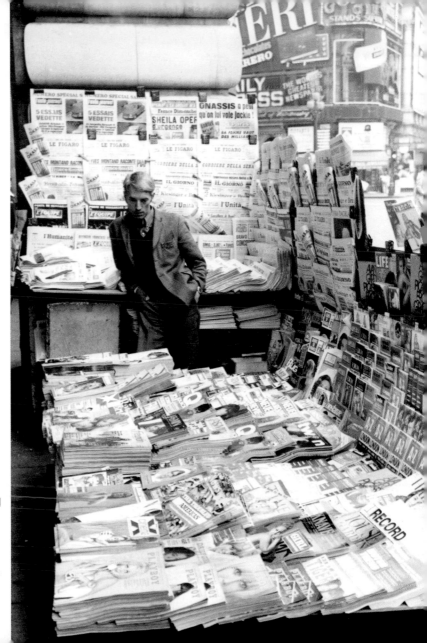

RIGHT: An open-air news vendor keeps an eye on his kiosk at Piccadilly Circus. He has a range of items on display, including A–Z books of London, *Playboy* magazine, *Jasmin*, *Life*, and several foreign language newspapers.

LEFT: Two men dressed for work walk along an elevated walkway above platform 10 at Liverpool Street station. In the foreground is a film poster advertising *Work Is a Four Letter Word*, 1970.

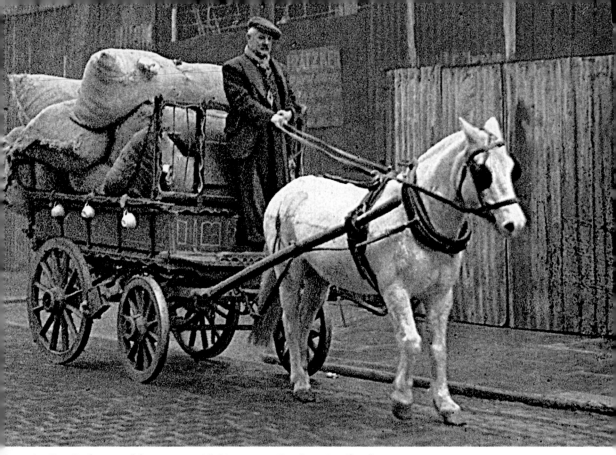

An East End rag-and-bone man with his wagon. Crockery is offered as an alternative to cash.

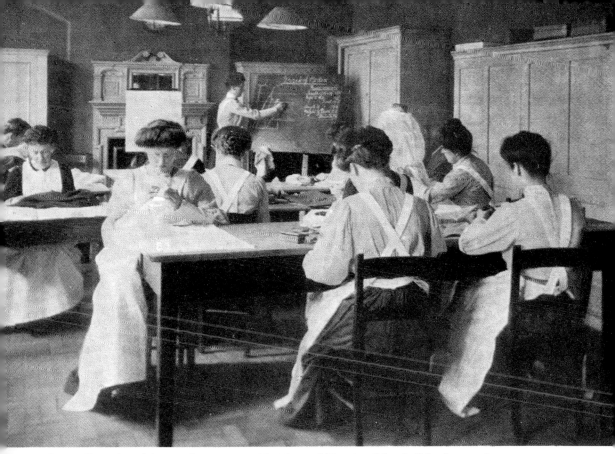

The needlework and dressmaking room at The National Training School of Cookery and Other Branches of Domestic Economy, London, *c.*1907.

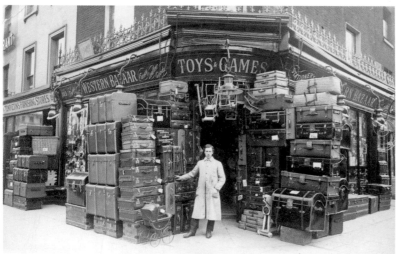

ABOVE: Suitcases and trunks are piled high outside a luggage shop in Paddington, while the store keeper stands proudly by.

RIGHT: The manned stalls of Covent Garden market, *c.*1907.

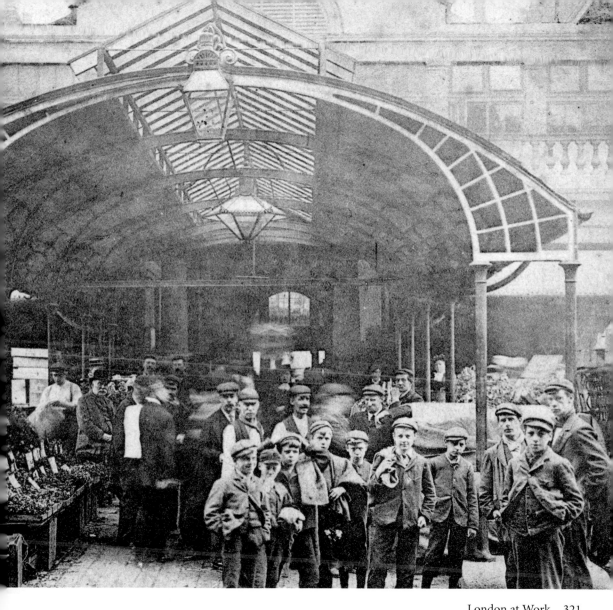

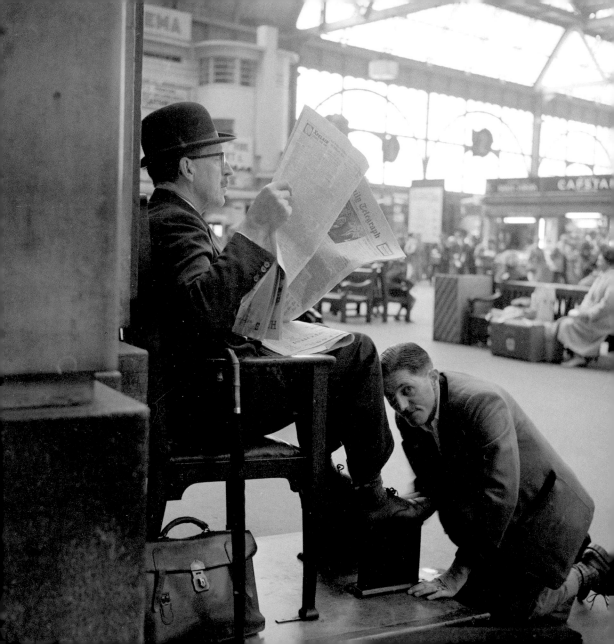

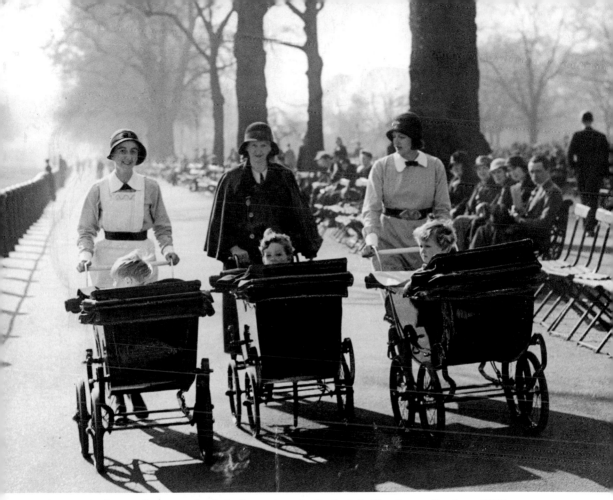

ABOVE: Professional nurses take their charges out for fresh air in Kensington Gardens, 1930s.

LEFT: A City gent is seated at Waterloo Station reading his newspaper while his shoes are polished by a shoe-shine man.

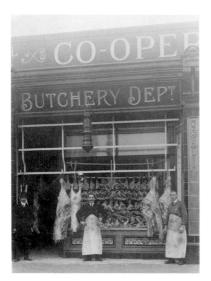

ABOVE: Butchery was a skilled job for a strong man.

RIGHT: A fishmonger's in Holloway, North London, 1907.

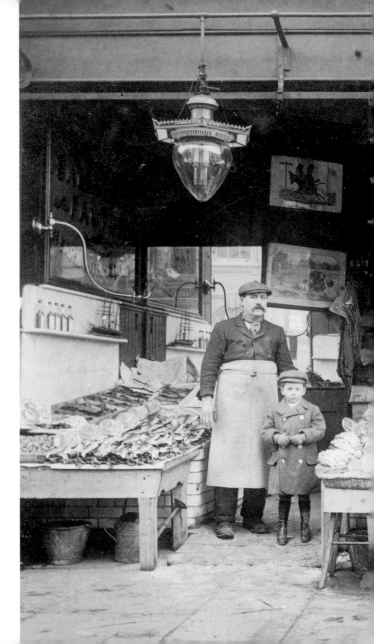

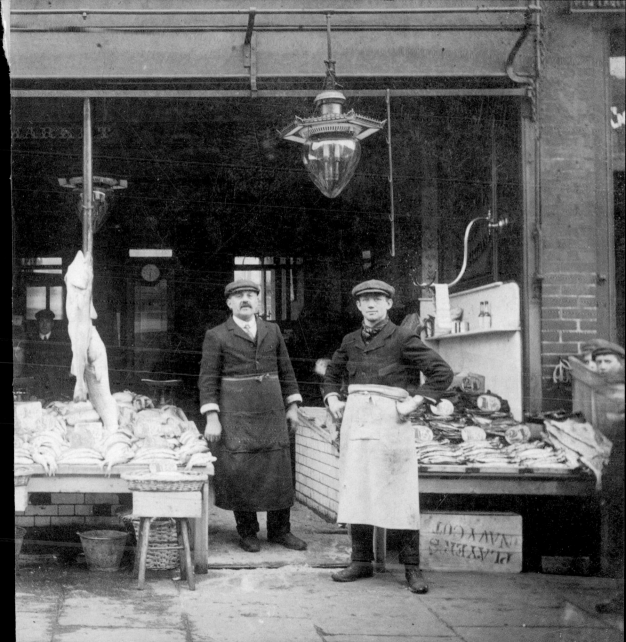

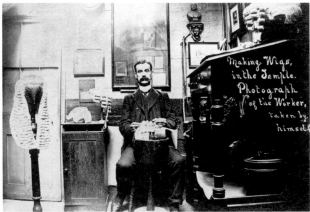

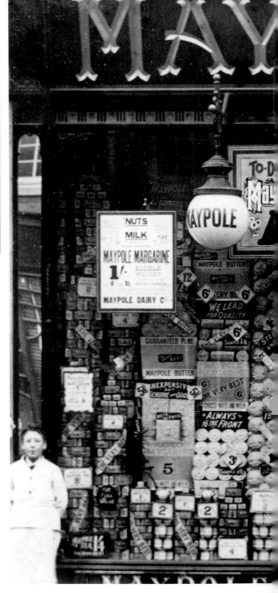

ABOVE: A wigmaker makes a wig for the legal profession, Temple, London.

RIGHT: The exterior of the Maypole store in Greenwich, 1914.

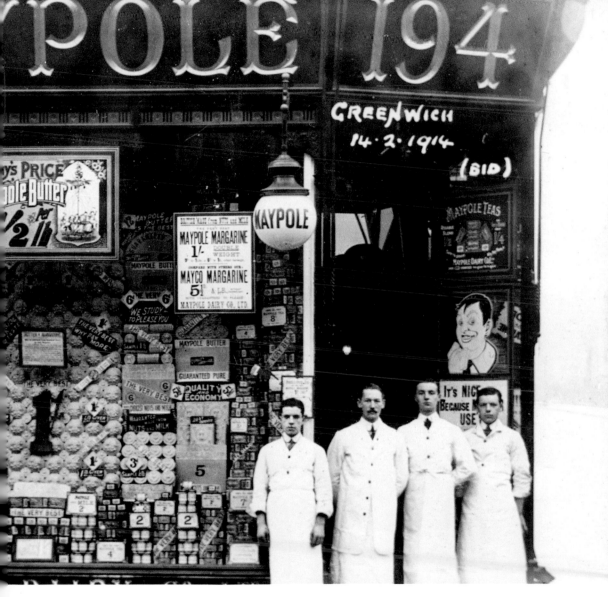

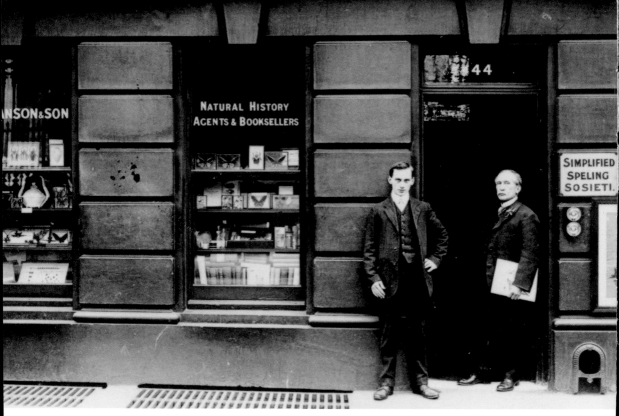

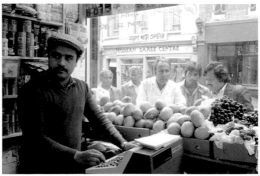

Above: A book shop at 44 Great Russell Street,
c. 1910–1912. Standing in the doorway are O E
Janson and R B Janson. A genteel profession.

Right: A Bangladeshi shop keeper in Brick
Lane, 1985.

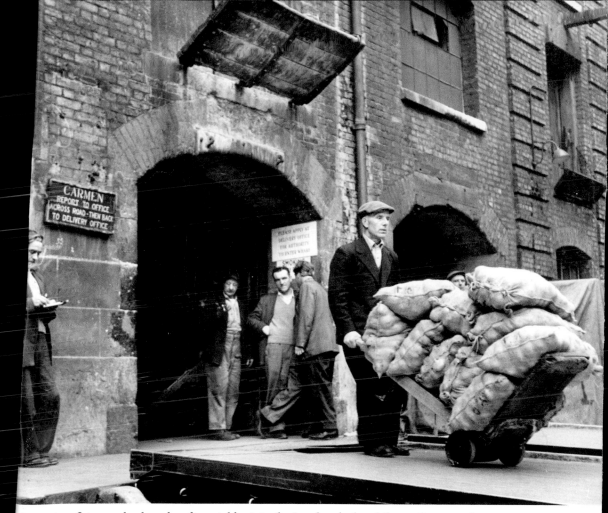

A man in a flat cap wheels sacks of vegetables into the London docks while another records man with a notepad records the goods being unloaded, 1959.

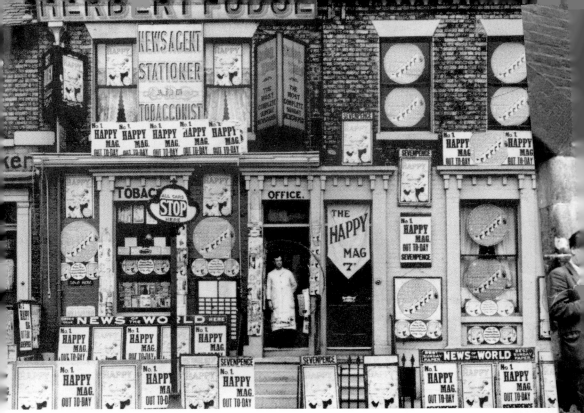

ABOVE: The marvellously named Herbert Fudge, newsagent, stationer and tobacconist of 313 Lee High Road, London. Mr. Fudge stands at the door, *c.*1930.

RIGHT: Miss Margaret Irving, pictured in her London tasting office, was the only woman tea taster in Britain and an authority in London as a connoisseur of all blends of tea.

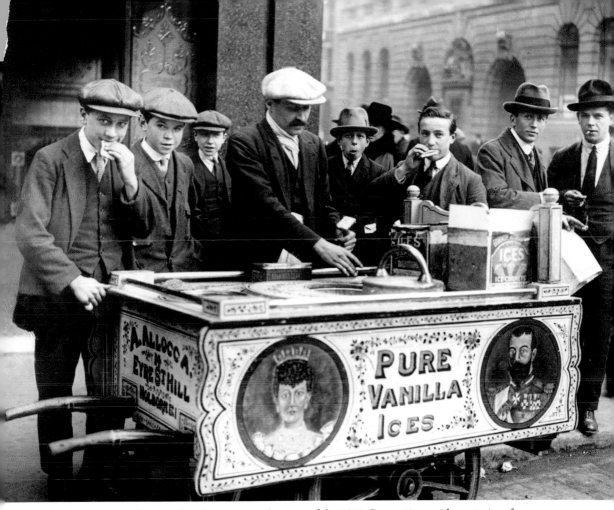

An ice cream vendor in a London street at the time of the 1911 Coronation, with portraits of King George V and Queen Mary painted on his cart and customers gathered around.

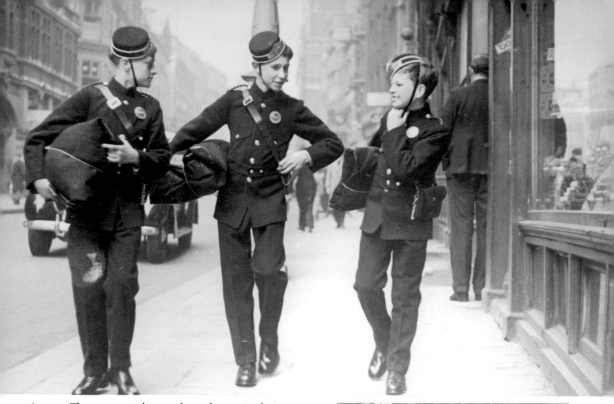

ABOVE: Three smart telegram boys, happy in their work, on duty on the streets of London, 1930s.

RIGHT: A group of telegram boys being taught how to get from one part of London to another in the shortest possible time, with the aid of the London Underground map.

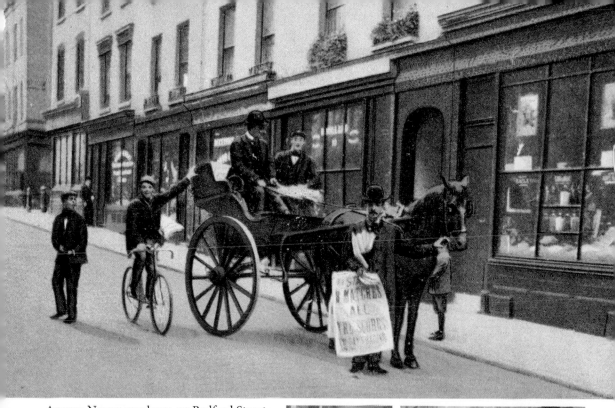

ABOVE: Newspaper boys, on Bedford Street, Covent Garden, *c.*1910.

RIGHT: A female employee (messenger) of the Reuter Telegraph Company, 1913.

FAR RIGHT: A three-wheeled handcart, used to deliver milk in London's East End. Two deliveries were made every morning and filled bottles and milk cans were left on doorsteps or brought to the cart to be refilled.

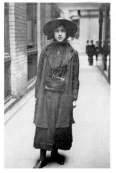

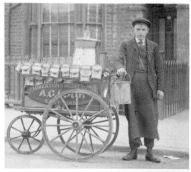

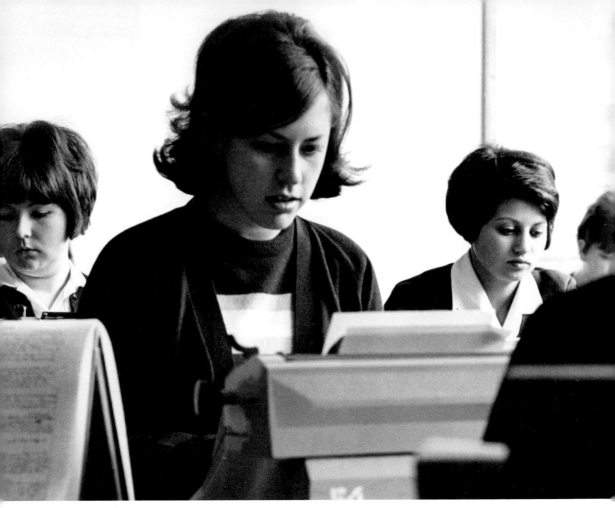

Young women take a typing class to better their employment
opportunities, 1965.

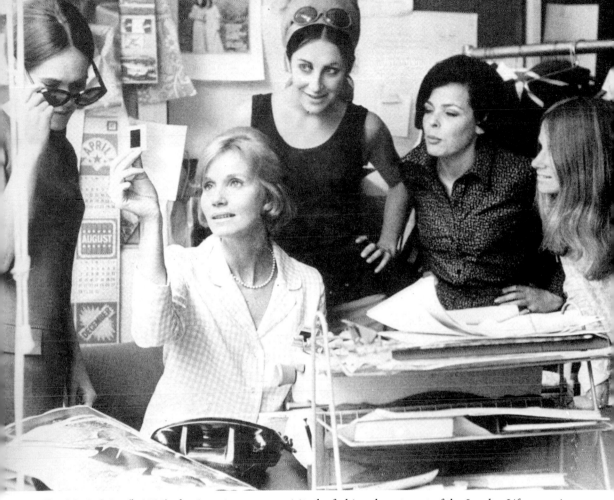

Eva Marie Saint (b 1924), the American actress visits the fashion department of the *London Life* magazine offices to pick up pointers for her role as a fashion editor in the film *Grand Prix, 1966*.

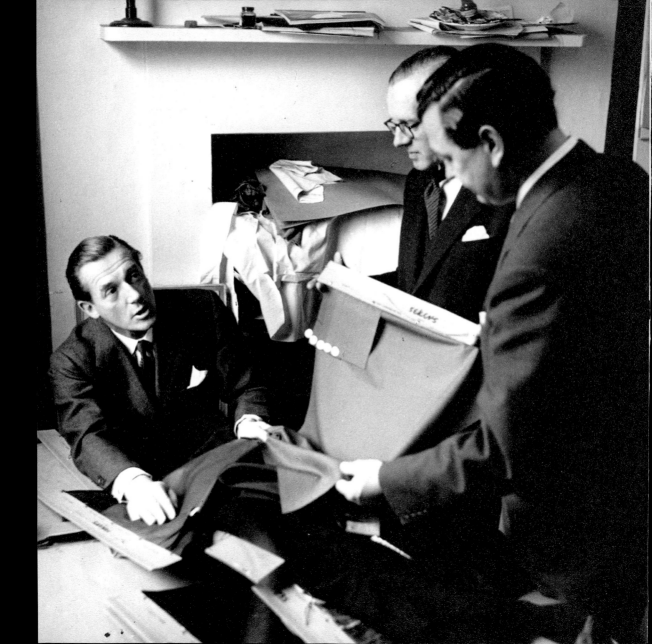

ABOVE: A large office building in St Botolph Street, E1, with people inside working at their desks, 1979.

LEFT: Luxury tailor Hardy Amies looks through fabrics from leading manufacturers, in his office at Savile Row, late 1950s.

ABOVE: Men work at the Hooper & Co (Coachbuilders) Ltd factory on the Kings Road, London. The company was founded as Adams and Hooper in 1805 and supplied horse-drawn carriages to Queen Victoria and King Edward VII. By the time of this photograph they had moved into the construction of motor bodies and aircraft.

LEFT: A hair stylist keeps attendance on three customers, 1961.

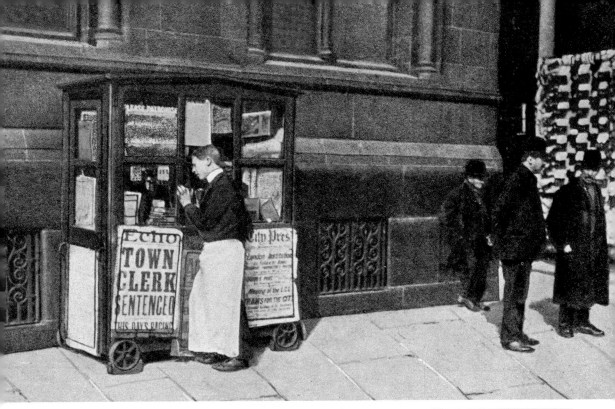

ABOVE: A newspaper seller at his kiosk outside the Prudential, in Holborn, *c.*1910.

RIGHT: A man advertises jobs on a sandwich board in Oxford Street.

ABOVE: A group of musicians gather in a London street in the late 1940s.

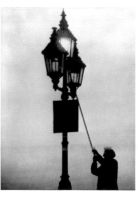

RIGHT: A lamplighter at work in the London fog before electric lights became standard.

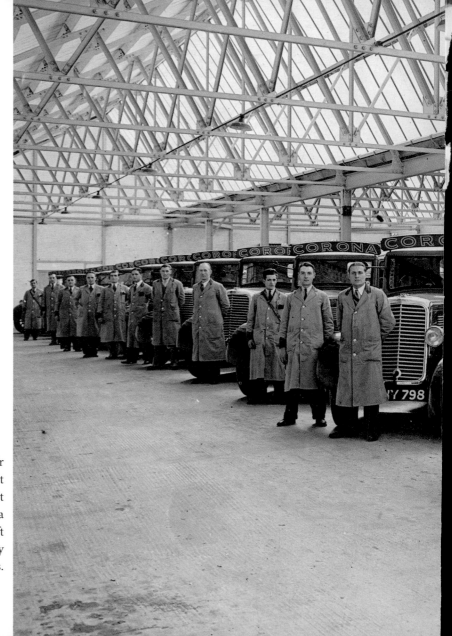

Corona vans and their drivers in a depot at Chadwell Heath, East London. Corona was a popular brand of soft drinks, delivered regularly to people's homes.

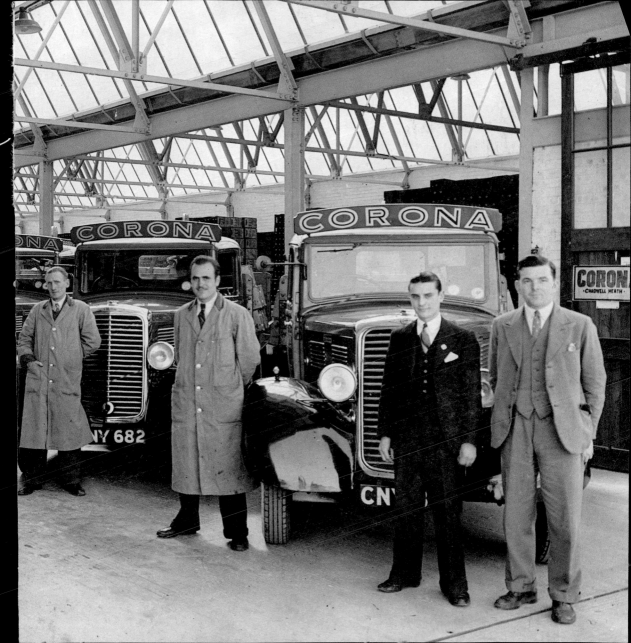

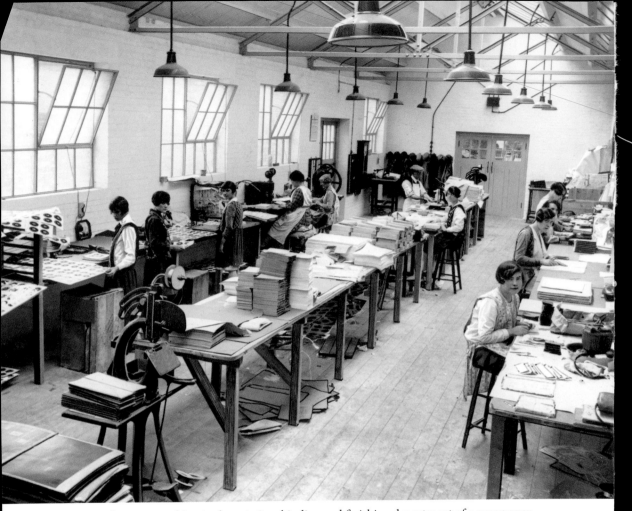

ABOVE: Rows of women working in the printing, binding and finishing department of a newspaper publisher's office, *c*.1930s.

RIGHT: A coalman carries his load in a black sack on his shoulder to a North Kensington address.

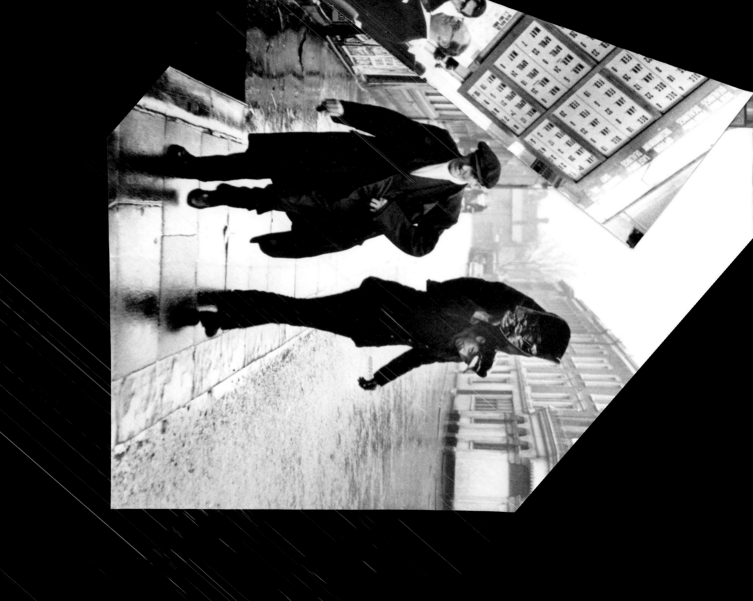

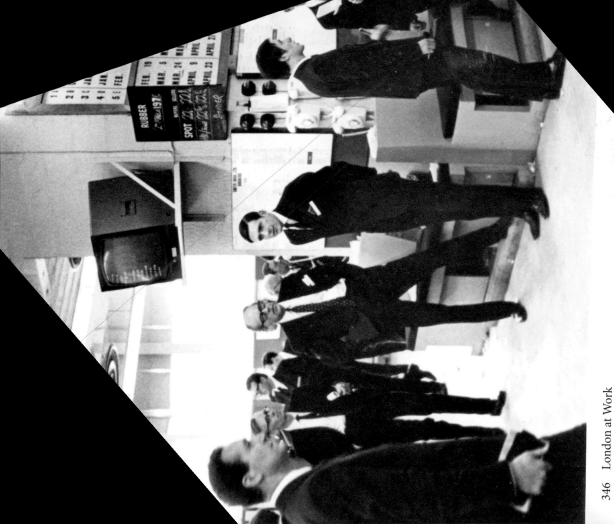

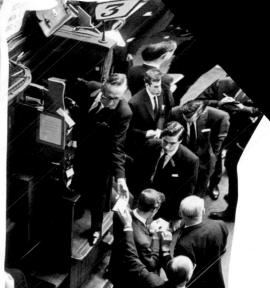

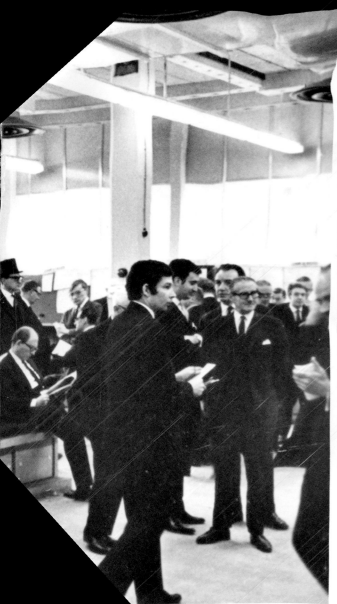

ABOVE: A trader passes a note from the exchange floor to a colleague in a booth, who will deliver the information on the deal.

LEFT: The trading floor of the London Stock Exchange, Throgmorton Street in the 1960s.

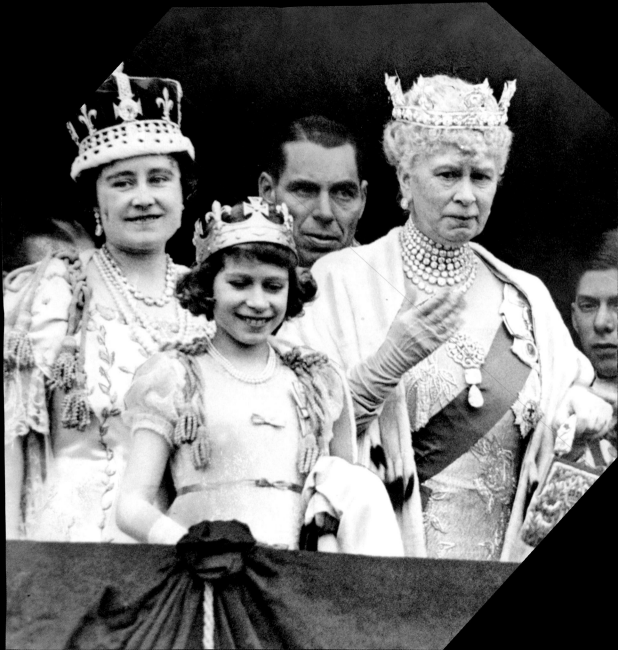

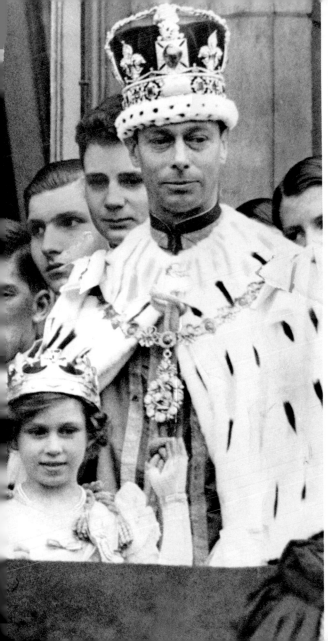

The Royal family make their traditional appearance on the balcony of Buckingham Palace following the Coronation of King George VI on 12 May 1937. From left: Queen Elizabeth, the future Queen Mother, Princess Elizabeth (Queen Elizabeth II), Queen Mary, Princess Margaret Rose and the newly crowned King George VI.

LONDON EVENTS

OVER THE last century, many of London's most famous events have

culminated in what we might term, 'the balcony scene'. In the middle of the Centre Room, in Buckingham Palace's East Wing, is a set of French doors through which the royal family habitually step onto the palace's balcony to acknowledge crowds who, during any momentous event in London, are naturally drawn down the Mall to the city's most famous residence. The balcony has witnessed some extraordinary scenes over the years. On the night of 4 August 1914, King George V and Queen Mary appeared to the cheering crowds, whipped up into a patriotic fervour induced by the news that Britain was at war. It's here in 1937 that ten-year old Princess Elizabeth, the future queen, together with her six-year-old sister Margaret Rose, peered out at immense crowds gathered below to hail the new King George VI—her father. She appeared alongside her family again on 8 May 1945, wearing her ATS uniform as London erupted into joyous celebration at the end of the Second World War and then on a dark November day in 1947 after her wedding to Lieutenant Philip Mountbatten. Less than five years later, she emerged in full regal splendour, wearing the imperial state crown and a magnificent Norman Hartnell gown after her own Coronation on 2 June 1953, giving the crowds and photographers perhaps the ultimate photo opportunity. At least until that famous kiss on 29 July 1981 when the Queen's son and heir, the Prince of Wales married Lady Diana Spencer, a union proclaimed the perfect love match at the time. For better—or for worse—the balcony scene has been the climactic part of a number of historic occasions.

The Queen and her family are London's front-of-house team—the ultimate heritage brand lending a royal sparkle to the city. From the ceremonial to the celebratory, the inaugural to the commemorative, the most momentous or noteworthy events have a gravitas bestowed upon them by royal presence. The Festival of Britain was opened by King George VI in a dedication ceremony at St Paul's Cathedral on 3 May 1951 and saw the royal family out in force, including Queen Mary, at almost 84 years old, who toured the exhibits in a wheelchair. The festival was intended to celebrate post-war British design, culture, science and technology, in much the same way the Great Exhibition a century earlier had showcased the glory of Victorian manufacturing and industry. Across its main site on London's South Bank, a range of futuristic buildings, sculptures and exhibition spaces became the touchstones of mid-century modern design, and were visited by an estimated eight and a half

The Royal family make their traditional appearance on the balcony of Buckingham Palace following the Coronation of King George VI on 12 May 1937. From left: Queen Elizabeth, the future Queen Mother, Princess Elizabeth (Queen Elizabeth II), Queen Mary, Princess Margaret Rose and the newly crowned King George VI.

LONDON EVENTS

OVER THE last century, many of London's most famous events have culminated in what we might term, 'the balcony scene'. In the middle of the Centre Room, in Buckingham Palace's East Wing, is a set of French doors through which the royal family habitually step onto the palace's balcony to acknowledge crowds who, during any momentous event in London, are naturally drawn down the Mall to the city's most famous residence. The balcony has witnessed some extraordinary scenes over the years. On the night of 4 August 1914, King George V and Queen Mary appeared to the cheering crowds, whipped up into a patriotic fervour induced by the news that Britain was at war. It's here in 1937 that ten-year old Princess Elizabeth, the future queen, together with her six-year-old sister Margaret Rose, peered out at immense crowds gathered below to hail the new King George VI—her father. She appeared alongside her family again on 8 May 1945, wearing her ATS uniform as London erupted into joyous celebration at the end of the Second World War and then on a dark November day in 1947 after her wedding to Lieutenant Philip Mountbatten. Less than five years later, she emerged in full regal splendour, wearing the imperial state crown and a magnificent Norman Hartnell gown after her own Coronation on 2 June 1953, giving the crowds and photographers perhaps the ultimate photo opportunity. At least until that famous kiss on 29 July 1981 when the Queen's son and heir, the Prince of Wales married Lady Diana Spencer, a union proclaimed the perfect love match at the time. For better—or for worse—the balcony scene has been the climactic part of a number of historic occasions.

The Queen and her family are London's front-of-house team—the ultimate heritage brand lending a royal sparkle to the city. From the ceremonial to the celebratory, the inaugural to the commemorative, the most momentous or noteworthy events have a gravitas bestowed upon them by royal presence. The Festival of Britain was opened by King George VI in a dedication ceremony at St Paul's Cathedral on 3 May 1951 and saw the royal family out in force, including Queen Mary, at almost 84 years old, who toured the exhibits in a wheelchair. The festival was intended to celebrate post-war British design, culture, science and technology, in much the same way the Great Exhibition a century earlier had showcased the glory of Victorian manufacturing and industry. Across its main site on London's South Bank, a range of futuristic buildings, sculptures and exhibition spaces became the touchstones of mid-century modern design, and were visited by an estimated eight and a half

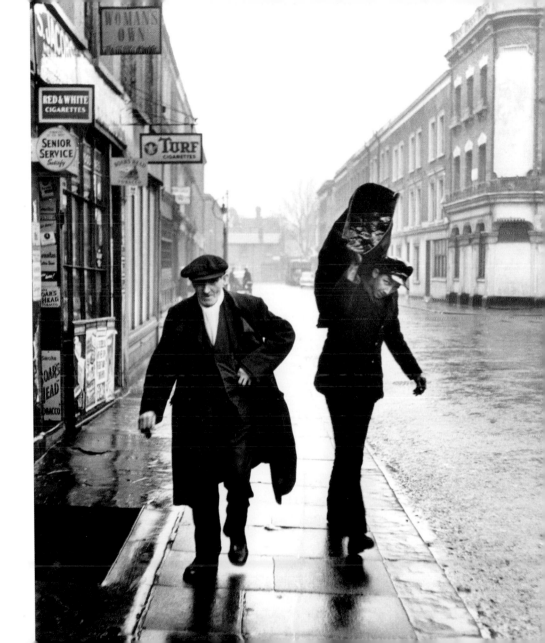

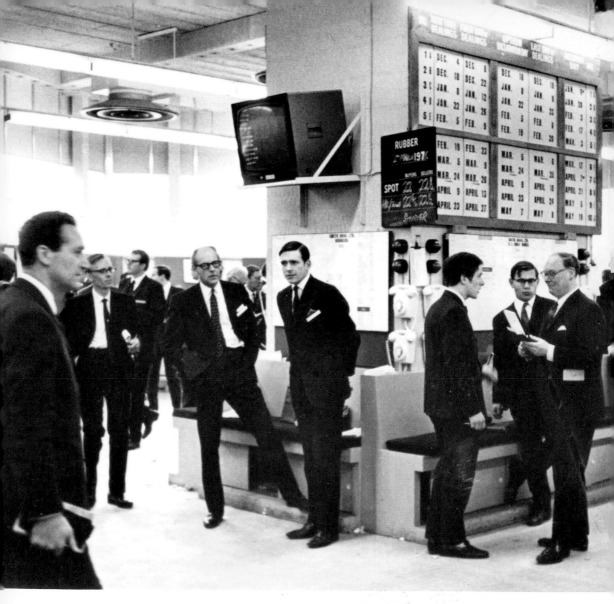

ABOVE: A trader passes a note from the exchange floor to a colleague in a booth, who will deliver the information on the deal.

LEFT: The trading floor of the London Stock Exchange, Throgmorton Street in the 1960s.

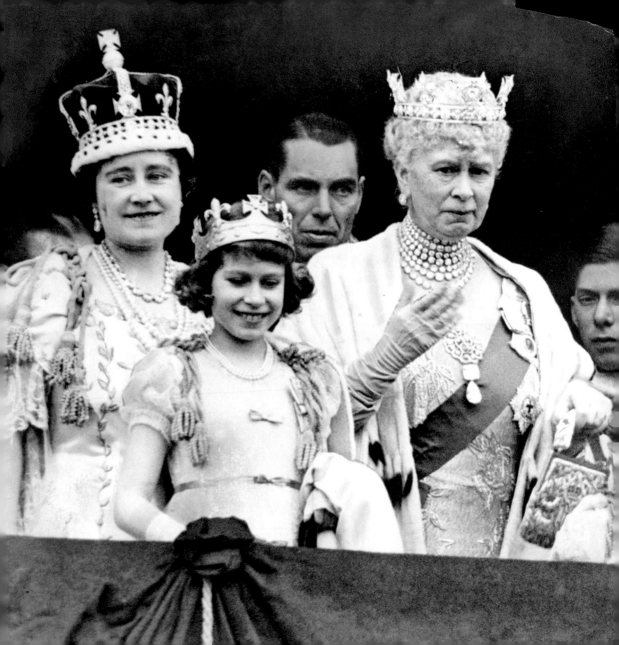

million people. Associated with the Labour Party, who had won the 1945 General Election, Winston Churchill viewed the Festival of Britain as, 'three-dimensional socialist propaganda'. Such was his contempt, one of his first acts on becoming prime minister in 1951 was to clear the South Bank site, though the Royal Festival Hall remains.

As the centre of government and the nation's political heartland, London is no stranger to protest and unrest. In the years leading up to the First World War, the suffragette movement gained pace and undertook increasingly militant measures in their quest for the vote. In May 1914, Mrs Emmeline Pankhurst called on her fellow suffragettes to petition the King at Buckingham Palace, an action leading to some ugly scenes and clashes with police. The suffragettes continued to make their voices heard that summer. They attacked shops and art galleries and interrupted sporting events and theatre shows, but the outbreak of war in August led to an immediate cessation of militant activity and instead, women lobbied to be allowed to work in industries to help the war effort. In November 1918, women aged 30 or elder recorded their votes at the ballot boxes for the first time in Britain, though it would be another decade before they achieved electoral parity with men.

In early May 1926, the city was threatened with paralysis when an all-out strike was called by the Trades Union Congress in support of coal miners who were striking over threatened wage cuts. The General Strike affected key industrial sectors including the docks, electricity, gas and railways, but the government quickly put emergency measures in place and the nine-day standoff was characterised by a decidedly upper-class effort to keep services running. Oxbridge graduates volunteered at railway stations, titled ladies were pictured peeling potatoes in Hyde Park in order to keep this new, albeit temporary, breed of worker nourished and the politician and diarist Alfred Duff Cooper noted that at his St James's clubs, Buck's and White's, 'they are all becoming special constables'. The comparatively short-lived General Strike was by no means London's only crisis. Disastrous accidents and fires (such as the one that destroyed the Crystal Palace in 1936), state funerals, the constitutional upheaval of the Abdication crisis, the Sidney Street siege of 1911 or the Brixton riots of 1981 all are part of London's fluctuating history. Some of these events reflect a cosmopolitan city where liberalism and (occasionally) dissension have room to grow. It is a place where people, from the Jarrow Marchers of 1936, to Aldermaston CND March of 1958 and anti-Vietnam protestors of the 1960s, go to have their voices heard.

There may be peaks and troughs, fracture and ferment, in London's past fortunes, but nostalgia for the past tends to focus our attention on the joyous; the 1953 Coronation, the World Cup of 1966 or the three separate Olympic Games held in the capital. But you don't need to wait a lifetime to experience one of the capital's iconic moments; London's annual events calendar has always offered a perpetual round of interest, tradition and spectacle over the years. Cruft's Dog Show (held in London until it moved to Birmingham NEC in 1991), the London Marathon, Notting Hill Carnival, the Lord Mayor's Show or the switching on of Christmas lights in Oxford Street all attract participants and spectators from near and far.

The London Season, lasting from the beginning of May to the end of July was once the highlight of smart society's year when the titled and wealthy would bring their unmarried debutante daughters to London to be presented at court. The three or four courts held every season attracted an inordinate amount of interest in the press, and day-trippers would line the Mall to gawp at the debs in their finery as they sat in the long line of cars crawling slowly toward the palace entrance. Court presentations were only part of this elaborate ritual. It was a chance for society to mingle, to see and be seen at key events such as the opening of the Summer Exhibition at the Royal Academy (traditionally the Season's opener) or at a dizzying round of parties and balls. Increasingly outmoded and certainly elitist, in 1958 the palace announced the end of court presentations. The day of the deb was over—their tulle frocks and dance cards making way for the miniskirts and Beatlemania. But vestiges of the Season in various forms continue. From glorious Chelsea Flower Show in May and garden parties at Buckingham Palace to the Trooping of the Colour on the Queen's official birthday in mid-June, to festivals, private views and summer fêtes, London likes 'a bit of a do'—and does them rather well.

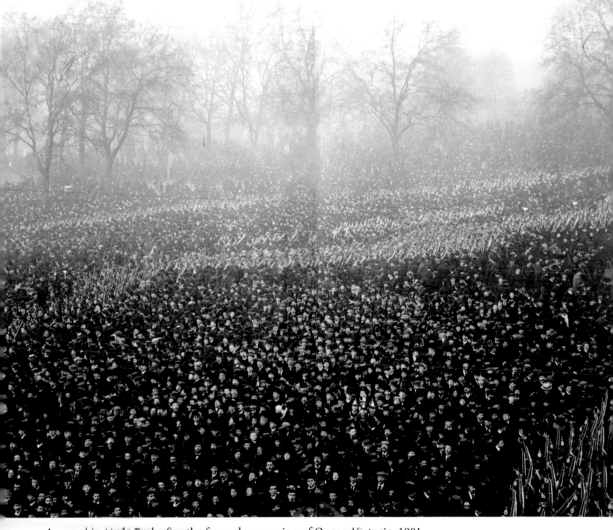

A crowd in Hyde Park after the funeral procession of Queen Victoria, 1901.

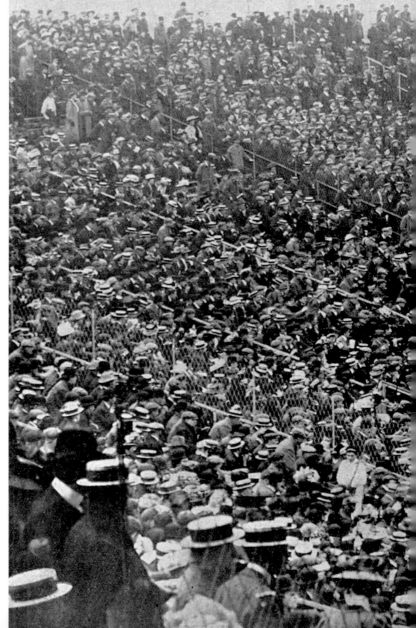

50,000 spectators witness the 60 miles (100 kilometres) cycle race at the 1908 Olympics. Up until this point, the events had been poorly attended, with thousands of seats unfilled each day. However, a lowering of ticket prices caused a surge in interest, and stands started to fill, 1908.

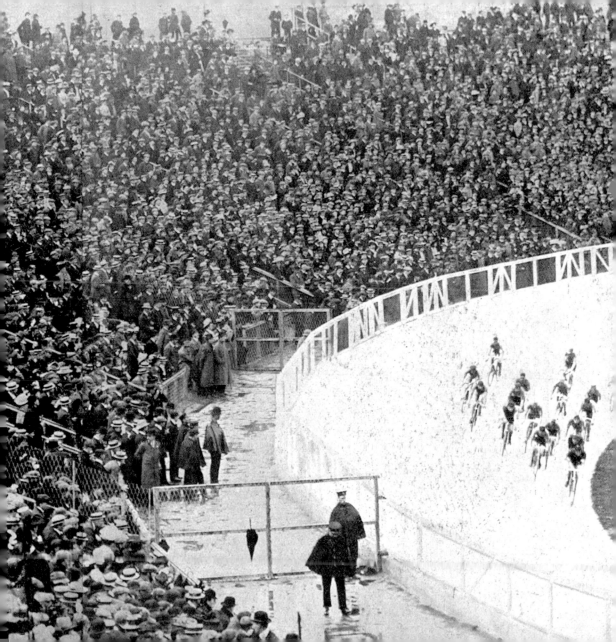

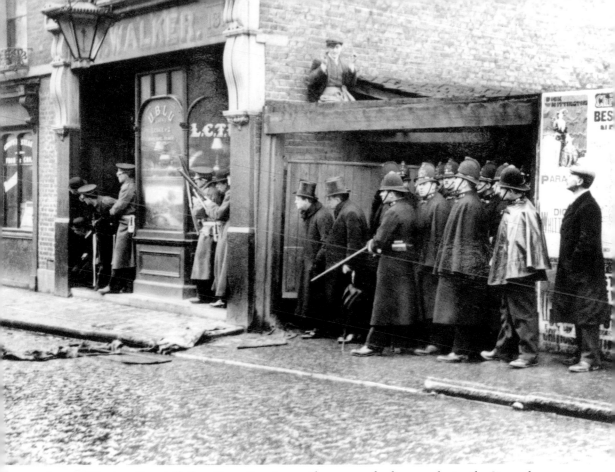

ABOVE: Winston Churchill, then Home Secretary, with a group of policemen during the Siege of Sidney Street in Stepney, East London, a notorious gun battle, on 3 January 1911.

LEFT: Outside the railings of Buckingham Palace people read the notice announcing the death of King Edward VII, 1911.

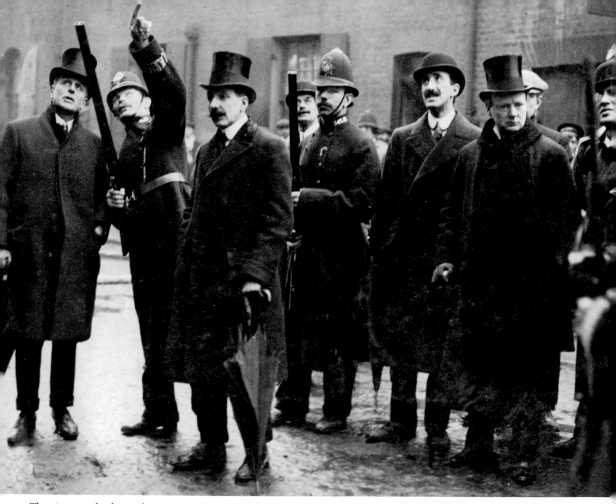

The siege took place when it was discovered that a gang of Latvian anarchists responsible for the deaths of three policemen during an attempted robbery were living at 100 Sidney Street. The street was cordoned off and the two sides fired at each other for some time. The siege ended with a fire inside the house, and the deaths of two of the gang. The involvement of the Guards was authorised by the Home Secretary, Winston Churchill, and caused some controversy.

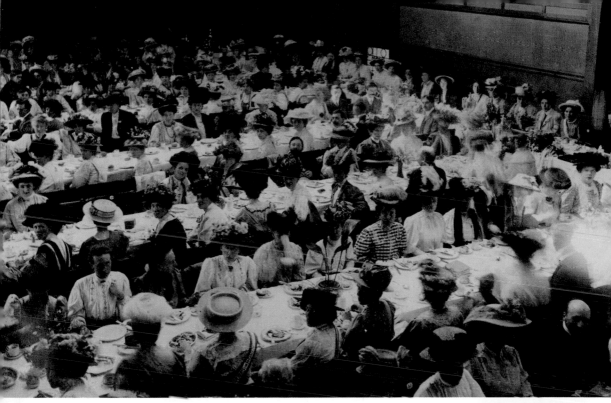

ABOVE: A 'Welcome Breakfast' for newly-released suffragette prisoners held at Queen's Hall, London, 31 July 1908.

RIGHT: An advertisement for an excursion train to London from Ipswich on Sunday 21 June 1908 to take part in the WSPU 'Women's Sunday' rally, a suffragette demonstration held in Hyde Park.

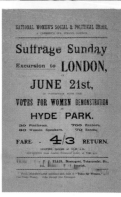

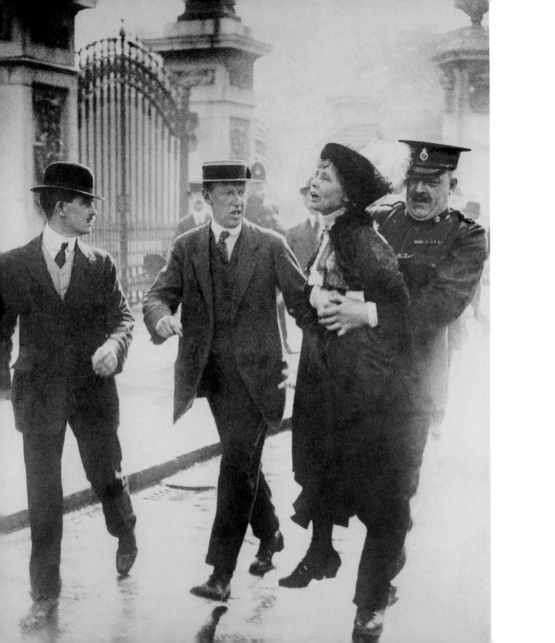

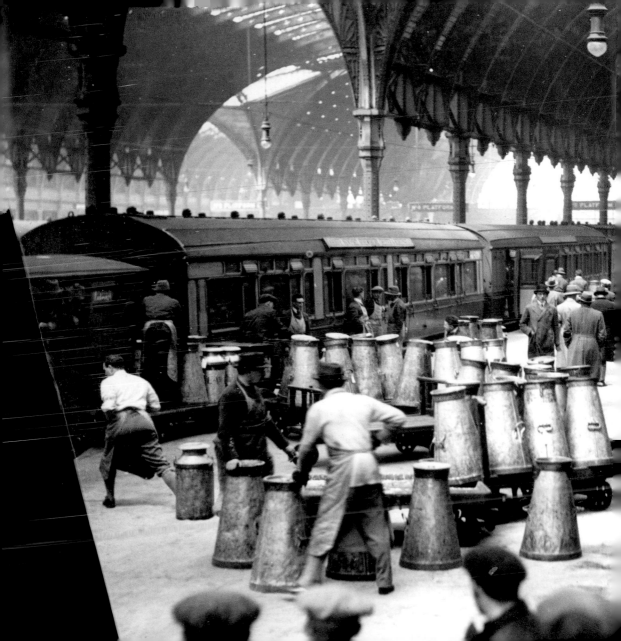

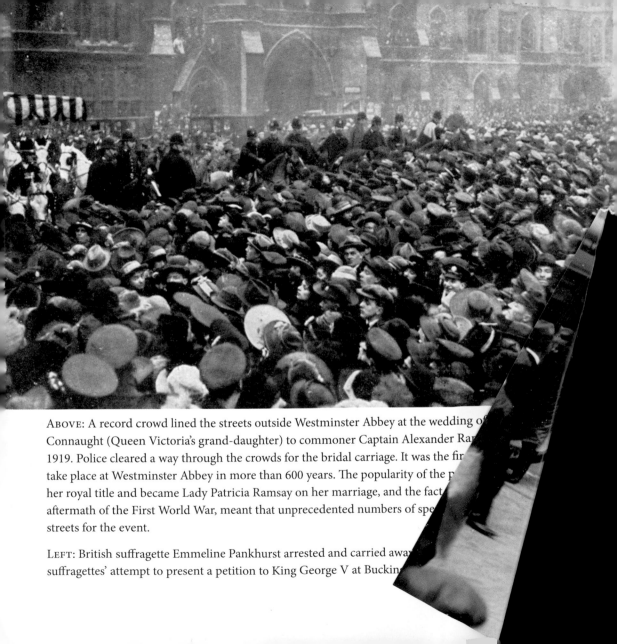

ABOVE: A record crowd lined the streets outside Westminster Abbey at the wedding of
Connaught (Queen Victoria's grand-daughter) to commoner Captain Alexander Ra
1919. Police cleared a way through the crowds for the bridal carriage. It was the fir
take place at Westminster Abbey in more than 600 years. The popularity of the p
her royal title and became Lady Patricia Ramsay on her marriage, and the fact
aftermath of the First World War, meant that unprecedented numbers of spe
streets for the event.

LEFT: British suffragette Emmeline Pankhurst arrested and carried awa
suffragettes' attempt to present a petition to King George V at Bucking

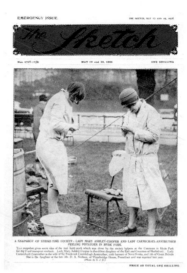

EMERGENCY ISSUE

The Sketch

No. 1737–1738 MAY 12 and 19, 1926 ONE SHILLING

PRICE AS USUAL ONE SHILLING

A SNAPSHOT OF STRIKE-TIME SOCIETY: LADY MARY ASHLEY-COOPER AND LADY CARMICHAEL-ANSTRUTHER PEELING POTATOES IN HYDE PARK.

ABOVE: A snapshot of strike-time society: Lady Mary Ashley-Cooper and Lady Carmichael-Anstruther peel potatoes in Hyde Park. In support of a strike by coal miners over the issue of threatened wage cuts, the Trades Union Congress called a general strike in early May 1926. The strike only involved certain key industrial sectors (docks, electricity, gas, railways) but, in the face of well-organised government emergency measures and lack of real public support, it collapsed after nine days. During the strike, society ladies were given much publicity for helping out at the canteens set up in Hyde Park, London to feed transport workers.

LEFT: Milk churns arrive at Paddington station during General Strike, 1926.

London '

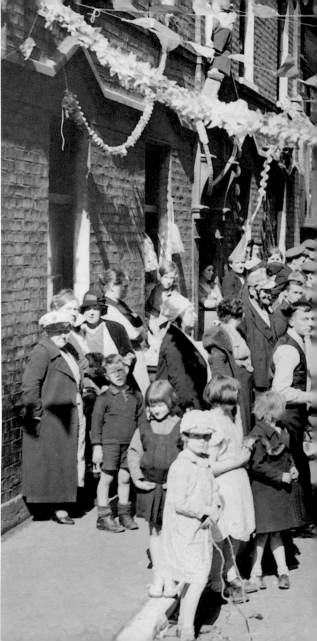

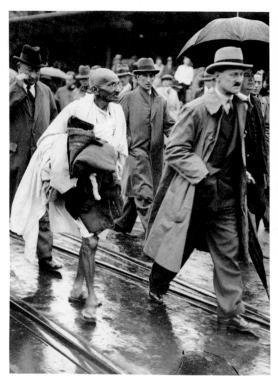

ABOVE: Mahatma Gandhi (1869–1948), leader of the Indian Independence Movement, takes part in the constitution conference in London, 1931.

RIGHT: A tea party is held for children in a ...et decorated with paper flowers in London's ... End on the occasion of the 25th anniversary ... George V's ascent to the throne, 1935.

n Events

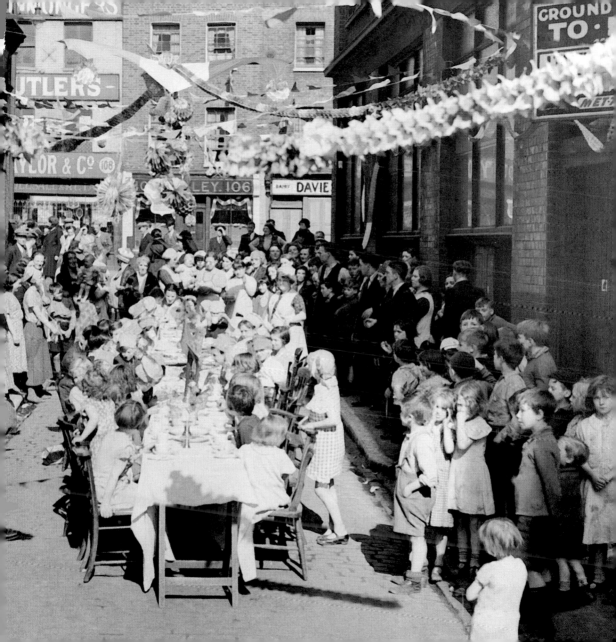

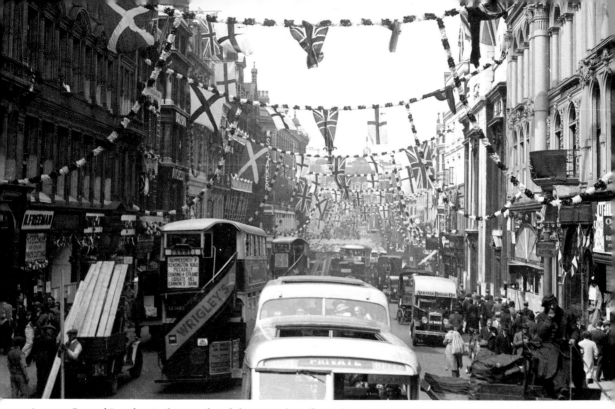

ABOVE: Central London is thronged with buses and traffic, gaily decorated with flags and bunting to celebrate the silver jubilee of George V and Queen Mary, 1935.

RIGHT: A silver jubilee celebration postcard, featuring portraits of the King and Queen Mary and a view of Buckingham Palace, London.

The British Broadcasting Company (BBC) officially opened for business in 1936 at Alexandra Palace and made front page news of the *Daily Sketch*.

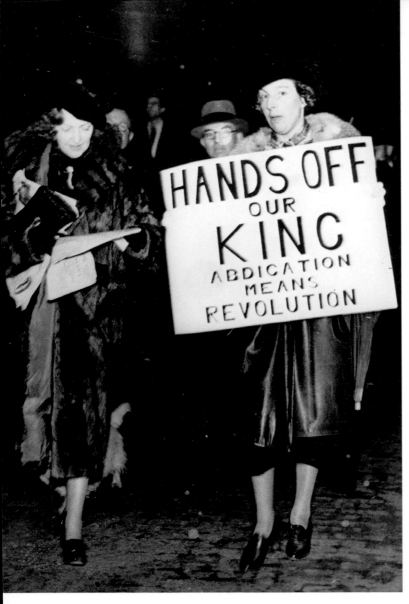

LEFT: Supporters of King Edward VII, who abdicated in order to marry the twice-divorced American, Wallis Simpson, demonstrate their support on the streets of London in December 1936.

BELOW: The front cover of the *Daily Mirror*, 11 December 1936 reports on the abdication of King Edward VIII and the succession of George VI.

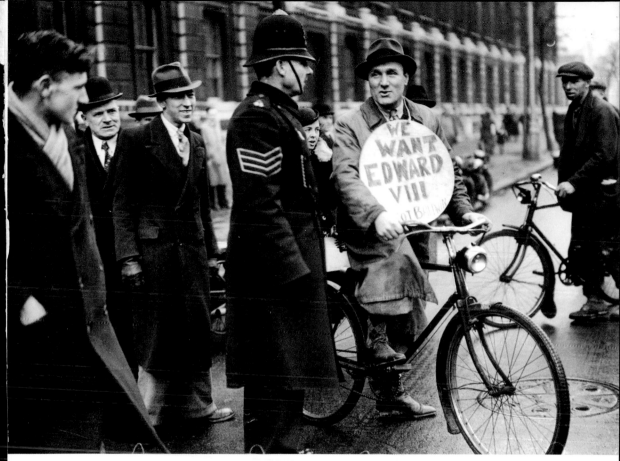

A cyclist sympathetic to the dilemma of King Edward VIII in December 1936, talks to a policeman in Downing Street, London. The king's desire to marry Mrs Wallis Simpson, an American divorcee, split the government and resulted in a constitutional crisis, with the prime minister, Stanley Baldwin refusing to allow the king to marry and have Wallis as his Queen. Edward abdicated in favour of his younger brother, Albert (King George VI) and became the Duke of Windsor, marrying Wallis in June 1937.

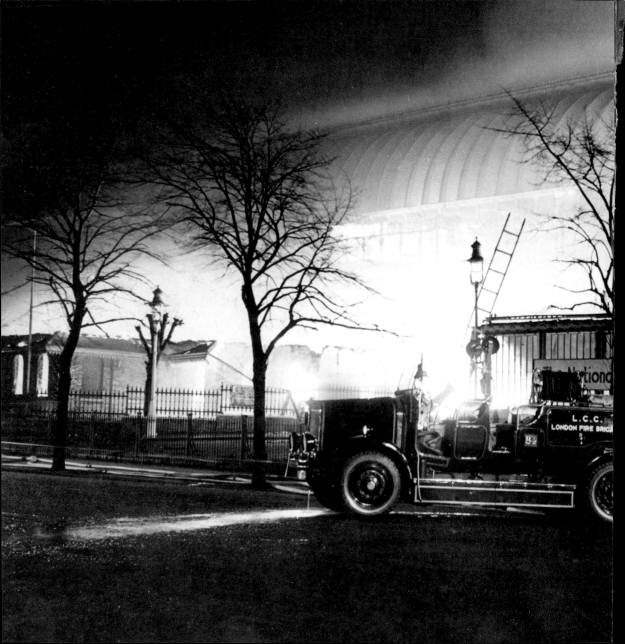

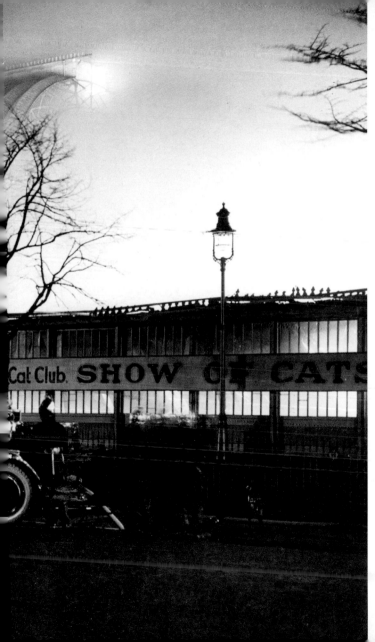

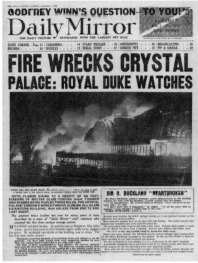

ABOVE: The fire at Crystal Palace makes front page news.

LEFT: Firefighters desperately try to put out the fire at Crystal Palace, South London, on 30 November 1936. The fire started after an explosion in the women's cloakroom and consumed the entire building.

ABOVE: Among the decorations in London inspired by the Coronation of King George VI and Queen Elizabeth in 1937 were these life-sized effigies of the royal couple, the focal point of the elaborate decorations on the facade of the London Pavilion.

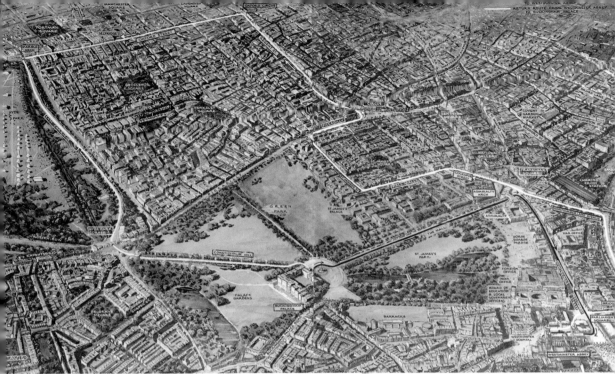

ABOVE: A detailed aerial view of central London shows the processional route to and from Westminster Abbey for the Coronation of King George VI in 1937. The route to the abbey from Buckingham Palace is marked in black, and the longer white route along Northumberland Avenue, Pall Mall, Piccadilly, Regent Street, Oxford Street, Park Lane and Constitution Hill shows the route the procession took on the way back.

RIGHT: The Coronation of King George VI was front page news with the *Daily Sketch*. With him are Queen Elizabeth, Princess Elizabeth (later Queen Elizabeth II), and Princess Margaret.

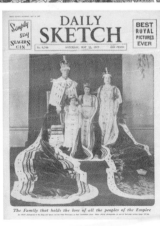

London Events 373

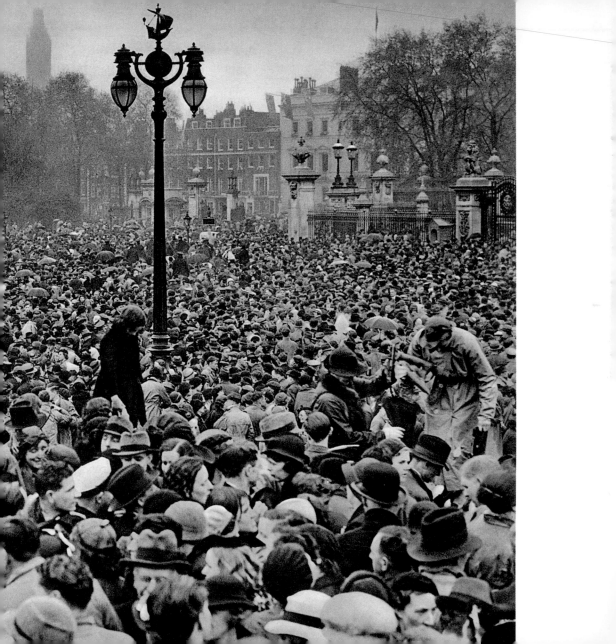

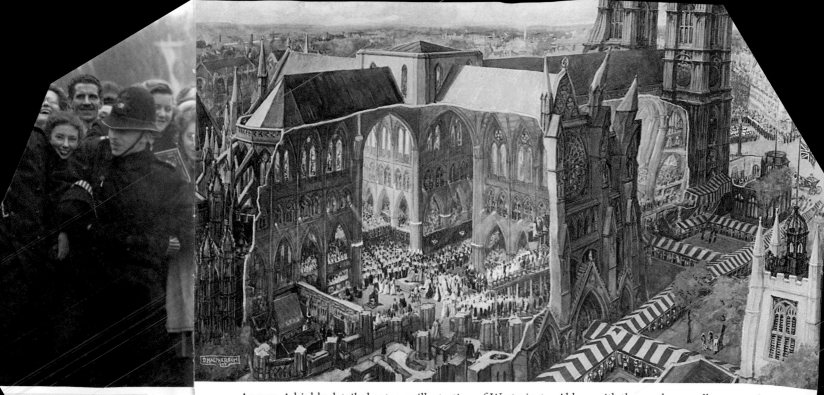

ABOVE: A highly detailed cutaway illustration of Westminster Abbey, with the northern walls removed to show the interior seating arrangements and the positions occupied by King George VI and his wife Queen Elizabeth during the different stages of the sacred Coronation ceremony on 12 May 1937.

LEFT: Crowds gather outside Buckingham Palace to await the appearance of the newly crowned King George VI and Queen Elizabeth, following their Coronation at Westminster Abbey on 12 May 1937.

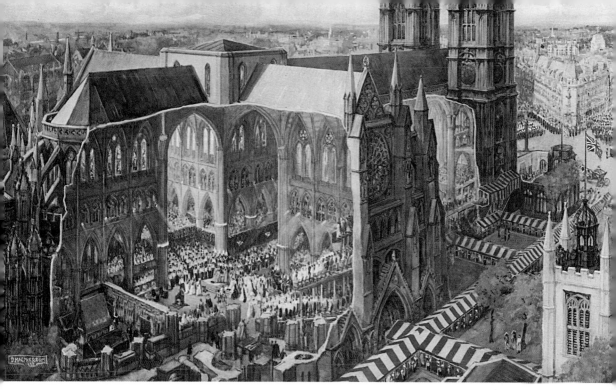

ABOVE: A highly detailed cutaway illustration of Westminster Abbey, with the northern walls removed to show the interior seating arrangements and the positions occupied by King George VI and his wife Queen Elizabeth during the different stages of the sacred Coronation ceremony on 12 May 1937.

LEFT: Crowds gather outside Buckingham Palace to await the appearance of the newly crowned King George VI and Queen Elizabeth, following their Coronation at Westminster Abbey on 12 May 1937.

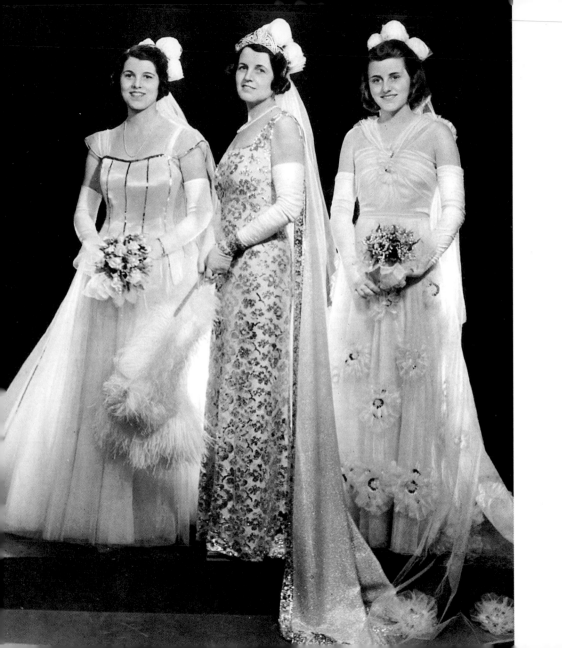

ABOVE: A familiar sight in central London during the Season – a long line of cars snaking its way up the Mall towards Buckingham Palace. Inside are debutantes and other ladies who are to be presented at court, all of them coming under the scrutiny of the crowds who gather to watch.

LEFT: Mrs Joseph Kennedy, wife of the United States Ambassador, in a photograph to mark the presentation of two of her daughters at the first court at Buckingham Palace in May 1938. On the left is Rosemary Kennedy (1918–2005), in the middle Rose Kennedy and on the right, Kathleen 'Kick' Kennedy. Kathleen met Billy Cavendish, heir to the Devonshire dukedom during the Season and married him becoming Marchioness of Hartington.

ABOVE: A row of police officers link arms to prevent the crowd surging forward during the royal wedding of 1947. Princess Elizabeth (Queen Elizabeth II) married Prince Philip, Duke of Edinburgh at Westminster Abbey on 20 November 1947. Crowds outside Buckingham Palace were rewarded by the appearance of the royal couple on the balcony afterwards.

RIGHT: Front cover of *The Illustrated London News* painted by Terence Cuneo celebrates the marriage of Princess Elizabeth and Philip Mountbatten (formerly Prince Philip of Greece).

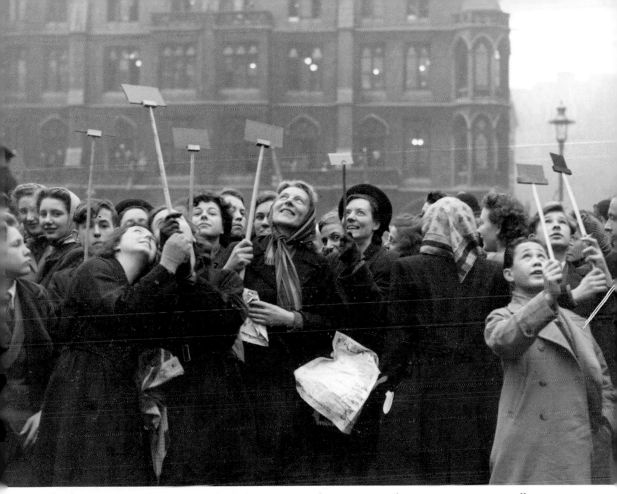

Enterprising spectators using makeshift periscopes of mirrors on sticks in an attempt to actually see something along the processional route at the royal wedding.

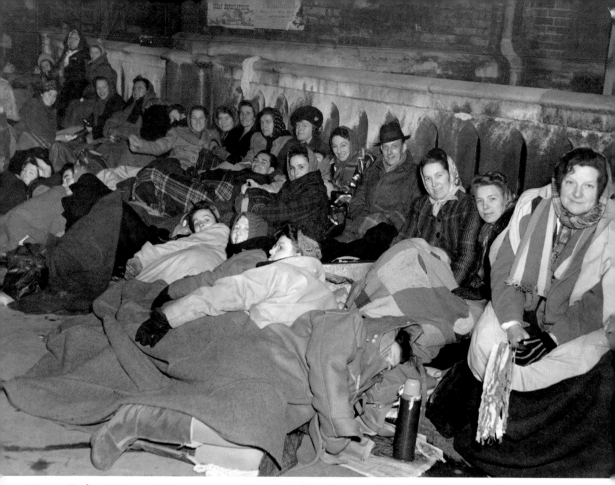

ABOVE: Enthusiastic spectators wrap up against the cold as they spend the night sleeping on the London streets in the hope of bagging a top spot along the processional route for the royal wedding on 20 November 1947.

RIGHT: The fountains of Trafalgar Square in London lit blue for a boy to celebrate the birth of Prince Charles on 14 November 1948.

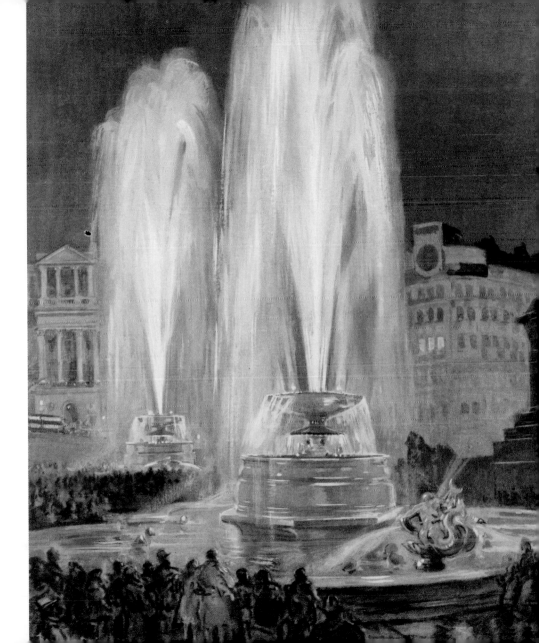

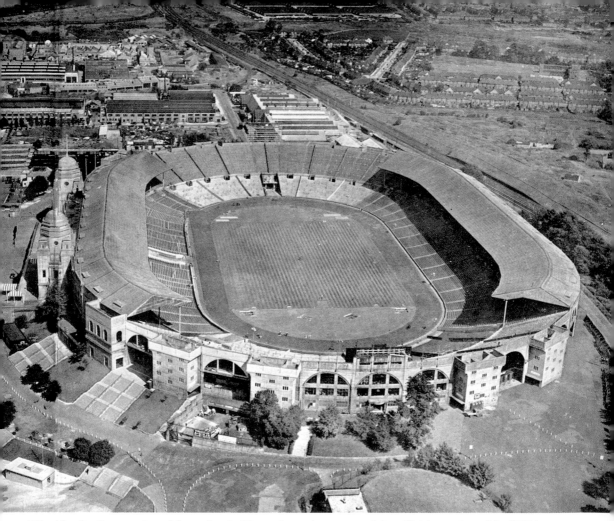

Wembley Stadium as viewed from the air. The main track events and the official opening of the XIVth Olympiad took place here, as well as the finals of the football and field-hockey, fencing, gymnastics and the Prix des Nations. The marathon also began and ended there. The platform at the far end of the stadium is in position for the Olympic torch.

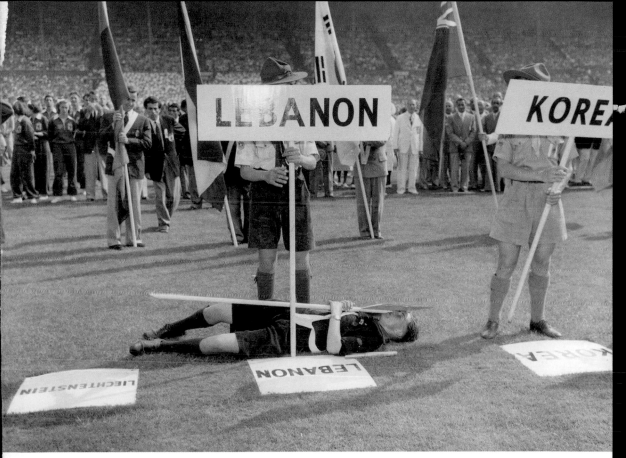

A scout collapses from heat exhaustion while holding a Liechtenstein nationality sign at the London Olympics held at Wembley Stadium, 1948.

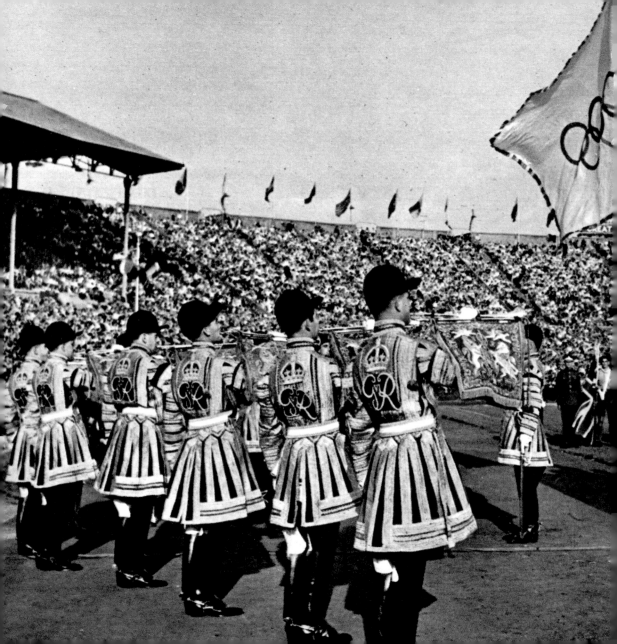

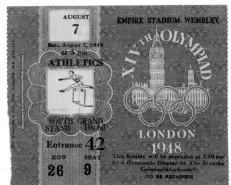

ABOVE: An admission ticket for the athletics events, held at the Empire Stadium, Wembley.

LEFT: The closing ceremony of the 1948 London Olympic Games, the XIVth Olympiad. A fanfare is played by royal state trumpeters.

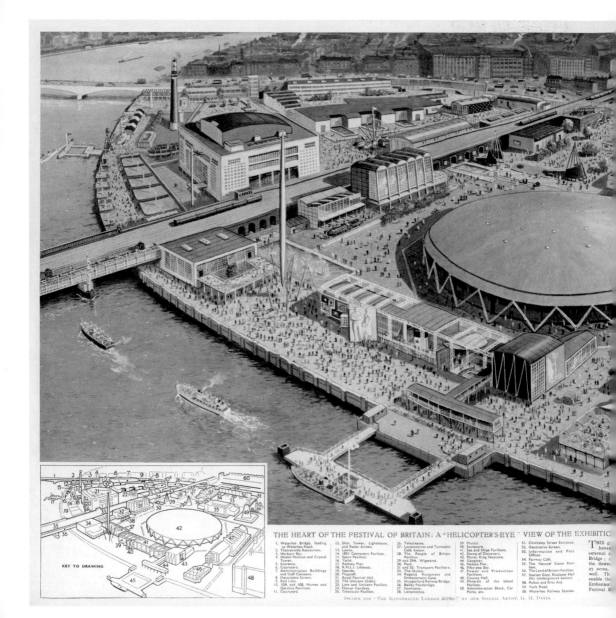

THE HEART OF THE FESTIVAL OF BRITAIN: A "HELICOPTER'S-EYE" VIEW OF THE EXHIBITION

1. Waterloo Bridge, leading to Waterloo Road.
2. Thames-side Restaurant.
3. Harbour Bar.
4. Health Pavilion and Crystal Tower.
5. Entrance.
6. Courtyard.
7. Administration Buildings and Staff Canteens.
8. Decorative Screen.
9. Red Lion.
10. 10A and 10B. Homes and Gardens Pavilions.
11. Courtyard.

12. Shot Tower, Lighthouse, and Radar Screen.
13. Sport Pavilion.
14. 1851 Centenary Pavilion.
15. Sport Pavilion.
16. Yacht.
17. Rodney Pier.
18. R.N.L.I. Lifeboat.
19. Seaside.
20. Flagstaff.
21. Royal Festival Hall.
22. The Unicorn (Café).
23. Lion and Unicorn Pavilion.
24. Flower Gardens.
25. Television Pavilion.

26. Telecinema.
27. Locomotives and Turntable Café below.
28. The People of Britain Pavilion.
29. 29 and 29A. Wigwams.
30. Pool.
31. 31 and 32. Transport Pavilions.
33. The Skylon.
34. Regatta Restaurant and Embankment Gate.
35. Hungerford Railway Bridge.
36. Bailey Footbridge.
37. Fountains.
38. Locomotive.

39. Murals.
40. Sculpture.
41. Sea and Ships Pavilions.
42. Dome of Discovery.
43. Mural, King Neptune.
44. Gangway.
45. Nelson Pier.
46. Fifty-one Bar.
47. Power and Production Pavilion.
48. Minerals of the Island Pavilion.
50. Administration Block, Car Parks, etc.

51. Chicheley Street Entrance.
52. Decorative Screen.
53. Information and Post Offices.
54. Fairway Café.
55. The Natural Scene Pavilion.
56. The Land of Britain Pavilion.
57. Station Gate, Escalator Hall (for Underground below).
58. Police and First Aid.
59. York Road.
60. Waterloo Railway Station.

THIS g
hove
external a
Bridge :
the down
27 acres,
wall. Th
enable the
Embankm
Festival l

DRAWN FOR "THE ILLUSTRATED LONDON NEWS" BY OUR SPECIAL ARTIST, G. H. DAVIS.

KEY TO DRAWING

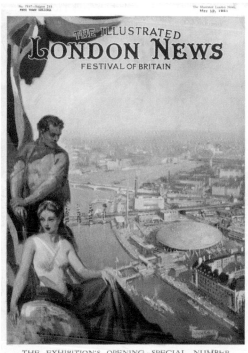

No. 7847—Volume 215
PRICE THREE SHILLINGS

The Illustrated London News,
May 12, 1951

THE ILLUSTRATED LONDON NEWS
FESTIVAL OF BRITAIN

THE EXHIBITION'S OPENING—SPECIAL NUMBER

ABOVE: The Festival of Britain exhibition opening, a special painting from *The Illustrated London News* painted by Terence Cuneo.

LEFT: An aerial view of the exhibition site of the 1951 Festival of Britain on London's South Bank showing the Dome of Discovery, The Skylon (a cigar-shaped structure that floated above the ground and other pavilions. Illustration by G. H. Davis for *The Illustrated London News*.

ITE, SHOWING THE LAY-OUT AND ALL THE CHIEF PAVILIONS.

vivid panorama of the South Bank Festival as it is to-day is viewed as it were from a helicopter
bove New Scotland Yard ; and it shows the location of all the major features and pavilions, the
ches and the various courtyards and restaurants. The site is divided physically by Hungerford
the upstream or nearer side of this the exhibits tell the story of the Land of Britain ; while
section is concerned with the British People themselves. The total area of the site is about
t will eventually be cleared, with the exception of the Royal Festival Hall and the new river
l, incidentally, has been the means of reclaiming about 4½ acres from the Thames, and will
e construction of an embankment walk with trees and gardens, a frontage worthy of the Victoria
hich faces it across the water, and of the new quarter which will grow behind it, with the
he National Theatre, and all the other features of a new section of Central London, as yet unborn.

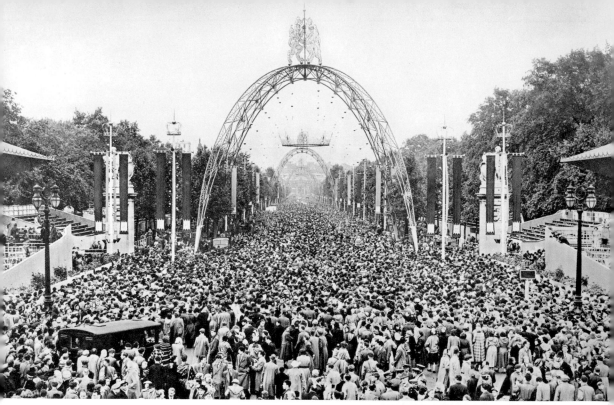

ABOVE: The Mall is packed with visitors anxious to try and catch a glimpse of Queen Elizabeth II following her Coronation on 2 June 1953. Visitors continued to pour into the capital to view the decorations erected for the Coronation of 1953, including the elegant triumphal arches spanning the thoroughfare.

RIGHT: A ticket for the Coronation in Westminster Abbey, 2 June 1953.

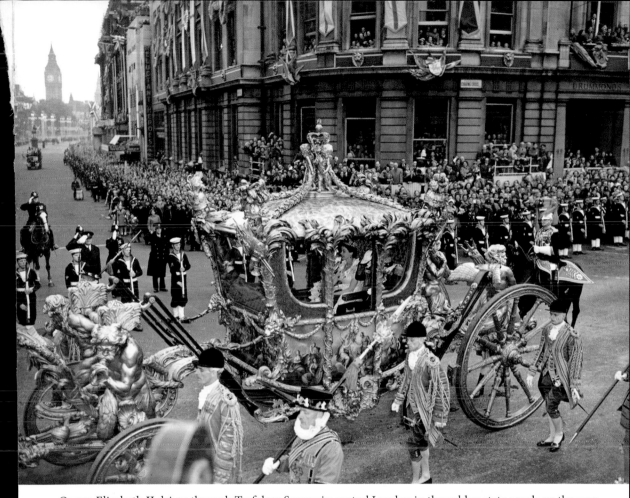

Queen Elizabeth II drives through Trafalgar Square in central London in the golden state coach on the way to Westminster Abbey for her Coronation.

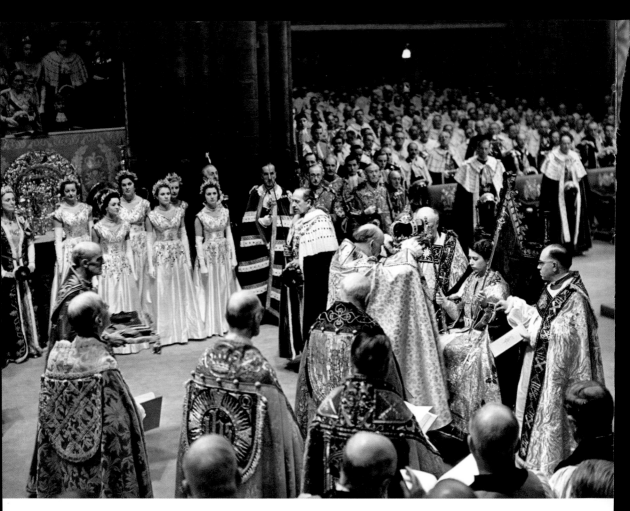

The Archbishop of Canterbury placing St Edward's Crown on the head of Queen Elizabeth II, the supreme moment in the Coronation service.

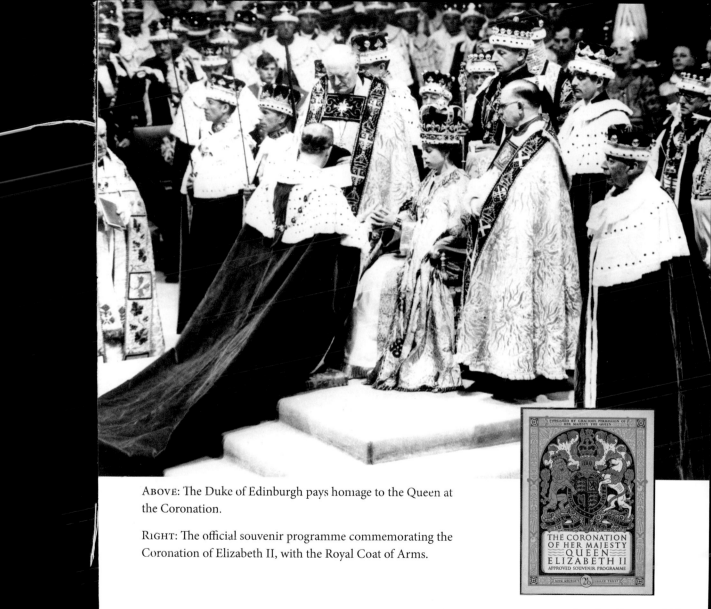

ABOVE: The Duke of Edinburgh pays homage to the Queen at the Coronation.

RIGHT: The official souvenir programme commemorating the Coronation of Elizabeth II, with the Royal Coat of Arms.

PUBLISHED BY GRACIOUS PERMISSION OF HER MAJESTY THE QUEEN

THE CORONATION OF HER MAJESTY QUEEN ELIZABETH II APPROVED SOUVENIR PROGRAMME

KING GEORGE'S JUBILEE TRUST 26

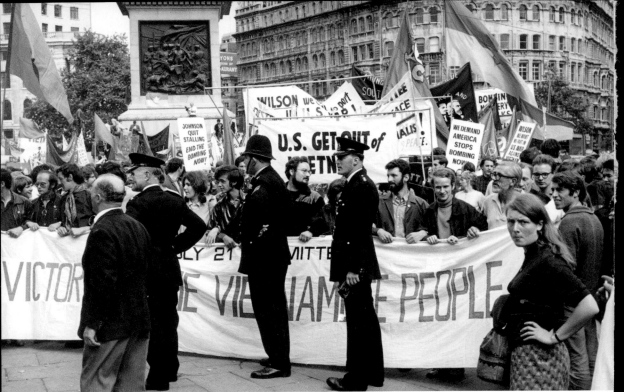

ABOVE: Protesters at an anti-Vietnam demonstration in Trafalgar Square in Central London, 21 July 1968.

RIGHT: The Aldermaston march at Turnham Green, 1958. Demonstrators marched from Trafalgar Square in London to the Atomic Weapons Research Establishment at Aldermaston. The march was organised by the Campaign for Nuclear Disarmament and was repeated annually from 1968.

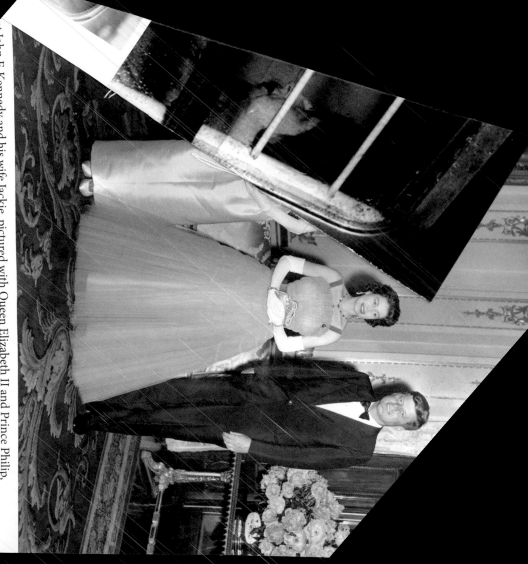

President John F. Kennedy and his wife Jackie, pictured with Queen Elizabeth II and Prince Philip, Duke of Edinburgh at a State dinner at Buckingham Palace during a visit by the President and First Lady in May 1961.

ABOVE: Christine Keeler, with Paula Hamilton-Marshall and Olive Brooker, taken in a police van for a hearing on charges of perjury and conspiracy to obstruct justice. All three faced charges 6 September 1963. The revelation that Keeler had an affair with government minister John Profumo threatened to bring down the Conservative government of the day.

RIGHT: Former British Minister of War John Profumo and wife Valerie Hobson arrive at home shortly after Profumo resigned his position. Profumo admitted having an affair with model Christine Keeler, 18 June 1963.

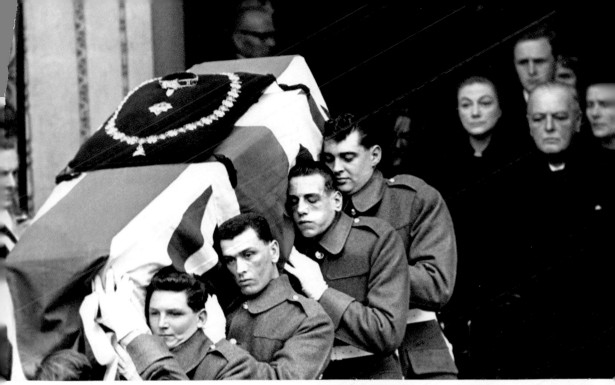

ABOVE: Watched by the mourning Churchills, the massive oak coffin of former Prime Minister Winston Churchill is carried with agonising care from St Paul's Cathedral on 31 January 1965.

RIGHT: Royalty and statesmen from many nations on the steps of St Paul's to watch the departure of the Winston Churchill's coffin as the last stage of its journey to Bladon churchyard, Oxfordshire, begins.

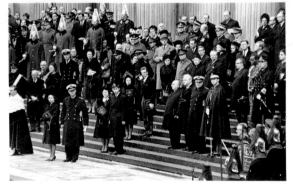

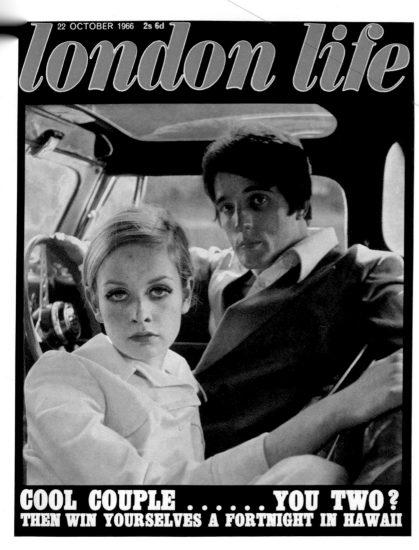

The front cover of *London Life* magazine, a short-lived publication, which documented and encapsulated the swinging sixties features Twiggy photographed with Justin de Villeneuve, her companion and manager from 1966–73. Villeneuve began life as Nigel Jonathan Davies and worked as a hairdresser before meeting a teenage Twiggy.

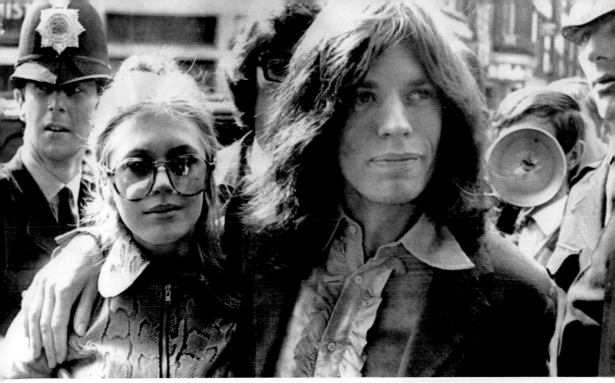

ABOVE: Rolling Stone, Mick Jagger arrives with girlfriend, Marianne Faithfull, at Marlborough Street magistrates court to face charges of possessing cannabis, following their arrest in a police raid at his home in Chelsea the night before, 1969. Rock and pop music became synonymous with youth culture during the sixties and led to an increasing media interest into the often louche lifestyles of rock stars.

RIGHT: The Beatles (1960–70). British musicians Paul McCartney, George Harrison, John Lennon and Ringo Starr, after conferring of the order, Member of the British Empire, (MBE), press conference, Saville Theatre, London, 26 October 1965.

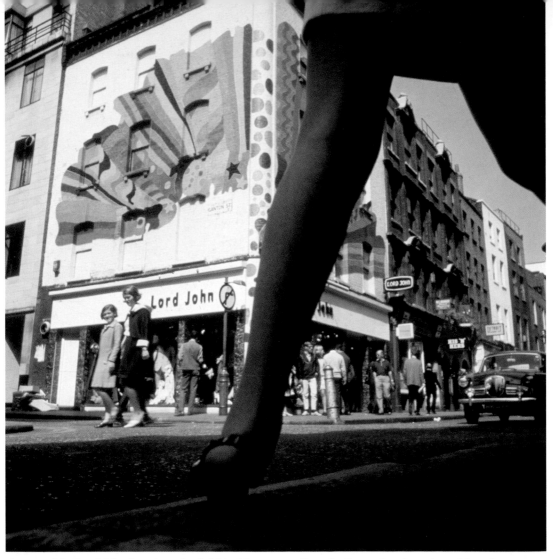

A view of the Lord John boutique for fashionable men on Carnaby Street, London, viewed from between the legs of a girl in a mini skirt!

PICTURE CREDITS

Retro London Photo Credits: All images are researched and supplied by Mary Evans Picture Library, Blackheath, London. Individual contributors available through the library, are listed below.

AGIP/Epic/Mary Evans: 397a
Alan Greeley/Mary Evans: 208
Country Life/IPC Media Ltd/Mary Evans: 339
English Heritage Archive /Mary Evans: 54, 66, 67, 68, 77
H L Oakley/Mary Evans: 137, 303b
John Frost Newspapers/Mary Evans: 367, 371, 373
John Gay/English Heritage.NMK/Mary Evans: 24, 28, 29, 30, 43, 48, 49, 100-101, 106, 123, 156, 157, 171, 175, 187, 220, 227, 258, 259, 260, 261, 264, 273, 274, 277, 283, 290, 296, 298-299, 305, 311, 316, 322
Illustrated London News/Mary Evans: 20, 41, 53-54, 59, 60, 61, 64, 71, 76, 77, 78, 98, 99, 108-109, 110, 112, 117, 131, 133, 139a, 139b, 141, 148-149, 159a, 159b, 161, 164, 168-169, 181, 268a, 268b, 271, 333a, 333b, 335, 354, 361, 368, 369, 372, 373, 374, 375, 376, 378, 381, 382, 384-385, 386-387, 387b, 388, 389, 390, 391, 393, 395a, 395b, 396
London Fire Brigade/Mary Evans: 33, 83, 84, 85, 86, 87, 88, 90, 91, 92-93, 93b, 94, 95, 96, 270, 371
Mary Evans: 2-3, 18, 23, 32, 36, 42, 62, 63, 68, 70, 80, 82, 105, 119, 120, 121, 122a, 122b, 124, 125, 126, 128, 129, 132, 133, 134, 135, 141, 143, 144, 145, 146, 155, 160, 162, 163, 174, 180, 190, 192, 193, 196, 207, 216a, 216b, 217, 218, 220, 221, 222, 224, 225, 237, 240, 242, 243a, 243b, 244, 257, 258b, 262, 263, 275, 281, 284, 286, 293, 294, 309a, 309b, 320, 323, 324, 326, 329a,329b, 340b, 347, 356, 358, 366, 391
Mary Evans/Andrew Besley: 343

Mary Evans/APL: 248
Mary Evans/Bill Coward: 36
Mary Evans/Bruce Castle Museum: 265b, 287, 344
Mary Evans/David Lewis Hodgson: 288
Mary Evans/Everett Collection: 194, 199, 360, 394a, 394b
Mary Evans/Epic: 40, 166,
Mary Evans/Francis Frith: 155b
Mary Evans/Gerald Wilson: 250-251, 282
Mary Evans/Grenville Collins Postcard Collection: 31, 35, 38, 44, 45, 46, 97, 115, 116, 177, 188, 208, 223, 224, 229a, 229b, 267b, 304, 305, 318, 319, 320, 321, 326, 340, 346
Mary Evans/Gould Wilson: 19
Mary Evans/Hardy Amies: 336
Mary Evans/Heinz Zinram Collection: 142, 306
Mary Evans/Henry Grant: 12, 13, 388
Mary Evans/James Eadie: 398
Mary Evans/Jazz Age Club: 111a, 111c, 120, 124b, 170a, 170b, 170c,
Mary Evans/John Benton-Harris: 25a, 25c, 231, 276, 295, 297, 345
Mary Evans/John Maclellan: 180, 256
Mary Evans/Ida Kar: 249
Mary Evans/Interfoto Agentur: 198, 272, 397
Mary Evans/Imango: 26, 127, 165a, 165b, 173a, 226, 241, 278, 313, 364
Mary Evans/Imango/Austrian Archives: 368
Mary Evans/Interfoto: 107
Mary Evans/Maurice Ambler Collection: 113, 115b, 186a, 186b, 187, 233, 291, 308, 310, 317
Mary Evans/Moyra Peralta: 234
Mary Evans/National Archives, London: 308, 274
Mary Evans/National History Museum: 328